A Roomful of Hovings

BY JOHN MCPHEE

Coming into the Country

The Survival of the Bark Canoe

Pieces of the Frame

The Curve of Binding Energy

The Deltoid Pumpkin Seed

Encounters with the Archdruid

The Crofter and the Laird

Levels of the Game

A Roomful of Hovings

The Pine Barrens

Oranges

The Headmaster

A Sense of Where You Are

A Roomful of Hovings

AND OTHER PROFILES

by John McPhee

FARRAR, STRAUS AND GIROUX, NEW YORK

To my mother, Mary Ziegler McPhee

"A Roomful of Hovings" appeared originally in *The New Yorker* and was developed with the editorial counsel of William Shawn. The four other profiles in this book also appeared originally in *The New Yorker* and were developed with the editorial counsel of William Shawn and, respectively, Robert Bingham ("Templex," "A Forager"), William Knapp ("Fifty-two People on a Continent"), and C. P. Crow ("Twynam of Wimbledon").

Published simultaneously in Canada

Printed in the United States of America
Designed by Betty Crumley

Contents

ONE

A Roomful of Hovings 1

TWO

A Forager 65

THREE

Fifty-two People on a Continent 119

FOUR

Twynam of Wimbledon 173

FIVE

Templex 201

A Roomful of Hovings

1967

FIFTH AVENUE

Each day, nearly all day, Thomas P. F. Hoving stood somewhere near the Short Portly rack in the John David clothing store at 608 Fifth Avenue. He wore a double-breasted sharkskin suit, with a fresh flower in his lapel. On his face was a prepared smile. He was a floorwalker. This was the summer of 1950, and he was nineteen years old.

"May I help you, sir?" Hoving would say to almost anyone who came through the door.

"I'd like to see Mr. Gard."

"Gard! See-You!" Hoving called out, and Mr. Gard, a master salesman, sprang forward.

See-Yous were people who asked for specific clerks. Otherwise, customers were taken in rotation. It was not unknown in that era for clothing salesmen to slip substantial honoraria to

floorwalkers to get them in the habit of turning non-See-Yous into See Yous. But Hoving was unbribable. He had learned that every salesman recurrently dreams of a rich Brazilian who—when it happens to be the dreamer's turn to wait on him—will walk into the store and order fifty-five suits. Hoving would do nothing that might spoil this dream. The door opens again, and a tall, slim, wilted-looking man enters the store and dispiritedly examines a display of ties; then he crosses to the rack of 42 Regulars and begins to finger the sleeves of the suits. This man is a Cooler. His constitution has just been defeated by the incredible heat outside, and he has come into the store to recover. Hoving is merciless. He says, "May I help you, sir?"

"Just looking," the Cooler says.

"Sir, you don't belong in this section," Hoving says. "You are a 39 Extra-Long."

To show Coolers what they were up against, Hoving would lead them directly to the area of the Hickey-Freeman suits—the best in the store, one hundred and twenty-five dollars and up. Hoving's idea of a summer place was Edgartown, on Martha's Vineyard. He hated this job—or, more precisely, he hated the idea of it—but it was apparently designed by his father as a part of a program of training, for his father, Walter Hoving, who was then president of Bonwit Teller and is now chairman of Tiffany & Co., happened to own, as well, the John David chain of stores. Young Hoving learned a lot there. He could fold a suit and wrap it in ten seconds; he also noticed that prostitutes who came into the store generally hunted for contacts along the suit racks, while homosexuals used the shoe department. Every lunchtime, all summer long, he went to the Forty-second Street Horn & Hardart and ate the same meal—hamburger, mashed potatoes, and a ball of chocolate ice cream.

When Hoving, after a brilliant year as City Parks Commissioner, had just become (at the age of thirty-six) Director of the

Metropolitan Museum of Art, he reflected, one day, on the John David summer. "Mr. Gard and Mr. Mintz were important influences on my life as a floorwalker," he said. "They told me, 'Don't buckle in. Do it honest. Only schnookers will ask to be brought out of rotation. The rich Brazilian will come to every man in his lifetime.' " Hoving said that he had not believed in the rich Brazilian until a day when one came in. "He bought twenty Hickey-Freeman suits," Hoving recalled. "The young salesman who had him was going bo-bo. Around the first of August, that summer, I began to get the ague from standing on my feet all the time. The man we all worked for was called Colonel Ladue. He had owned the chain before my father did, and had been retained to run it. You had to call him 'Colonel' or he'd get disturbed. You *know* what kind of a guy that is. He had an adder's glance—without a nod, without a smile, without a crinkle of the eye. That summer killed me on the mercantile business."

EDGARTOWN

Hoving in Edgartown, in the summers of his adolescence, was a part of what he describes as "a wild bicycle set, semi-richies, cultured Hell's Angels of that period." They had names like Grant McCargo, Dikey Duncan, and David Erdman, and they numbered up to fifteen or twenty, with girls included. Hoving was not the leader; he could apparently take or leave everybody. Nonetheless, he was thought of by some of his friends' mothers, though they seldom had anything really gross or specific to cite, as the sort of boy who was probably a corrupting influence on their children. He went out with a scalloper's daughter. His family didn't give him much money—never more than two dollars a week—so he washed

cars, worked in a bicycle-repair shop, painted sailboats, caddied
for golfers, and set pins in a bowling alley. Sailing races were the
main preoccupation of the pack, and Hoving was always a crew-
man, never a skipper—in part, he says, because he never had a
skipper's feel for the wind and the sea, and in part because he
never owned a boat. All the boys wore blue or white button-
down shirts. Hoving had both kinds, too, but he also appeared
in patterned sports shirts, which were an emblem of immeasur-
able outness. He didn't care. Everybody wore a stopwatch around
his neck, for the racing. One day, when the boys were fifteen,
they discovered another use for the stopwatches. Grant Mc-
Cargo bought a case of ale—"local poison, eighteen cents a
can"—and, as Hoving continues it, "we all went into the grave-
yard and sat on friendly stones; we had shot glasses, and every
thirty seconds everybody drank a shot of the ale until we were
completely zonked." He played tennis barefoot, and his idea
of real action was a long, cool ride in the breakers. "Great!
Great!" he would say when he felt an impulse for the surf.
"Let's go out to Barnhouse Beach and get boiled in the rollers."
When he went to the beach, he took books along, in his bicycle
basket, and he read them while he was lying in the sun recover-
ing from the rollers. Robert Goldman, who later roomed with
Hoving at Princeton and is now a writer of musical plays, was
an occasional visitor to Edgartown in the years when Hoving
was there. "He had a precocity typical of New York kids,"
Goldman remembers. "You know, you leap right from child-
hood into being twenty-one. Tommy was always hip, always
absorbed with upper bohemia. He made newspapery references.
He was the first person I ever heard use the word 'great' in that
special sense. Everything was 'great.' I went to Edgartown un-
invited once, and I was pretty much on the outside of things,
and a situation came up one day when Hoving said, about me,
'Hey, let him play.' I've never forgotten it. He was an unaffected

city kid, with spirit to him. He never made me feel like an intruder. Some of the others did." Hoving clowned and joked a lot, and he haunted an empty house once with Dikey Duncan (using sheets, chains, and foghorns) until the police put a stop to it, but he was actually quite shy, and he felt sure that he was not at all popular. One index of popularity in Edgartown, however, was the number of bicycles that could be found stacked outside one's house, and wherever Hoving was living was where the biggest stack of bicycles was. To be sure, this was in part because of the warm personality, unfailing generosity, and utter permissiveness of his mother, who was apparently neither as staid nor as consciously social as most of the other parents in Edgartown, and whose house (always a rented one) was a sanctuary for young people from discipline of any kind. She had been divorced from Tom's father when Tom was five years old. Her name was—she died in 1954—Mary Osgood Field Hoving, her nickname was Peter, and she was a descendant of Samuel Osgood, the first Postmaster General of the United States. Her father, Tom's grandfather, was such a fastidious man that he kept a diary of the clothes he wore. His wife left him, and from the age of two Tom's mother was brought up by an aunt. She married Walter Hoving when she was a débutante, pretty and blond, a cutout exemplar of the girl of the nineteen-twenties. Although she never married again, men were always attracted to her in clusters, and—according to Nancy Hoving, Tom Hoving's wife—"old half successes with moon in their eyes still ask about her." Some of her friends would act, on occasion, as surrogate fathers to Tom and his older sister Petrea, or Petie, turning up at child functions where parents are supposed to appear. Both Tom and his mother had strong tempers, and the two of them would sometimes have conflagrationary fights. Friends once came upon them sitting in a doorway in Edgartown together, weeping. Tom

eventually learned not to participate—to act, when something unpleasant came up, as if it weren't there. (This is a faculty he is said to have kept.) His mother's emotions sometimes overflowed in the opposite direction as well, and the more demonstrative she was toward him, apparently, the more he pulled away, developing a general aloofness that characterized him for some years—until he was ready to take part in things on his own terms. Remembering himself at Edgartown, he once said, "I'm sure the other mothers thought, Poor Peter, with a son like that! I was pretty scrawny, uncoördinated, and slovenly." He fought constantly with his sister (he once pushed her out on a roof and locked the window), but he was unusually close to her—they were two years apart in age—and he has named his only daughter Petrea for her. His particular friend was Dikey Duncan, whose family held the Lea & Perrin's Worcestershire Sauce franchise in the United States. Hoving and Duncan had the same attitude, according to Hoving's description: "Cool. We cooled it, you know. The same thoughts came to us. Dikey was bland, thin, and wiry, and he had a delightful irresponsible touch. We all used to go out to South Beach and play capture-the-flag, then sit around a great fire and get zonked. Dikey, who liked whiskey, would suck away at this bottle of Black Death. Everybody else drank Seabreezes. There were periods of forty days when we were never not drunk in the evening. One night, Dikey shambled down to the yacht club and insulted many parents, and our introduction to booze came to a grinding halt." Grant McCargo had a car (something Hoving never had), and the others would monitor McCargo's speed with their stopwatches, having determined beforehand the distances between various landmarks on the island. McCargo, as Hoving remembers him, was a silent young man who was very much worth listening to when he spoke, and his favorite object was a

Wright & Ditson tennis-ball can, from which he drank his Seabreezes. ("He was always getting fuzz in his mouth, and the drinks tasted of rubber.") With the tennis-ball can in one hand and the steering wheel in the other, McCargo used to drive all the way across Martha's Vineyard at night with the headlights turned off, while Hoving, Duncan, and additional passengers assessed his progress with their stopwatches. Hoving's Edgartown era came to an end after a beach party. The pack turned over a large sand-moving machine and set its fuel tank ablaze. Hoving caught the next ferry for the mainland, and he has never been back to Edgartown. With a mixture of shame and dramaturgy, he has always claimed that he can never go back, because the rap for the sand-moving machine is on him still. He is a lover of intrigue, secrecy, and mystery, and he sometimes finds shadows more interesting than the objects that cast them. He could, of course, go back to Edgartown, but not as a boy, and that is probably what he actually means. David Erdman, the skipper whom Hoving served as crewman summer after summer, cannot remember that Hoving in Edgartown gave even the faintest of hints of the future that awaited him. "He showed no artistic inclinations at all," Erdman said recently. "If I had been told that he would eventually be the Director of the Metropolitan Museum, I would have laughed and laughed and said, 'You've got to be kidding.'"

RORIMER

In the spring of 1959, when Hoving was a graduate student in art history at Princeton, he gave a lecture at an annual symposium at the Frick Collection, in New York, on certain antique sources of the Annibale Carracci frescoes in the Farnese Gallery, in Rome. The symposium was known among graduate

students as "the meat market"—a place where the young are examined by experienced eyes from museums, galleries, and universities, and where futures can be made or ruined. Hoving's palms had been damp for weeks. He feared, among other things, the presence of Erica Tietze-Conrat, an art scholar who attended the symposium unfailingly and had been known to stand up in the middle of a young man's reading and shout, in a martial Wagnerian accent, "You! Are! Wrong!" Hoving, acting on a reasonable guess, had found unmistakable similarities between ancient sculptures in the National Museum in Naples and figures in the Carracci frescoes in the Farnese. He had learned that the sculptures now in Naples were actually housed in the Farnese Palace when Carracci was doing his work there, and this was the gist of what he presented at the symposium, in a twenty-minute talk illustrated with slides. Erica Tietze-Conrat did not interrupt him, and when he had finished she applauded strongly. "A few moments later," as Hoving continues, "a man, 39 Short Portly, whom I didn't know, came up to me and asked if, in my work on the Farnese Gallery, I had encountered records of a large sixteenth-century marble table inlaid with semiprecious stones that had once been in the center of the gallery. I said I did not remember seeing anything about such a table, and he asked if I had time to have a look at it, since he happened to have it. I said sure. I had no idea who the man was, and I guess he assumed that I knew. He had deep, deep, penetrating, steady brown eyes that didn't blink. He led me out onto Fifth Avenue and a number of blocks north, up to the Metropolitan Museum. We went in at the Eighty-first Street entrance and up the stairs to the office of the Director, and by then I had figured out that he must *be* the Director, but, to tell you the truth, I had no idea who the Director of the Metropolitan Museum *was*. So I kept sidling around his desk while he talked—trying to get a look into his 'in' box, you know—and finally I saw his name, James J. Rorimer."

After they had looked over the marble table, which is now in the center of a room full of Italian Renaissance paintings, Rorimer asked Hoving what he was going to do when he left graduate school. Hoving said that he thought he might work in a gallery and that he had already been interviewed by George Wildenstein and a man at Knoedler's. "Really?" Rorimer said. "I'm surprised. Go to a dealer and you'll never work at any museum in the United States. Go to a museum and you can later work, if you like, at any dealer's shop in the world."

Rorimer invited Hoving to come into the city and have lunch with him each Wednesday for a while, and Hoving did. Later that year, Hoving went to work for the Museum, at an annual salary of five thousand and five dollars. He soon became a curatorial assistant in the Museum's Medieval Department and at The Cloisters, and one of his first assignments was to write a letter of declination to a New York dealer who had offered for sale, in a letter with a photograph, a twenty-four-by-twenty-six-inch marble Romanesque relief that was then somewhere in Italy. In a margin of the dealer's letter Rorimer had written, "Not for us." The photograph looked so interesting to Hoving that he asked his superiors in the Medieval Department if he could study the relief for a while before writing to the dealer. He was told, with fatherly understanding, to go ahead and do that, and for a week he went through book after book and hundreds of pictures, but he found nothing that could help him to trace the source of the relief and discover whether there was any substance to his feeling that it was of uncommon interest. So he wrote the letter ("We regret to say that we do not feel that this piece will fit into our collection . . .") and sent it off, but the matter continued to preoccupy him and he kept looking. Two days later, in a book on twelfth-century Tuscan sculptures, he found a picture of a Romanesque marble pulpit that had once stood in the Basilica of San Piero Scheraggio, in Florence—a church that became completely entombed in

Cosimo de' Medici's administrative offices, the Uffizi, when they were constructed in the sixteenth century. Hoving eventually learned that Dante had spoken from this pulpit, and so had St. Antoninus and Savonarola. In 1782, the pulpit had been dismantled and moved just across the Arno from Florence to a church in Arcetri, where it is today—three-sided, and standing against a wall. The pulpit is decorated with six reliefs, carved in fine yellow-white Maremma marble, which have been called the masterwork of Florentine Romanesque sculpture. As Hoving studied photographs of these scenes, all from the story of Christ, he was struck by the thought that the piece he had turned down in his letter to the dealer belonged among them, but he couldn't see how it would fit in. He sought out publications about the pulpit, one of which had appeared as recently as 1947 and one as early as 1755. A Florentine scholar named Giuseppe Carraresi had written in 1897 that he believed the pulpit had once been a freestanding structure (not set against a wall, as it is today) and had originally been decorated with seven reliefs, the eighth space being left open as an entryway. The trail was getting extremely warm. The scene in the photograph submitted by the dealer was of the Annunciation. There was no Annunciation scene among the reliefs still on the pulpit, although an Annunciation would logically belong among them. Finally, Hoving noticed something odd about an inscription that ran along a marble slab under one of the reliefs. The inscription said, "*Angeli pendentem deponunt cuncta regentem*"—"The angels let down the hanging King of Kings." But angels were not lowering Christ from the Cross in the scene above; He was being let down by Joseph and Nicodemus. Between the word "*Angeli*" and the word "*pendentem*" was a vertical break in the marble, directly below the left-hand edge of the Deposition relief. The "*i*" in "*Angeli*" was slightly curved and was formed in a different way from any other "*i*" in the

pulpit inscriptions. The "*i*" was, in fact, demonstrably a fragment of a "*u*," the rest having been broken away, and the original word could not have been the plural "*angeli*" but must have been the singular "*angelus*," just right for the beginning of an inscription under a relief—the missing seventh relief—showing Mary being visited by an angel of the Lord. Rorimer, with surprise and considerable pleasure, told Hoving to write a second letter to the dealer, putting the Annunciation relief on reserve for the Metropolitan Museum.

Earlier, when Rorimer assigned Hoving to The Cloisters, he told him that in certain ways he envied him. Rorimer, himself a medievalist, had worked for the Museum since his graduation from Harvard, and he had developed The Cloisters, in its present location, from the beginning, after a Rockefeller gift in 1934 established the site and the building. As curator of The Cloisters, Rorimer liked to spend many hours carefully going over medieval sculptures with ultraviolet light. He loved the disciplines of scholarship and the pleasures of exploratory trips to Europe. And, as Director of the Museum—which he became in 1955—he missed these things. Hoving had been at The Cloisters only a few months when Rorimer took him on a long trip, mainly through France, Spain, and Italy—wives and, in Rorimer's case, children included: eighty-five hundred miles in a green 1953 Chevrolet station wagon with license plates from Ohio, where Rorimer had a farm. He wanted to show Hoving all his sources—dealers, private collections, friends, university people. The trip was the most important single influence on Hoving's development in the Museum. He got the feel of Europe as Rorimer knew it, saw the architecture through Rorimer's eyes, and, along the way, formed a deep friendship with Rorimer himself.

In the Loire Valley, Rorimer climbed out through a window of a château in order to escape from a boring guided tour, with

all the other Rorimers and the Hovings following. Everywhere they went—in every church, museum, or other monument—Rorimer said, "Pick out the three best things. What would you like to have? Why?" Then he would incite what Hoving describes as "great fierce mock arguments." One of these concerned the portal carving at the Cathedral of Angers and whether or not it had been restored. The Hovings and the Rorimers stayed overnight in Angers, and in the morning Hoving got up at six o'clock and went to have another look at the portal. As he rounded a corner of the cathedral, he met Rorimer, coming the other way. On the third day of the trip—after a lazy, wine lunch—Rorimer went to sleep at the wheel. Hoving did almost all the driving for the rest of the trip. Rorimer always had a pocketful of cigars, and he filled the car with smoke and laughter. When guidebooks were available, he and Hoving looked at them only after they had visited the places and objects described, the better to practice their eyes. On an altar in the old cathedral in Salamanca, they saw a seated copper-gilt, Limoges-enamel Madonna that was, as Hoving remembers it, "resplendent, with almond, stunning eyes." The piece was so resplendent, in fact, that they began to argue over whether it had more likely been made in the twelfth century or in, say, 1959. Rorimer posted his children in key places to look out for guards; then he and Hoving took off their shoes, climbed the altar, and studied the enamel surface through a pocket glass. "It's glorious," Rorimer said as he peered through the glass. "This proves to both of us that you've got to get right to a thing. You can't do it from a distance. You've got to touch it." Rorimer had a passion for professional anonymity and secrecy. Ordinarily, he had about him an air of cloaked movements and quiet transactions, of undisclosable sources and whispered information—a necessity, surely, in the museum world, and something that Rorimer had refined beyond the dreams of espionage. Accordingly, when he and Hoving turned

up, by arrangement, at a certain garage in Genoa, Rorimer carried a French newspaper and instructed Hoving to speak only in French while they went inside and viewed, for the first time, the Annunciation relief from the pulpit in Arcetri. Afterward, Rorimer coolly covered his tracks by leaving the French newspaper in the garage. Then they drove to Arcetri, to look at the pulpit itself. Leading away from the front of the church in which the pulpit stands is an extremely narrow street called Costa di San Giorgio, and many museum people from various countries have houses and apartments there—for example, John Pope-Hennessy, who is, inevitably, known as John the Pope and is now Director of the Victoria and Albert Museum, in London. Rorimer, of course, wanted to visit the church without attracting any attention at all, but the green Chevrolet station wagon became wedged between facing buildings on the Costa di San Giorgio, and Italians poured out of doorways and surrounded the car. Soon museum types were swarming all over Rorimer: "How long have you been here?" "Where are you staying?" "Why didn't you let us know you were coming?"

Some months after Rorimer and Hoving returned to New York, Erich Steingräber, Director General of the Germanic National Museum, in Nuremberg, came to the Metropolitan, at Rorimer's invitation, and spent more than half a year studying the collection. Hoving attached himself to Steingräber, and for days and days they went around the Museum, opening cases, handling things, and talking about them. Hoving says, "He taught me everything in the book—how to look at a work of art, how to judge its style, the tricks of forgers. There was a difference between Rorimer and Steingräber as connoisseurs. Jim liked big things—masses, big spaces, façades, tapestries. He was not interested in iconography; he was interested in the large scale. Steingräber loved enamels, carvings, reliquary caskets, small sculpture, jewelry. I like them all, but I don't have Jim's gift for the massive things."

In November, 1965, when the Mayor-elect offered Hoving the job of Commissioner of Parks for the city, Hoving went into Rorimer's office and said, "Jim, he's offered me the big marbles. What shall I do?"

Rorimer said, "No matter what I told you, you'd resent it."

"I'm going to think about it tonight," Hoving said.

Rorimer slapped his desk, and Hoving thought he could see in Rorimer's face both anger and disappointment. Rorimer said, "All I can say is, I know what I would do if I were your age." Hoving has never been completely sure that he understood what Rorimer meant.

"I hope that someday I will be allowed to come back," Hoving said a week later.

"You will," Rorimer said. "Absolutely."

Hoving went to the May, 1966, board meeting at the Museum as a trustee ex officio, a position he held automatically as Parks Commissioner. Rorimer also had him sit in that day on an impromptu meeting of the purchasing committee, which considers works of art, looks at slides, and makes decisions. Hoving remarked of one piece that the Museum ought to pass it up, because it was very similar to something they already had. Rorimer said, "Just because you're our landlord, you don't have to tell us what to do." Hoving remembers that Rorimer was in great form that day, full of vivacity and jokes, sitting on the edge of his desk and swinging his legs. He died that night, while he slept.

SCHOOLBOY

Hoving sometimes refers to private schools as zoos. He went to four. The first one, Buckley, phased him out, as Hoving puts it, in the fourth grade. The school's explanation was smooth

with use. Perhaps Tommy needed more individual attention, a smaller school? Eaglebrook, a pre-prep school in western Massachusetts, was chosen. He was there for five years, and they were the best years of his youth. Items from the school's records show that although Hoving came from "an unstable background," he eventually made an "excellent social adjustment" and was a "friendly, outgoing, engaging, fun-loving, irrepressible, happy-go-lucky, impulsive, irresponsible, but industrious" boy, who got into "a good healthy amount of trouble." He was extremely thin, but he played football, baseball, and hockey, and he became (and still is) an expert skier. He played the piccolo and the flute. He spent a great amount of time reading. The I.Q. that had been reported from Buckley was not particularly high, but he earned excellent grades. C. Thurston Chase, the retired headmaster of Eaglebrook, remembers him as "a likable scamp, a good guy, not a future Met director," and Chase goes on to say, "He had a very dominating father—handsome, driving, cocky, and lonely—whose charm wore thin when he visited Eaglebrook. He wanted the boy to be vigorous, hard-studying, and successful. Tom was easygoing, and not overly ambitious. He was interested in creative and artistic things, but not overly energetic about it. He reacted unfavorably to his dad's pushing. His mother was quite different. She was loving, soft, and lonely." In 1942 and 1943, when Hoving was eleven and twelve, he spent the summer at Eaglebrook. A work camp had been established there, so that students from various schools could help relieve the wartime labor shortage on local farms. Today, when he reflects upon his childhood, it is this experience on the farms of the Pioneer Valley that seems to come most readily and fondly to mind. "I liked hoeing best," he says. "Walking. Moving. Competing with the guy in the next furrow. We hoed corn, hoed potatoes, hoed tobacco. It was hot and humid under the gauze of the tobacco tents. We clipped

onions and thinned out apple blossoms, and we grew our own
food in gardens around Eaglebrook. There were three hundred
of us altogether. We'd go out early in the morning and start in
on a mile of corn. We drank too much water at first, and
fainted. Then we learned the rhythm of that kind of work from
Polish farm ladies. We made twenty-five cents an hour. At
noon, we ate sandwiches and field tomatoes, and drank iced tea;
then we slept off lunch in the cool earth of the corn furrows.
The corn had a kind of mystery. You were out there and it was
very high, all around you. I learned to chew tobacco. When you
were working, chewing gave you something to do and kept you
from getting thirsty. After a while, I became a foreman—thirty
cents an hour, wow!—and I blew a whistle to get people back
into the furrows. At night, we had dinner out on the grass
around the school. We talked, and sang. Someone had a guitar.
And we had interminable puppy-love affairs. On Saturday
nights, we would go off in a truck to Greenfield or some other
hot frontier town and buy bubble gum and cinnamon rings, go
to two movies, and drink incredible amounts of Moxie." During
the school year, Hoving frequently took his turn as a dish rinser
in the school kitchen ("It was thrilling to work in the deep
sink; it isolated you into manhood"), and one of his early
heroes was Dick Davis, the school cook, who remembers him as
a fairly tall and very neat boy who always had his hair combed
and who "had a little chip on his shoulder about his father but
still was proud of his father." Eaglebrook considered Hoving so
outstanding that his name was carved in six-inch block letters in
a traditional place of honor above a fireplace, where it appears
today. He moved on, in 1946, to Exeter, where he lasted six
months. He was thrown out for general insubordination. In the
moment that precipitated his dismissal, he slugged a six-foot-
five-inch Latin teacher, who had given him an A-2, signifying
that his work was excellent but his attitude poor. "The place

was too big for me," Hoving says now. "It was a junior college. There was no discipline there. I drove people out of their skulls. Getting tossed out changed me. It took my confidence down. My father was furious and wouldn't speak to me for a while. Exeter said I was immature, sloppy, and slovenly, and had bad attitudes. This got to me." Curiously, he established a remarkable number of enduring friendships in his short time there, and although he finished prep school at Hotchkiss, it was with Exeter friends that he roomed at college. At Exeter, he was given the nickname Loper—for his long, loping gait on the athletic fields—and his Exeter friends call him Loper today. As a goalie in intramural hockey, he mimicked the gestures and language of the pros. "He was like a George Plimpton fantast," one of his teammates remembers. "He was always hitting the sides of the cage with his stick—you know, playing a role, in the best sense—and shouting, 'On the right! On the right!' He was about twenty per cent too much. He knew all the words. I wouldn't exactly say he knew the music. Oh, and he had this squint, like a large, lean Chinese who has tasted something bad, ducking that almond of a head into his shoulders." When Hoving arrived at Hotchkiss, he had already entered what some of his friends and relatives have described as the introverted era of his life. He frequently got up at five-thirty in the morning and went to the library, alone. He paid a cleaning woman for the use of a key to a large closet, so that he could go in there and read after 10 P.M., when the lights went out. He made high grades, but he apparently passed through the school like a shadow. His favorite teacher, confronted recently with Hoving's name, thought a moment and then said, "He did not blaze a trail across my memory." Another teacher remembered Hoving as "an aloof and standoffish boy, colorless, reticent, self-contained, quite beyond criticism, but not caught up in a warm way with the class," and added, "Altogether, one would not

have a feeling that he would become the public figure he is."
Hoving was known among his Hotchkiss classmates as Schmo.
"Most of them thought I was a real jerk," he said recently. "I
was very, very withdrawn and introspective. They were a pretty
sophisticated bunch of cats, and pretty dull. The student
council tried to stop me from smoking. I don't buy when my
contemporaries tell me they don't like my attitude. I didn't go
to the football or basketball games. I was a loner. I was on the
outs. I was totally uninterested in school spirit. I had gone to
boarding school since the fourth grade, and I had seen enough
rah-rah. I lived for vacations. The thought of being locked up
there for weeks and weeks—I used to sweat with the horror of
it. If you see your life in terms of weather, Hotchkiss was over-
cast and threatening. Trees were green there in my last year,
because it was my last year." That year, 1949, he was elected to
the Cum Laude Society, the preparatory-school equivalent of
Phi Beta Kappa. On January 30, 1967, he received a telegram
from the Hotchkiss student council: "IN RECOGNITION OF YOUR
SUCCESS, A HOLIDAY HAS BEEN GIVEN IN YOUR HONOR."

ART AND FORGERY

When Hoving was twenty, he had a summer job with a large
interior-decorating company that had been hired by Walter
Hoving to beautify a branch store in Ohio. His own account of
this job is as follows: "So there I was, with the boys clawing and
scratching. The firm needed someone who was straight—a 'non-
creative type,' as they put it—to catalogue the materials they
were going to use and to see to it that the stuff got to Ohio."
Paintings were among the materials that the decorator was
using, and one of Hoving's responsibilities was to collect certain
works—"turgid nineteenth-century landscapes, third-rate Barbi-

zon School"—at a restorer's shop in the East Fifties. While he
was there one day, he noticed a couple of Utrillos in a bin, and
a Boudin, and a Renoir. Then he saw a half-finished Utrillo
and, in a bin next to it, an Utrillo that had only just been begun
and was little more than a sketch on canvas. Noting Hoving's
absorption, the owner of the shop offhandedly informed him
that a good Utrillo took about thirty minutes to do, that a
Boudin came out best if it was done almost all at once, but that
a Renoir took at least a day. Since then, Hoving has never
looked at a Boudin or an Utrillo without deep suspicion. He
believes that he can tell Renoirs. The owner of the shop also
said to him, "Who the hell knows the difference?"—a question
that would, of course, become a major one in Hoving's life. At
the time of the Hungarian uprising, when he was twenty-five
and had completed one year of his course of graduate study, he
went into a dealer's shop in Vienna, where he saw a painting
that he recognized as Goya's "Man at the Grindstone." His first
thought was "It's a fake." But he knew that this particular
Goya belonged in the Budapest Museum of Fine Arts, and it
was rumored that any number of Hungarian art treasures were
being taken out of Hungary. He left the shop and returned with
books on Goya. He studied the painting, and when other
people came into the shop the dealer deftly made sure that the
Goya was hidden. The dealer managed to suggest that the
canvas was too hot to bring much of a price. Hoving finally
bought it for two hundred dollars. He paid and he learned.
"Trust your first impression," he says. "Always trust your
immediate kinetic reaction. Don't think of how it could be
possible. That guy did a great con job on me. During the
Hungarian revolution, every forger in Vienna was busy forging
private and public Hungarian treasures." In 1964, as an assistant
curator at the Metropolitan, aged thirty-three, he was consider-
ing for purchase a bronze-and-enamel pax, a votive object meant

to be kissed. Something about it bothered him. He used a microscope and saw clearly that it could not have been kissed over a long period of time. Real paxes show unbelievably soft wear. Under the microscope, this pax showed minute scratches. It had been kissed artificially. "When you consider a work of art, what do you do?" Hoving asks. "The process is basically intuitive, but it is good to have a guideline. Write down that absolutely immediate first impression, that split second. Write anything. 'Warm.' 'Cool.' 'Scared.' 'Strong.' In six years of studying hundreds of items for the Museum, I never ended up feeling warm about something I had written 'Cool' about, or the reverse. Then ask yourself: Does it have a use? A purpose? If it's a late-fourteenth-century casket, say, has it been used? Look where it has been worn. Is the wear haphazard? Forgers cannot possibly reproduce that. Many forgeries fall down because things have not been used. In the Middle Ages, nothing was made just to be observed. Everything had a purpose, either as an icon or as something else. Once, with Erich Steingräber, I studied a finger reliquary that was in a storeroom at The Cloisters. The piece had a ring on it that could not be removed. Rings were usually later gifts, placed on finger reliquaries as a kind of homage. Steingräber was very suspicious. On the ring was a fine emerald. Gems on reliquaries were usually not of top quality. The reliquary was riveted together, and there was no way to get into it. Reliquaries were not tombs. There were times when their liturgical use required that the actual relic inside be handled directly. All these items built up, and the thing began to disintegrate. We removed the rivets and found that the interior could not have held a finger. We eventually discovered that the thing had been made in a workshop in Paris for a man with a gem collection who loved reliquaries. You peel a work of art like an onion. Shred every layer from it. Is it in the style of the time? How many styles exist within it? Study the

iconography and the manner in which it is handled. What does it intend to say? Parallels, parallels, always seek parallels. Use scientific means—ultraviolet light, X-rays, and so forth—but always in context with your eye. Scientific analyses can be used for or against a work, like statistics. Your eye is king. Get in touch with other scholars—everybody you think is expert. The idea that there is fierce competition among museums in this respect is laughable. Everyone helps everyone. Learn the history of the piece—where it is from, what collections it has belonged to, all the information surrounding its discovery. Then get the work of art with you and live with it as long as you possibly can. You have to watch it. Watch it. Come across it by accident. I used to have the staff at The Cloisters put things where I would come across them by accident. A work of art will grow the more it is with you. It will grow in stature, and fascinate you more and more. If it is a fake, it will eventually fall apart before your eyes, like a piece of plaster. . . . Max Friedländer, the great art historian, once said, 'It may be an error to buy a work of art and discover that it is a fake, but it is a sin to call a fake something that is genuine.' Nothing in art history is more glorious than bringing something back from the shadow of being thought fake. The only way to know art history is to be saturated. If you are going to buy early-Christian glass, you *know* all the known early-Christian glass. You *know* what forgers do. They put on a piece something that will draw most of your attention, such as a simulated-antique repair. They usually do it so the repair looks kind of rinky-dink. We once discovered that we had a forgery in which the forger had taken old wood and old canvas, painted it, rolled it, created beautiful craquelure, damaged the whole thing, and restored it in three different styles. It was beautiful, and well it might have been. The forger was the father of one of the greatest painters of the twentieth century. Steingräber taught me that wormholes made by real worms are L-shaped.

The test is, you pluck out a hair and push it into a wormhole and see if it bends. Punched holes don't bend. However, I once came upon a piece that was supposed to be fifteenth-century German wood sculpture, and I learned that the maker had used actual worms to eat the thing. A wise forger will make an error—an explainable error—because he knows that inconsistency can be a mark of genuineness, if the matrix of the inconsistency is right. We have two beautiful fifteenth-century silver censers. One is authentic, and the other is an unbelievably beautiful copy. The forger *put his toolmarks on the old piece.* I love forgeries! I love the forger's mentality! Once, with two carvers and two other art historians, I tried to make an ivory forgery myself, so I would have the experience. Why ivory? For one thing, no scientific test will show you a damn thing about ivory. We picked an epoch from which there are two known dated pieces, vastly different from each other. One is classical, one is hieratic, and they were both made in Rome around A.D. 400. We decided to do a classical one. Old senatorial families in Rome in that era ordered classical ivories, because they were trying to look ancient—like members of the Racquet Club trying to recapture imperial days. There are ways to age modern ivory. You put it on a roof for a while and let the elements do it, or you bake it in a tin box with pine needles, or you skin a rabbit and bury the ivory in the skin. We did it with the pine needles. To get a smooth patina, I rubbed the ivory on the inside of my thigh for hours and hours. We removed dust from the interstices of an old ivory and applied it to the new one. Then we showed it to five experts. Four thought it was real. Later, we destroyed it. . . . There is a standing dictum about forgery: It will never last beyond one generation. The style of the maker is permeated by his generation. No matter how he tries, his own time will eventually show in what he does. There is a lot of forged Coptic on the market today. Coptic is strong,

overstyled, overstated. Our day is like this. Primitive art is col-
lected for its strength and its brutality. Our age appreciates this
and seeks it out. Therefore, Coptic art is being forged today.
We are too close to it to see the forger's style. People a genera-
tion hence may howl with laughter and wonder how we could
have been fooled. In 1880, in the time of the salons and so
forth, Viollet-le-Duc did some restorations in Notre-Dame de
Paris, Amiens, and other cathedrals. He tried to bring back the
High Gothic of the fourteenth century, but it isn't honest
Gothic in our eyes; it's too smooth and elegant and 1880. . . .
What limits a forger is that he has to be cautious. He can't be
free in his creation. The simplest kind of forgery is the direct
copy. You walk into a shop and see something, and you know
the original is in the Vatican, and that's that. Another kind is
the pastiche—something copied from parts of many things and
put together in a way that repeats nothing over all. Then, there
is the thing that is not a copy and not a pastiche but totally
inventive and completely within the feeling of a time. This is
the toughest, the one that gets you. The Etruscan Warriors that
were once here in the Museum were not copies, and they
were of the time. The forger, Alfredo Fioravanti, had sat
down and thought it through. Han van Meegeren studied
Vermeer and decided that he must have had an earlier style
that was different. Then van Meegeren forged an early phase
of Vermeer. The wildest forgery that I have ever dealt with
personally was an over-life-size Virgin and Child in limestone
that was offered for sale to the Museum. The dealer claimed
that it was 1380 to 1400—the very beginning of the super-
elegant and aristocratic International Style. Call it Ger-
man—I can't tell you where it actually was. The photographs
he sent were stunning. Rorimer and I went to see it. The guy
had put it on a pedestal in one of the most beautiful churches
in Europe. His cousin was the sacristan. Rorimer thought it was

French and didn't belong there. We were cautious, but we almost bought it. Then word came from a colleague in New York that he had found it in an old sale catalogue, and had learned that a gallery had sold it for fifteen hundred dollars to the dealer who was now trying to sell it to us for three hundred and fifty thousand. He was selling a real piece forged to look older than it was. The piece was early sixteenth century, and he had substituted on forged stone the graceful trumpet folds of the International Style for the hard zigzag of the later period. This dealer and I are the same age, and he is a friend of mine and a hunting companion. I confronted him with the entire story, supported by photographs, but he has never admitted what he did. Last week, he sent me pictures of another object that he wants to sell, and it appears to have been worked on by the same 'restorer.' This dealer is an imp of a man with a constant smile, and he always says to me, 'Tomás, do not worry. I would never do anything to *you*.' "

FATHER AND SON

It is said on Fifth Avenue that the fashion image of Bonwit Teller is the image of Walter Hoving, and that while he was its president there was not a store on the Avenue that was not terrified of Bonwit's. Walter Hoving, a truly visionary merchant, believes that the customer is not always right, and the twin plinths of his philosophy are good taste and quality merchandise. Before going to Bonwit Teller, he built the modern Lord & Taylor, giving the store the stylish veneer it enjoys today. He began as a recruit in the training squad at Macy's, and—something unheard of in the department-store milieu—he skipped the buying phase completely and straightaway became a merchandise manager. Moving on to Montgomery Ward, in Chicago, he completely did over the mail-

order catalogue to give it a contemporary feeling. The rising curve of his later experience on Fifth Avenue made a curious loop in 1959, when maneuvers that he himself had initiated backfired and he was pushed out of Bonwit Teller. Tiffany & Co. was his consolation prize. Very much a man of the city as well as of the Avenue, Walter Hoving was once elected mayor in the *Daily News* straw vote. Several times, he was actually asked to run for mayor, but he always declined, explaining privately that he was not interested because he had been born in Sweden and could never be President. He said also that he thought it an impossibility to be mayor and not to be corrupt. In the great sales-tax fight of 1943, Mayor Fiorello LaGuardia called Hoving "that floorwalker." Hoving said, "Yes, and he is the little flower in my buttonhole." Hoving started the U.S.O., and he was assistant manager of Thomas E. Dewey's first Presidential campaign. (Curiously, a speech writer and key figure in the same campaign was Elliott Bell, the editor of *Business Week*, who is now Tom Hoving's father-in-law.) Walter Hoving has been known among his employees as a man of little or no humor but of considerable warmth, energetic leadership, and generosity in his attention to the ideas of others, always giving full credit where due. Except in the first respect— for humor pours out of Tom Hoving like wine out of a bottle— the description is one that also has been made by colleagues of Walter Hoving's son. Johannes Hoving, the father and grandfather of the two more recent Hovings, was a Swedish heart surgeon who emigrated to avoid political heat in Stockholm. His wife, Helga Theodora Petrea, was a Danish opera star and had once been a favorite of the King of Denmark. They lived on 114th Street, in what is now Spanish Harlem. At the age of forty, Johannes Hoving retired and returned to Sweden, where he spent most of the rest of his life writing a five-volume history of the Hoving family, a project that was underwritten by generous support from his two sons in America, Walter and

Walter's brother Hannes, who is now a dentist in Ossining. Thomas Pearsall Field Hoving was born in New York, on January 15, 1931. His early childhood was spent in Lake Forest, Illinois. He was a fat, blond little boy. He remembers his father's dressing up as a spook, in a flowing sheet, and calling himself Diplodocus. He remembers real candles on a Christmas tree and putting them out with pieces of wet cotton on the tips of long bamboo rods. He remembers a ferocious police dog his father had, named Pansy. And he remembers living with his sister and a nannie in a place called the Deerpath Inn while his mother and father were getting their divorce. One frightening night, the inn burned down. From the age of five, Tom lived in New York apartments with his mother and sister, and as the years passed he emptied countless water-filled wastebaskets out of apartment windows. He decorated a long hallway in one apartment as an Egyptian tomb, the result of a temporary fascination with Egyptology that he had developed at the Metropolitan Museum. "I'd just go right in—ssah!—right into the Egyptian wing," he says of his boyhood visits to the Museum. "The Egyptian wing—none of the other trash. I remember the shawabti figures very well. I didn't care much for the mummies. I examined the reliefs and the cartouches, and I looked deeply into the lips of King Akhenaten—because all we have is the lips." An even greater influence on Hoving's young mind was Loew's Seventy-second Street Theatre, which was, in a sense, his fifth prep school, and the colorful and colloquial language he uses today often seems to be coming from a sound track. On Friday evenings, Petie and Tom would go over to the River House to have dinner with Walter Hoving and their stepmother, Pauline van der Voort Steese Dresser Rogers Hoving, who had been the widow of Colonel Henry H. Rogers, the son of one of the founders of the Standard Oil Company. When Tom, aged eight, met her for the first time, he had crawled under a desk and stayed there. Later, he took one of

her rings and buried it in the Park. For some time, Petie and Tom visited their father and stepmother every Friday night. On these occasions, Walter Hoving had them bow and curtsy to empty chairs; he took assessments of their fingernails; and he taught them table manners, which they lacked. Sometimes the children visited their father and stepmother on a three-thousand-acre estate in Southampton that had once belonged to Colonel Rogers. The children were left pretty much alone to wander among its terraces, gardens, and colonnades. The great house was more or less in the neo-baronial style of William Randolph Hearst—a kind of San Simeon East—and across a large pond was a smaller house, built in the form of the stern of a Spanish galleon. Colonel Rogers had used a sixty-five-foot boat to ferry guests across the pond. There was a sheep meadow that could be used to park eight hundred automobiles. Under the main house, an elaborate system of tunnels led to a steam bath, a wine cellar, a ship-model museum. Tom and Petie spelunked among these tunnels and roamed the vast property outside. When he was ten and she was twelve, they were given a pickup truck to go around in. They took Errol Flynn out for a drive once and didn't know who he was. There was an apple tree that overlooked the pond, and Tom used to sit in its branches for hours. "I would just sit there and look at the pond and think," he remembers. "When they saw me in my tree, they left me alone."

In 1949, Walter Hoving, who was then a trustee of Brown University, said to his son, "You can go to any college in the country, but I'll only pay your way to Princeton." Tom now conjectures that his father may have been mindful that a number of Tom's Edgartown friends were going to Brown. On the day of Tom's graduation from Princeton, his father gave him a thousand dollars and said, perhaps to spur him on, "There. That's all you'll ever get from me." Tom's wife, Nancy, says that by the time they were married, later that year, they

had nothing in the bank. In 1955, just after Tom was dis-
charged from the Marine Corps, he called his father from
California to say that he had given a great deal of thought to
what he wanted to do, and had decided to go to graduate
school. To Tom's considerable surprise, his father seemed quite
pleased. "In my time, graduate school wasn't really necessary,
but now I believe it is," Walter Hoving said on the phone. "I
think you're doing the right thing." Unfortunately, he had mis-
understood. He thought that Tom was referring to the Harvard
Business School, when in fact Tom's intention was to take a
Ph.D. program in art history at Princeton. When this bubble
reached the surface and popped, Walter Hoving said "Art
history?" and went on to make it clear that he considered the
subject nonsense and would not underwrite such a plan. Tom
applied for and got a scholarship at Princeton for graduate
study.

During Tom's undergraduate years, Walter Hoving had signed
up both of his children for a series of Johnson O'Connor career-
aptitude tests, to help gauge their futures. Petie, who, like
Nancy, went to Vassar, remembers that "Tommy was brilliant
in damned near everything, so Daddy decided that the Johnson
O'Connor tests were no good." Petie's own career, unlike
Tom's, followed their father's. She has worked for Lord &
Taylor for the past four years, and before that she was at
Bonwit Teller for fourteen years. She is married to a real-estate
man and has three sons, but in the office she is Miss Hoving,
buyer for the department that handles misses' dresses in the
thirty-to-a-hundred-and-twenty-five-dollar range. She says that
some of the older employees at Lord & Taylor occasionally
shake her hand and say glowing things about her father, who is
still a kind of presence there, and is regarded as the great figure
in the store's history. "People really worship him there, and at
Bonwit's, too," Petie says. "Yet I don't think he has a personal

friend in the world. There are many parallels between Daddy and Tom. Both are outgoing, warm, full of action, and adored by the people who work for them. Both are strong in their opinions. But their opinions differ, of course. Tom is very liberal, very up to date, angry, and wanting to do things about it. Daddy is for Barry Goldwater, and so on. The opinions Daddy has were not wrong twenty years ago."

Twenty years ago, when Walter Hoving was still being mentioned as a candidate for mayor, Tom was at Hotchkiss. Now Tom is the Hoving in town. He is sensitive to the implications of this, and seems at times—with never a word spoken—to be attempting to protect his father, and he goes out of his way to suggest that his rapport with his father is close. When Tom was sworn in as Commissioner of Parks, on December 1, 1965, in the Central Park boathouse, a reporter looked blankly at Walter Hoving, who was standing with other members of the family, and said, "Hey, are you Mr. Hoving's father?" A few weeks later, several hundred engraved invitations went into the mails. "I'd like you to meet my son Tom, the new Parks Commissioner," the invitations said. "So come if you can and have a drink with us at the Racquet Club on Wednesday, January 5th, between 5 and 7—Walter Hoving." Petie has kept a large scrapbook on her brother and his time in office. She pasted her father's invitation into it and wrote across a corner of the card, "Tom's *Bar mizvah!!* 1966."

PARKS

One winter evening, Mayor Lindsay sat down in his living room and, for an hour, considered the loss of his Parks Commissioner. "I caught hell for appointing him," he said first. "People said to me, 'Who's he? A minor curator from The Cloisters.' But Tom

has a natural, unstudied political talent. There's nothing he can't do. . . . He is a thoroughly civilized man. He understands the dynamics of institutional life. In the Museum, he'll make the mummies dance. I knew that if the trustees came to him, I would lose him. He said to me, 'It's impossible not to accept,' and, of course, that's true. It's like a call to a judgeship. It's impossible not to accept." After a pause, apparently for reflection on what he had just said, the Mayor continued, "It's like cutting off my arms and legs to see Tom leave. He's going into an important city institution, bear that in mind. He's been the best company in the administration. In this business, you have so little time to yourself that when you do have it you get choosy about your company. If I went to the movies or the opera, Tom is one of the few people I would always want to have come along. I think he has a complicated future. There's a limit to how long a young man can run a great institution. This is the sadness, sometimes, of university presidents who are there too young. Incidentally, and in passing, he would be a great candidate for mayor."

Lindsay first met Hoving in a hallway of an apartment building in 1960. They were both passing out pamphlets having to do with Lindsay's 1960 congressional campaign. "God damn it, how did we get two people working the same building?" Hoving said. Then he saw who the other man was. In 1965, Hoving wrote a white paper for Lindsay's mayoral campaign, detailing what was improvable about the city parks system, and the white paper reflected the principles on which Hoving acted throughout his tenure as commissioner. In graduate school, he had studied the planning of ancient cities, and as an undergraduate he had developed an enduring admiration for the man who created the great parks of New York, Frederick Law Olmsted. Hoving approached his job with a historical and conceptual bias in relation to the nature of open areas in an urban

milieu. He thought that they should be something more than a scattering of topographical interruptions in the infrastructure of the city, and should be designed and used so that they would have the same effect as works of art—"to teach, to enrich, to relax, and to inspire." When Hoving actually began his work as commissioner, he proved, to the astonishment of almost everyone who had ever known him, that he could generate more froth per day than all the breakers on the beaches of Queens. His assistants filled fifty-two scrapbooks with newspaper clippings having to do with the city's parks during his first year in office. His so-called Happenings drew thousands of people into the parks to, say, fly kites (five thousand kites), paint masterpieces on a hundred and five yards of canvas (three thousand painters), build castles of plastic foam, or see meteor showers (clouded out). People began to gather around him in multitudes at these affairs. Girls ran up and threw their arms around him. He was Hans Christian Hoving. When the Goldman Band opened its summer season in Central Park in 1965, five hundred people were there. In 1966, Hoving arranged a Gay Nineties party for the band's opening and thirty-five thousand were there. They gave him a twenty-minute standing ovation. But Happenings happen and are over. Basic principles, and construction, linger. Hoving's work had a great deal of depth as well as reach and verve. When he took over, he said he wanted to change the Parks Department's basic approach to design. Highway engineers had been creating structures and parkscapes for the city, working with maps and charts, away from the sites. No one in the rest of the world would ever have thought of asking New York for help in the planning of parks. Hoving said, "I want to make the Parks Department's work the absolute highest quality in the United States." And he did. He brought a full-time architect into the department for the first time ever, and he himself raised the money privately for the

architect's salary, to get around the drag of Civil Service. As consultants, he tried to get some of the best-known architects in the world. They were cool until he had been in office about three months, and then they began to respond—Philip Johnson, Marcel Breuer, Edward Larrabee Barnes, John Carl Warnecke, and Kenzo Tange, who did the National Gymnasium for the Olympics in Tokyo. Some of these consultants have taken on work for the department. Tange and Breuer (with the landscape architect Lawrence Halprin) are designing a sports park that will occupy the World's Fair Grounds and will include facilities for almost every sport that can be played in a city—football, badminton, drag racing, archery, basketball, swimming, tennis, baseball, softball. Breuer, Johnson, and Barnes developed competing designs for the new three-hundred-stall public and police stables that will be built beside the Eighty-sixth Street Transverse in Central Park. They all lost to the firm of Kelly & Gruzen, who shrewdly put the stables underground, preserving the Park above. Hoving said early in 1966 that he wanted to open up a bicycle and walking trail on the old Croton right-of-way in the Bronx. Felix Candela, the Mexican architect who is celebrated for thin-shell concrete construction, is expected to design a bridge that will eliminate the one major break left in the trail. Any kind of bridge would have done the job functionally, but Hoving reached out for one of the greatest structural engineers in the world. Confronted with the need to choose a designer for a new community swimming pool in the Bedford-Stuyvesant section of Brooklyn, Hoving and the Director of Park Design, Arthur Rosenblatt, decided that to choose a great architect would not be good enough. They chose, with inspiration, Morris Lapidus, out of whose pen ran the Fontainebleau, the Eden Roc, and half the other hotels in Miami Beach, and the Summit and the Americana in New York. A twenty-nine-year-old architect designed a Central Park

playground just north of the Tavern on the Green. A center for old people will be going up in Tomkins Park, in Brooklyn. A recreation center for young people, with a swimming pool, clubrooms, and jukeboxes, will be built on West Twenty-fifth Street, in Manhattan, and will have an illuminated theatre marquee with blinking lights telling what is going on inside. Among the hundreds of ideas that Hoving has left behind, one is that park facilities should be thought of as if they were profitmaking ventures, because the purpose is to bring people into them.

Hoving said at the outset that he wanted to create vestpocket parks in small spaces throughout the city and portable parks (that is, parks with equipment that could be taken up and used again) in lots that were temporarily empty. He established a dozen vest pockets, and the portables, it was hoped, would follow. He said that he wanted to close the roads of Central Park to motor vehicles on Sundays, in favor of bicyclists, and he said that he wanted to establish parks on piers, to bring the people closer to the city's beautiful harbor. He made the first moves toward opening the piers and succeeded in opening the roads. After one year, he left more than events behind, and, long before his time ended, other cities here and in Europe were asking for his advice—San Francisco, London, the District of Columbia, Boston, Cleveland, Akron, Yonkers. "The most significant thing we accomplished is the entire change of direction in design," Hoving says. "We are now the innovators in the country."

That winter evening, soon after Hoving had resigned as Parks Commissioner, the Mayor said, "Running a huge department is a big political office. Tom rose to it like a bird. He stumbled occasionally, and he walked in with his jaw now and then, but each time he got stronger and better. His antenna is good. There's no disguising anything with Tom. If I ran again for

this office—or, indeed, for any other office, which is most un-likely; in fact, zero chance—I would turn again to Tom." Even before Hoving went into the Parks Department in 1965, he had decided to leave the Metropolitan Museum. He was going to accept the directorship of the Wadsworth Atheneum, in Hartford. He made this decision because he felt that the general experience of the Hartford position—running a large museum and collecting in all fields of art history ("You know, Chinese porcelain, Renaissance bronzes")—would improve his chances of one day becoming the Director of the Metropolitan Museum, which was his ambition, he has disclosed, almost from the moment he started to work there. Rorimer had been curator of The Cloisters before becoming Director of the Metropolitan, and Hoving feared that the trustees would want to vary the pattern. He says that he is sure he would never have been chosen had it not been for his time in government, and that the commissionership prepared him for the job in the Museum as the Wadsworth Atheneum never could have.

CURATOR

In the Fuentidueña Chapel at The Cloisters, there is a Romanesque doorway from the Church of San Leonardo al Frigido, in Massa-Carrara, Tuscany. It is a beautiful thing, carved in Carrara marble, and its architrave depicts, in some twenty figures, the entry of Christ into Jerusalem. Close inspec-tion shows that the head of an apostle in the center of the architrave has a yellowish color, quite different in tone from the rest of the apostle's body and from all the other figures. In 1893, a Countess Benkendorff-Schouvaloff wrote from Nice to Italian archivists in Milan to tell them that the doorway, which had

been taken from the Massa-Carrara church when it fell into
ruin some years earlier, was installed in her villa in Nice.
Hoving learned all this in 1960, as an ancillary result of his
research on the Annunciation relief from the Romanesque pul-
pit in Arcetri. He wrote to a friend in Nice asking him to go see
the present Count Benkendorff-Schouvaloff and have a look at
the doorway. The friend wrote back and said, as Hoving
paraphrases the letter, that "the Count had split long ago" and
there was now a high-rise housing project where the Benken-
dorff-Schouvaloff villa had once stood. Hoving reasoned that
Romanesque doorways don't just disappear. This one had to be
somewhere. He wrote and asked his friend to keep looking.
Soon the friend wrote and said that the doorway was lying in
pieces behind the housing project. A local dealer in Nice was
sent to have a look and he cabled, "CONDITION TERRIBLE, NOT
MARBLE." A year later, happening to be in Nice, Hoving went
to the housing project and searched around in the weeds out
back, just for his curiosity's sake. In high grass among old apple
trees he found the blocks of stone. They were marble, all right,
and they were in excellent condition. "It was easy to get the
doorway out of France," he says. "The French couldn't have
cared less, because it was an Italian doorway. When the Ben-
kendorff-Schouvaloffs moved it to Nice, Nice was a part of
Italy. So the doorway never left Italy. Italy left *it*." The heads
of two apostles were missing from the architrave. One is still
missing, but Hoving found the other—the piece with the
yellowish cast—in a beauty parlor in the center of Nice.

Much as the pulpit relief led Hoving to the San Leonardo
doorway, the doorway led him to a holy-water font, also from
Tuscany, that had been carved at about the same time. Hoving
found the font at 125 East Fifty-seventh Street, in the shop of
the dealer Leopold Blumka. He just happened to see it there

while he was out for a Saturday-morning walk, and he was
struck by the close stylistic similarity between the figures on the
font and the figures on the Massa-Carrara doorway. (In another
shop on East Fifty-seventh Street, he later found, and bought
for the Museum, a pendant that proved to be one of two
known reliquaries of St. Thomas à Becket.) The holy-water
font now stands beside the doorway in the Fuentidueña Chapel
at The Cloisters. In the St. Guilhem Cloister, which is adjacent
to the Fuentidueña Chapel, is the Annunciation relief from
Arcetri. As Hoving moves from room to room in The Cloisters
and looks at one object after another, including his own acquisi-
tions, he says, "Ooh!" and "Ah!" and "Great!" and "Unbeliev-
able!" In the Treasury, he stops before a wood carving of Sts.
Christopher, Eustace, and Erasmus that was done by Tilmann
Riemenschneider, of Würzburg, in 1494. "Look how that
crackles with energy," he says. "It's linden wood, but see how
dark it is. It was probably stained in the nineteenth century.
The thing is incredible, isn't it? Look at those faces. I bought it
here, in New York. It cost like hell, but nobody remembers how
much now—and who cares? We *have* it." He moves on to a
reliquary shrine that once belonged to Queen Elizabeth of
Hungary (acquired by him in 1962), a reliquary bust of St.
Juliana (1961), and a Rhenish Crucifixion carved by an un-
known master (1961), of which he says, "This is one of the
most beautiful Calvaries ever made. It was in an auction and
sold for a sum so low that I could have bought it out of my
paycheck."

As a curator, Hoving went to Europe six or seven times a year
on acquisitional ventures, staying in cheap hotels in Paris near
the Boul' Mich ("Ratty hotels, always ratty—I like to be
anonyme"), stuffing himself on Bélon oysters ("Hepatitis?
Who cares? You might as well go big"), and trying to get to
bed by 1:30 A.M. in order to be in reasonable shape to see

dealers the next day ("whose names, of course, I cannot divulge"). He ranged from London to Istanbul, but the most important acquisition of his career he made in Zurich. He had heard, from a friend in a museum in Boston, that a man named Ante Topic-Mimara—a Yugoslav by birth, an Austrian by citizenship, and a resident of Tangier—possessed an ivory cross of uncertain origin, which he kept in a bank vault in Zurich. The general suspicion, Hoving learned, was that Topic-Mimara's cross was a fake—in part because of inconsistencies in its iconography and in its inscriptions. For example, where ordinary liturgical phraseology would read "*Iesus Nazarenus Rex Iudeorum*," an inscription on Topic-Mimara's cross read "*Iesus Nazarenus Rex Confessorum*." Hoving had written his doctoral dissertation on medieval ivories. He wrote to Topic-Mimara asking for photographs of the cross. Topic-Mimara replied that he was making no photographs available but that if Hoving would meet him in Zurich he would show him the cross itself, and that Hoving would find it "something unique in the world." All this had such a melodramatic resonance that it did seem to add up to forgery, but Hoving still had not had that "first impression," that "immediate kinetic reaction," and he went to Zurich to have it. He found Topic-Mimara to be "heavyset, 46 Short Portly, with a stubble, slightly hunched shoulders, a rapid walk, slightly turned-in feet, darkish hair, and a face like a crowd." Topic-Mimara spoke Serbo-Croatian, German, and Italian. In Italian, he said to Hoving, "I am a simple, humble man. A humble artist. I live in Tangier." The bank vault was subterranean, and there Topic-Mimara had cabinets full of objects—goblets, ancient glass, stained glass, pieces of tapestry. Withholding the cross, he showed the other things to Hoving, piece by piece. In time, Hoving learned that Topic-Mimara had acquired most of these things just after the Second World War, when he moved from city to city and country to

country buying art treasures that were available and relatively
cheap because of the disasters of war. With the complicity of
an American colonel, he had filled two boxcars in Berlin with
uncounted treasures and removed them to Tangier. Now, in
1961, in Zurich, after running through his current repertory, he
finally brought out the cross, wrapped in a large black cloth.
When Topic-Mimara removed the cloth, Hoving looked at the
cross for a moment, and then wrote, on a piece of paper in his
hand, "No doubt." Re-creating the moment, he said recently,
"It was staggering. A truly great, great thing. Just exactly where
it fitted into history I didn't know, and at that point I didn't
give a damn. It didn't seem to have the nervous, fluttering
quality of the eleventh century, so I guessed the twelfth."
Hoving asked for photographs to take back to New York, but
Topic-Mimara still refused. Each day, for three days, Hoving
went to the vault and spent eight hours looking at the cross.
Topic-Mimara sat near him and read newspapers. At noon, they
ate sandwiches. Each day, as they entered the room, Hoving
set his Rolleiflex on a table in front of Topic-Mimara and again
appealed for pictures. He was always turned down. Topic-
Mimara left him alone in the vault only once, and as he went
out he picked up the Rolleiflex and slung its strap over his
shoulder. "I'll be back in ten minutes. Take all the pictures you
care to," he said. "I will," Hoving said. As the door closed
behind Topic-Mimara, Hoving reached into his shirt, where he
had a Minox. Quickly adjusting the tiny camera, he took eight
pictures of the cross. Then he continued his study. Carved in
walrus ivory, the two-foot cross had sixty-three cryptically ab-
breviated inscriptions in Greek and Latin and a hundred and
eight carved figures, which were sharply detailed and extraor-
dinarily alive in their gestures and expressions—in Hoving's
words, "a great crowd of deeply undercut figures, distributed
over the surface in a lacy network, carved with breathtaking

skill." He decided that, among other qualities leading him to the same conclusion, the cross had so many irregularities that no forger could possibly have made it. He also decided that given the long, beautifully postured figures, the damp-fold elegance of the draperies, and the complicated carving, it had to be English. Topic-Mimara, for his part, never said where or how he had obtained it. Hoving took the Minox film to Munich and had it developed with supreme care in the Minox laboratories there. He then went to Erich Steingräber and showed him the pictures. Steingräber said that the cross could not be other than authentic. When Hoving returned to the United States, the pictures of course sparked the interest of Rorimer, and, in turn, of Kurt Weitzmann, a professor of art and archeology at Princeton and the foremost voice in the world on Carolingian and Romanesque ivories. When Weitzmann saw the pictures of the cross, he said, "I must go to see it." On separate occasions during the year that followed, Rorimer and Weitzmann both visited the vault in Zurich, and came away with positive reports. Weitzmann said that the cross was unparalleled. Meanwhile, word reached Rorimer that Rupert L. S. Bruce-Mitford, of the British Museum, was coming to conclusions about the cross himself. "There is a sense of timing in this sort of thing," Hoving says. "A museum man has to sense when to wait things out, when to bluff, and when to move fast. The trustees did not want to meet Topic-Mimara's full price, and we were trying to wait him out. Then, one day, Rorimer's sources told him that the British Museum was really on the move, and Rorimer said to me, 'You go tomorrow.'" Hoving, following a plan that he and Rorimer worked out, went to Zurich with ski boots under his arm, so that he would appear to be just passing through on his way to the snowfields. He ran into Topic-Mimara in a hotel lobby, and Topic-Mimara, who was wearing a fez, said to him, "You shouldn't have come. The

English are coming tomorrow. I have given them a complete option."

Bruce-Mitford soon arrived with Peter Lasko, a colleague. "Ah, here is Hoving, just passing through on a ski trip," Lasko said.

Bruce-Mitford said, "Well, Mr. Hoving, I imagine you feel something like Paul Revere."

Hoving felt more like a skier who had just fallen into a ravine. In the end, however, Topic-Mimara limited the option to three weeks, and Bruce-Mitford was unable to meet the deadline—apparently because the Exchequer would not approve of a sterling drain as heavy as Topic-Mimara's price, which was well over two hundred thousand pounds. In the morning of the twenty-second day, Hoving and Topic-Mimara went back to the vault. "You are also buying the rest of my collection, of course," Topic-Mimara said. Hoving said no, he was not. Then, in Hoving's words, "Topic-Mimara handed me the cross and I handed him the money, and a bank vice-president was standing there watching this, losing his mind." Hoving wrapped up the cross and sent it home air freight. Then he went to Paris for a few days to relax. The piece he had just acquired has been said to be more valuable than the entire Guelph Treasure.

Continuing his research, Hoving attempted to find where and when the cross was made. It had no recorded history. Nothing whatever was known about it except that it had been in the collection of Ante Topic-Mimara. In New York and in Princeton, Hoving went through hundreds of photographs of Romanesque English art, looking at every kind of work—stone carvings, illustrated manuscripts, metalwork, cathedral façades, ivory. When he had looked at everything, he found that he had set aside seven photographs in which were figures that had struck him as having stylistic similarities to the figures on the cross.

Two of the photographs were of objects of unestablished origin. The five others were all of things that had been made in or near the Suffolk village of Bury St. Edmunds. Hoving deciphered the sixty-three Greek and Latin inscriptions on the cross. Sixty-three seemed to him to be an inordinate number for anyone to put on a two-foot piece—a very literary and English thing to do. Although the inscriptions were arranged in flowingly graceful patterns, written communication was obviously an even more important element in the intent of the maker. So Hoving put all the inscriptions together and read them as a literary whole. The message that emerged was powerfully anti-Semitic, condemning the Jews for killing the Saviour whose existence their own prophets had foreseen and proclaimed. Hoving then searched through the Patrologia Latina—which includes two hundred and eighty-two volumes—for anti-Jewish writings and disputations, particularly in medieval England. In a typical disputation, a Christian would speak and then a Jew would answer. "I found that these disputations were learned and friendly until the middle of the twelfth century, but after that the Christian had all the lines," Hoving says. "The Jew would answer back with stupidities. This was fraudulence, McCarthyism, on the part of the writers. A wave of anti-Semitism had obviously arisen at that time. Of the inscriptions on the cross, with all their linguistic irregularities, I found twenty-two in the Patrologia Latina." Hoving then went to England and worked in the Courtauld Institute of the University of London. The evidence he assembled, both stylistic and historical, continued to point to Bury St. Edmunds. He learned that on June 10, 1181, a young boy of Bury St. Edmunds was murdered, supposedly by crucifixion, and that the death was blamed on Jews. He learned that a monk named Samson was elected abbot of the Benedictine monastery of

Bury St. Edmunds in 1182, that Samson was a particularly vehement leader of anti-Semitic campaigns, and that fifty-seven Jews were killed in a riot, of unexplained origin, in 1190, in Bury St. Edmunds. Hoving went to Bury St. Edmunds, where almost nothing is left of the abbey, and stood on Samson's grave. At Cambridge University, nearby, he went to Pembroke College, whose library houses many volumes of twelfth-century Bury St. Edmunds manuscripts, bound in deerskin. At random, he removed a volume marked M-72 from its shelf. It was the Gospel of St. Mark, and it had been copied in the decade 1140–50. At some later date, another hand had written an annotation below the words "Rex Iudeorum." "Rex Confessorum," the annotation said, with a further note that this change in language was occasioned by "the perfidiousness of the Jews." Reflecting on that moment, Hoving says, "I had a long way to go, but the matter was essentially solved with this discovery." From then on, evidence accrued more rapidly, and in the Bury Bible, made in Bury St. Edmunds in the twelfth century, he found populated initials whose figures looked almost exactly like those on the cross—the same sharp outlines, precise gestures, pointed beards, and damp-fold garments. He was able to date the cross (1181–90) and to conclude that it had been made for, and under the direction of, Abbot Samson. "The cross is a virtual seminar in the style of the late twelfth century," he wrote in a paper that he plans soon to expand to book length. "In the figures, one can detect the inexorable and fascinating change from a Romanesque to a decidedly early-Gothic point of view implicit in the development of increasing attenuation and a dramatic movement away from the confining surface. The literary content voiced in the proliferating scrolls or cut into the flesh of the ivory is, like the figural carvings, the Passion and Resurrection. But it goes a step further, for it also rails against those who did not believe in Christ as Saviour and

Messiah—namely, the Jews. It is against this poor, alien people and their synagogue, harried and persecuted throughout centuries, that the text of the cross directs itself with wrath. The cross may not be the only medieval monument that carries on a polemic against the Jews, but it is not matched in vehemence. The passage of time makes the contents of these writings no less harsh. But it must be remembered that this is the accepted attitude of the church militant of the late twelfth century. Today there may appear to be an incongruity between such superb artistic form and the vehemence of a number of the inscriptions, but in Romanesque times religious tolerance did not exist. The cross is intellectual, yet pedantic; clever, yet forced. It is English, above all—imaginative, dramatic, literary, independent of rules, far too rich, yet poetic and adventurous in its attempt to be encyclopedic. It even reaches beyond its insular character and expresses what was in the wind throughout the entire Christian world during the late twelfth century, for the cross is symbolic of the crusading spirit, both good and evil. It is one of those rarest of works of art that are both the strength and weakness of its era—the mark and the explanation of an entire epoch." It stands in an illuminated glass enclosure on a pedestal in the center of the Fuentidueña Chapel at The Cloisters, where people can see it from a distance of inches and can walk around it and examine all of its sides. "Look at it," Hoving says, standing before it. "Isn't it beautiful? Look at the work that went into it. Can you *imagine* someone thinking that was a fake?" The 1966 Annual Report of the Metropolitan Museum, which was published some months before Hoving was appointed director, listed four great acquisitions that marked the eleven years of the directorship of the late James Rorimer: Rembrandt's "Aristotle Contemplating the Bust of Homer"; the Merode Altarpiece, which is Robert Campin's Flemish triptych showing the Annunciation; the Antioch

Chalice, once thought by scholars to be the Holy Grail; and—
as the fourth of these treasures has come to be called—the
Cross of Bury St. Edmunds.

PRINCETON

On Friday, January 12, 1951, Hoving and his Princeton
roommates decided that the time had come to pull themselves
together, that their general and flagrant neglect of the uni-
versity curriculum was approaching a critical intensity, and that
the weekend then beginning should be spent in solid intellec-
tual endeavor by all, since the term's final examinations would
begin on Monday. The principal architect of this plan was
Thomas S. Godolphin, a brilliant young man who, like Hov-
ing's other roommates, had known Hoving at Exeter. Godolphin
further reasoned that what the group needed most was a long
and untroubled night's sleep, and that they should all go to a
movie that night, turn in early, and address themselves to their
work first thing in the morning. Between the movie house, in
Palmer Square, and their room, in Holder Hall, was a delica-
tessen. Walking back toward the campus after the film, the
roommates passed the delicatessen, and one of them suggested
that they assure themselves of a perfect night's sleep by having
a glass or two of milk punch before sacking out. So they bought
a gallon of milk. Milk punch had become a favorite among
them, and they had a large assortment of sweets and spices that
they liked to put in it to complement the basics—milk and
whiskey. Their favorite drink the year before, when they were
freshmen, had been Seabreezes. The freshman year had not
been an inspired one for this group. "We were just doing prep
school all over again," Hoving says now. "And that carried us
through. I had an appalling cut record. I went to classes in the
first week of each term and didn't go again until finals. I went a

lot to New York, and haunted the Orpheum Dance Palace, in Times Square. An extremely temporary charge account was established for me at a night club called La Rue, in order to get me out of the Orph and also out of the Automat Bar on Eighty-sixth Street, a favorite place of mine, where you put a quarter in a slot and got a Martini—you know, pretty pestiferous. Dikey Duncan, who was at Brown, came down frequently to the city, and we once ran up a five-hundred-dollar bill at the night club, setting up everybody in sight. Dikey tried to pass himself off as the youngest-ever president of Lea & Perrins. We wore white ties and tails every night. We'd hit a few debbie parties and sink back into the Rue." In Princeton, meanwhile, Hoving watched his classmates from an aloof perspective, made sarcastic, cynical, and funny remarks about everything he noticed, and showed no interest at all in extracurricular activities, with one brief exception. He tried hard to get into the Press Club, a semi-professional organization through which undergraduates serve as paid stringers for newspapers and the wire services. He had worked during the summer of 1949 as a copyboy at the *Daily Mirror*, where—as he describes it—his job was to "fold carbon sandwiches, go out for heroes, and place bets." He continues, "The *Mirror* was a bookie joint, as far as I could see. The teletype room was enclosed in glass, and every time the race results came in from some track the crush of people almost broke the glass. The writer I liked best had a drawerful of comic books. I myself wrote letters-to-the-editor. Two kinds—singers and howlers. We used to write howlers by pounding our fists on a table for a while to warm up." In the university Press Club competition, he extended himself to interview a man who was pushing a wheelbarrow all the way across the American continent and happened to be passing near Princeton, but, even with that scoop to his credit, he lost out to Tom Godolphin. Godolphin was a superior poker player, and he and Hoving used to play regularly in the afternoons. Robert Goldman, the

playwright, who was another of the roommates, recalls these games vividly. "Afternoon cards in college is serious cards," he says. "I remember Loper with the green eyeshade doing the Cincinnati Kid. If anybody had had the sleeve guards, he would have put them on." Things continued in this pattern through the autumn and early winter of the sophomore year, and on the Friday night in 1951 before the first-term examinations the roommates drank their milk punch and then collected supplies for another batch. There was a fireplace in their room, and they built a memorable fire. They started up a player piano they had, and when they ran out of liquor they borrowed more from neighboring rooms and invited the occupants to join them. At about 2 A.M., they drew their curtains and established a proctor watch, and when university proctors entered the Holder court-yard the milk-punch party observed a period of silence. Soon they began to feed the fire with T-shirts, shoes, phonograph records, and minor pieces of furniture. In the early morning, they got a ten-gallon can of milk from the Walker-Gordon dairy, which is two miles from Princeton, and by late afternoon they were putting Drambuie, vodka, curaçao, crème de menthe, gin—everything they could find—into the punch. The party went on through Saturday evening, and in the early hours of Sunday morning the fireplace fire was still going. They had put chairs and pillows into it, and several worsted suits. They had, in fact, burned up almost everything in the room except the player piano. Someone went out and came back with an axe. The piano played on while it was being hacked to pieces, and all the pieces were given in tandem to the flames. Princeton's grading system goes from a high of 1 to a low of 7, and at the end of the senior year a student's final departmental grade must be better than a 4 or he gets no degree. Hoving's average at the end of that first term in his sophomore year was 4.46. "I have been to several serious, artistic Happenings where, in a highly creative

and avant-garde way, pianos have been smashed," he said recently. "I watch this with a ghostly smile."

In the second term of his sophomore year, Hoving went to a preceptorial in Art 301, a course he had signed up for that dealt with sculpture from the Renaissance to the present. Princeton students, in most courses in the humanities, go to two lectures and one preceptorial each week. In preceptorials—or precepts, as they are called—five or six students sit around a table with a professor and exchange ideas on the assigned reading and related material. This system was initiated by Woodrow Wilson when he was president of Princeton, and since Wilson's time a student's performance in precepts has always been an important part of his final grade. This particular art precept was attended by two seniors, three juniors, two graduate students (sitting in), and one sophomore, Hoving. The professor, Frederick Stohlman, set on the table a graceful piece of metalwork that had several flaring curves and was mounted on a base of polished hardwood. Stohlman asked each student, in turn, to say whatever came into his head about the object. Hoving heard the others using terms like "crosscurrents of influence," "definitions of space," "abstract approaches to form," "latent vitality," and "mellifluous harmonies." He felt unconvinced, unimpressed, unprepared, utterly nervous, and unsure in the presence of older and more knowledgeable students. A warm flush came over the back of his neck—something that still happens when he finds himself in an uncomfortable position. Finally, Stohlman and the others looked at him, and waited for his contribution. "I don't think it is sculpture," he blurted out. "It's beautifully tooled, but it's not sculpture. It's too mechanical and functional." Stohlman, an authority on Limoges enamels, was an inspiring teacher, and it was he who, some weeks later, first put into Hoving's hands a work of art of importance—a piece of Roman glass. Now, in the precept, he looked at the other

students and warned them of the dangers of getting caught in their own lecture notes, and went on to say that anything should be looked at first as an object in itself, and not in the light of secondary reading or artistic theory. Finally, he pointed out that the sophomore was right—that the thing on the table was an obstetrical speculum. "From that moment on, I had fantastic confidence," Hoving says. "I was never again afraid to say, 'I don't believe that.' Three weeks later, if that hadn't happened, I might have been talking about elegant *sfumato* and sweeping diagonals, but, fortunately, I have never looked at a work of art through a cloud of catchwords. In the technical language of the history of art, you can draw a cocoon around anything, whether it is a Campbell Soup can or an obstetrical speculum. That's what those cats in the precept did. A work of art should be looked at as a humanistic experience, an object on its own. It betrays what it is immediately." Hoving got a 1 in that course. He decided to major in art and archeology, and for the next two years he made regular trips to New York for drawing courses at the Art Students League. In Princeton, he retreated from nearly all non-academic activity of any kind, roomed alone during his last two years, and was seldom seen even by his friends. He audited undergraduate art courses that he was not enrolled in, and he sat in on graduate seminars. He wrote his senior thesis on "The Origin and Development of the Early Christian Basilica." His final departmental grade was a straight 1, and he was graduated from the university with highest honors.

SEVENTY-THIRD STREET

On a bamboo easel in one corner of the living room of Hoving's apartment, at 150 East Seventy-third Street, stands a work by Dan Basen in which a hundred and eight finishing nails have

been inserted in canvas like pins in cloth, all in regimented patterns of "X"s and palisades; the whole of it, nails and canvas, is painted white. The room itself appears to have been last painted in the early nineteen-thirties, and, its contents aside, suggests a room in an old hotel in, say, Scranton, Pennsylvania. On one wall is a Ruth Abrams abstract called "Woman Sleeping," and across the room is another Abrams—this one representational, of a woman brooding. Five hooks-and-eyes of graduated sizes, mounted on a plaque, are labelled "Sex," sculptor anonymous. Framed and under glass is a large sketched composition by Knud Nielsen that consists of fragments of Hoving: several aspects of his head, and a study of his hands—tapered, talon fingers holding the head of a griffin. On a freestanding set of shelves is a Basen head of Hoving, made from blocks and chips of wood that Basen nailed together, partly wrapped in strips of canvas, and daubed with paint. The likeness is remarkable. Across the room is a Basen fetish—two mobile boxes within a third box, which has been screwed to the wall; on top of the exterior box is a full-size model, made of wood with photographs glued to it, of the Cross of Bury St. Edmunds. On a two-foot-long table near the door is a sixteenth-century French marble sculpture of the Virgin and nursing Child. In a glass-front cabinet are a fourteenth-century French ivory (half of a diptych); a fifth-century Syrian drinking glass that was found with the Antioch Chalice and was eventually given by the King of Sweden to Hoving's grandfather; an Etruscan terra-cotta head; a Günther Uecker icon, consisting of a board with a nail in it; and a fifteenth-century Russian icon given to Hoving by Ante Topic-Mimara. By the cabinet is a cloud box by Adrian Guillery and Dick Hogle, who also did a six-foot cylindrical "Column of Light" that stands in another corner of the room, and, elsewhere in the apartment, a four-foot mechanical man whose head lights up in various colors when it watches a television set. The mechanical man, according to

Hoving, "mixes his own bulbs." Resting on another living-room table one evening not long ago were an original sketch by Charles Dana Gibson, several sketches by Mario Avati, and a sketch of a woman with open skirts by Egon Schiele. On the floor behind a chair was a small, portable hi-fi, and in it a Judy Collins record was turning. She was singing Bob Dylan's "Just like Tom Thumb's Blues":

"Don't put on any airs
When you're down on Rue Morgue Avenue
They got some hungry women there
And they'll really make a mess outta you."

Hoving said, "I think it's the saddest song I've ever heard, and I'm not even sure I know what it's about. I'm hung up on Judy Collins." The hour was six-thirty. He had a pitcher of Martinis in one hand, and he sat down in a chair and began to open the day's mail. "Swine!" he cried out, and tossed a letter aside. He glanced at another letter and wrote "Hire him" across the top of it. A third letter invited Hoving to join a club. "I hate memberships," he said. "I once had a summer membership in the Racquet Club and I couldn't stand it—the snobs running and screaming." The phone rang. "No, it's O.K., it's all right," he said. "I think we ought to go for that; the ring is beautiful. The whole *Schmier* . . . See if you can haggle them down. We'll try to use curator's funds. The time has to be critical, and it's getting very hairy." He snapped his fingers. His life, after a year in the Parks Department, seemed to have become a series of snaps—snap decisions, snapped fingers. Moreover, he was then working at two jobs. He was still Commissioner of Parks and, *de facto*, he was Director of the Museum. "I've been too damned busy to be thoughtful," he said. "But I was taking stock of myself last night, and I'm

terribly dissatisfied. At times like that, I see myself as a failure—going into things, having all the fun, and getting out without taking care of the details." His daughter, Trea—a pretty, blond nine-year-old who goes to the Spence School—was sitting beside him, trying to learn how to play a recorder. Hoving wondered aloud if she couldn't learn somewhere else. She stayed where she was. He looked cross-eyed and shrugged. His wife, Nancy, arrived home from work and made herself a drink. She works downtown, in the office of the city's Coördinator of Addiction Programs. Both she and Hoving have their own Hondas. After a while, that evening, they got into an argument. It was political, not personal, having something to do with Bed-Sty, which is how both Hovings refer to the Bedford-Stuyvesant section of Brooklyn. Mrs. Hoving is at least as fast on her feet as Hoving. When, during their Bed-Sty argument, he responded to a question with a circumlocution, she said, "Don't give me a public answer." Hoving clapped his lips up and down, like hands. Hoving is not only a verbal wit but a facial comedian as well. His face moves all the time while he talks. He winces, wags his eyebrows, and smiles the smile of a cozy wolverine. A few minutes later, he was describing, in words and sounds, a sailboat luffing and flapping through a narrow inlet. The talk had changed to his summer plans—five short cruises, spaced out from June to September, as a member of the foredeck gang of a friend's fifty-foot racing sloop called Blixtar. He has raced to Bermuda five times on Blixtar. Three years ago, Blixtar was nearly run down by a freighter in a black fog. "You felt this clammy, crawling fear," Hoving said. He whistled, wailed, and made foghorn sounds. He went on, "Then we heard the slap of the screws—thwa thwa thwa—and the thing went by us a hundred feet away." The talk centered for a while on dangerous situations, and soon Hoving was demonstrating how Sicilians, as they leave their houses in the morning, auto-

matically swivel their heads to check on the mood of Mount Etna. While Hoving was a graduate student, he lived in Italy for a year, studying in Italian museums and working for several months at an archeological dig in Sicily. During that year, he also painted, sketched, wrote short stories, and began to keep a personal journal that, within two years, exceeded two hundred thousand words. It contains compact but incredibly thorough descriptions of every building and every object of artistic interest he visited, and it also includes essays on subjects as disparate as cybernetics and Italian rock 'n' roll, and an eloquent chronicle of the infancy of his daughter. Most notably, though, it is a record of the self-questioning of a man in his middle twenties who seemed to want more than anything else to know the extent of his potentialities as a painter and a fiction writer, and who wondered if, alternatively, he would ever be able to find himself in the scholarly discipline of art history. All that, however, was now on the shelves of cabinets in the living room, and he was describing what it felt like to lie down on the black earth in the crater of Etna. "You could hear the lava bubbling—blump blump blump—and all these zonked bees walked all over you," he said. "Millions of bees are attracted to the sulphur, which does something to them. They're all up there taking trips. Every step you take, you crunch generations of bees. Fow! Shall we go?" He meant to dinner. During his time as Parks Commissioner, a secretary typed out a schedule for him every day, and he sometimes made as many as three speeches in eight hours, and seldom spent an evening at home. That night, he and his wife had accepted an invitation to The Four Seasons.

An enormous Picasso hangs there, eighteen feet high. Hoving said, looking up at the painting, "I would pay seventy-five thousand dollars for that. It's just beautiful."

His wife said, "Do you know how much the restaurant paid?"

"A hundred thousand," Hoving said, and his eyebrows bounced up and down.

EIGHTY-SECOND AND FIFTH

Hoving, wearing a turtleneck jersey and a sports coat, stood just inside the main entrance of the Metropolitan Museum. "Come in. Come in. Don't touch! Don't touch!" he said, and he turned and walked through the Great Hall, with his hands clasped behind his back. This was a Sunday morning in March, and the place was empty. His eyes swept the high, vaulted, train-station ceiling and ran down the grimy walls. He said, "Note the great space, the classical reminiscences, in 1911 style. We're going to sandblast. Shall we go to the Gyppies?" As he would have done twenty-five years ago, he went first to the halls of Egyptian art. His eye was caught by a stone relief of sailors in action. "People say that Egyptian art is pattern-repetitive," he said. "It isn't. Look at that rope disappear and reappear beyond the sail. This was utter realism to them. . . . Look here. . . ." The god Amun, from the Temple of Amun, at Karnak—pure gold, seven inches high. "That's one of the best pieces in the joint. How would you like to own *him?*" Hoving walked on through a roomful of Egyptian gold until a jewel casket that belonged, in 1900 B.C., to the Princess Sit Hat-Hor Yunet arrested his attention. He said, "Talk about Art Nouveau, Mies van der Rohe, or anything at all, this is just as beautiful as any piece of furniture made throughout history." In the Chapel of Ra-em-Kui, he stopped before a wall decorated with beasts. "Look at those horn shapes," he said. "That couldn't have been done by a people who had any written language but the

hieroglyphic. If any other museum in this country had this chapel alone, it would consider itself to have an Egyptian collection." The government of the United Arab Republic has given the United States a temple from Dendur, below the Aswan Dam, in gratitude for the American money that helped save Abu Simbel. American museums were competing for the temple at that time, and Hoving wanted it very much. The stone of the temple is porous, and vulnerable to erosion in a humid climate. Hoving had had a new two-million-dollar wing designed (and approved by the Museum's trustees) just to hold the temple. As conceived by Hoving, the walls of the new wing would be sheer glass, so that the temple would be visible—most dramatically when illuminated at night—from Fifth Avenue and from the surrounding acreage of Central Park. Meanwhile, the Smithsonian Institution, in Washington, his chief competitor, wanted to put the temple outdoors, on the bank of the Potomac. "They think they're going to dip it in something," Hoving said. "In our vast, glass case, it would glow like a work of art, which it is. That temple makes me so nervous I can't sleep." (It has since been awarded to the Metropolitan Museum.)

Hoving wandered on through the Museum without pattern or plan, and kept quoting Rorimer: "What are the three things you like best? Pick three." Picking his own in the Ancient Near Eastern collection, he stopped by a sculpture in heavy black diorite. It had been carved from a cube, and very little of the cube had been removed in order to reproduce the likeness of Gudea, ruler of Lagash. "Look at that little black atom bomb," Hoving said. "That is one of the few pieces here I would take off and go lumping down the track with. This entire Ancient Near Eastern collection has been built up since the mid-nineteen-fifties. Look at that Syrian bull. How would you like to have *that* and touch it every day? When you consider that these

Sassanian pieces weren't here ten years ago, you can see the sort of thing that can be done. People think this Museum is loaded, but I don't think we have enough. We should develop the pre-Columbian collection. Do you know how many great Nabataean bronzes we have? None. There may be stuff we have no idea of the existence of. The notion that we're supposed to collect only masterpieces is a little bit false. Concepts of masterpieces change. We're collecting for five hundred years from now. We're after the top quality, but since the Museum is a great encyclopedia of man's achievement, we also collect backup material—footnotes and appendices to great chapters in art history. Every great treasure needs a supporting cast. Come on upstairs. I'll show you what I mean." A minute later, Hoving stood in a roomful of Rembrandts. The Museum has so many Rembrandts that they go around a corner and out into an antechamber as well. Hoving's attention settled on "Aristotle Contemplating the Bust of Homer," which Rorimer bought for two million three hundred thousand dollars, and in which Aristotle wears over his shoulder a blue-gold and almost iridescent chain of honor, presumably given to him by Alexander the Great. "We have thirty-two Rembrandts," Hoving said. "The collection was outstanding before the 'Aristotle' arrived. But reaching out for it was important, because the 'Aristotle' became the preëminent Rembrandt in the collection. Look at that chain. That alone is worth two million three. We hate to put that figure down anywhere, but all you can say is—it was worth it. Look at the thought, the loneliness, in that human, moving face. When I learned the other day that the National Gallery had bought that Leonardo—the 'Ginevra de' Benci'— for six million dollars, I couldn't sleep all night. We should have reached for it. The reputation of the Metropolitan has always been based on its power to acquire things without reserve. A museum can lose that sort of knife-edge. It's a matter

of attitude. If you lose that *one* day of going for the great thing, you can lose a decade. Any trustee should be able to write a check for at least three million dollars and not even feel it. We are a collecting institution, and mobility is the only thing that wins in this game of collecting—making a decision and moving out. If I live to the year 2000, before I die there will be a painting sold for twenty-five million—well, a work of art, not necessarily a painting." He stopped for a moment before two other Rembrandts—"Man with a Magnifying Glass" and "Lady with a Pink"—and said that in his opinion they were "on a level" with the "Aristotle." Close by was a painting called "Old Woman Cutting Her Nails." "That's not a Rembrandt," Hoving said. "It's probably Nicolaes Maes. The label says, 'Signed and dated Rembrandt, 1648.' There are subtleties in the museum business, let me tell you. Do you want to know what quality is? Come look at this." He took off as if he were a floorwalker on his way to the Hickey-Freeman suits. Finally, he stopped before a van Eyck, showing, in two panels, the Last Judgment and the Crucifixion, with green country, behind the cross, reaching away to snow-covered mountains. "In my opinion, this is A No. 1 in the Flemish collection," he said. "Why? Just look at it. The color. The drama. Possibly it is not van Eyck. The Alps bother me. Whatever it is, it is a great painting. Do you want to see my favorite picture in the Museum? This way. You know, people say art is long and life is fleeting. In my opinion, it is the other way around. Mummius bought all the great treasures of Lysippus and Praxiteles. Nothing remains. We don't have *a single thing* from the workshop of Praxiteles. Nothing is preserved from the vaunted collections of Rome. Private collections disappear quickest of all. You have to band together to last, and this is one of the arguments for a big museum. There it is—the Havemeyer Degas. Isn't that something?" He was standing in a roomful of French Impressionists,

and his gaze was fixed on Degas's "Woman with Chrysanthemums," his own subjective choice as the treasure of treasures in the Museum. "There is something about it—I can't explain it, I don't know how to describe it," he said. "Keep looking at it. You have to stand here and hang into it. Absorb its nature. Forget the label. Ask yourself questions. Look at the thought in the woman's face. What is she thinking? What is she about to say? Everything clicks in this painting. It has classical assurance. Just as a flower piece, it is staggering. It's, for me, got everything." He then walked away quickly, and, on his way out of the room, paused a moment in front of the full-lipped woman in Renoir's "By the Seashore." He said, "Look at the difference between this Renoir and that turgid portrait over there—when he began to sell out." He waved a thumb at Renoir's "Mme. Tilla Durieux." Then he went around a couple of corners and stopped at Cézanne's "Man with a Straw Hat" and, near it, Monet's "La Grenouillère" and "The Green Wave." All three were identified as having come from the Havemeyer Collection. "What an eye Mrs. Havemeyer had!" Hoving said. "She picked the best of the best. Wow! What an eye! All the ones that make you thump forward. Come look at this Goya." He moved like a ray through several walls until he stood before "A City on a Rock," in which a city stands on a butte above a battle scene of terrible bloodshed and burning flesh. "That's a stunning picture," Hoving said. "I don't know what it's all about. It made a great impression on me when I was fifteen years old. Some people think that it isn't a Goya, that it's too loose, but since it's a Havemeyer, I'd give it the benefit of the doubt. How many incorrectly attributed pieces there are in the Museum depends on who you talk to. With a million and a half things in the house, there have to be some errors. Look at these drawings." He was now walking through a temporary show of Goya drawings. "Our collection of Goya drawings is just sickeningly

great," he went on. "About ninety per cent of all our prints and drawings are kept in storage, but don't let that mislead you. One of the great myths about the Museum is that lurking below the main floor are fabulous treasures. You bring most of them up and show them and—ickkk." He doubled back on himself and was soon standing before three enormous battle scenes—each on about a hundred and seventy-five square feet of canvas—by Giovanni Battista Tiepolo. He said that he had bought them for the Museum in 1965, he was not sure where. His eyebrows moved up and down like brushes, somehow carrying the implication that he had walked out of Italy on stilts, with these great canvases rolled around his legs. "The Museum has never done anything slightly illegal," he said. "And you had better believe that. We are no more illegal in anything we have done than Napoleon was when he brought all the treasures to the Louvre. Our scope is excellent, but if I were to tell you what we want most, prices would go up—kccp that in mind. Our collecting is done in secrecy. In the world of art, drop a spoon in Cleveland and ten seconds later they hear about it in Munich. Are you beginning to feel why I like coming back to the Museum? In The Cloisters, I was surrounded by objects— things, rather than people. I needed to get away from it for a while. After Jim Rorimer died, the six youngest trustees of the museum became a committee to choose a new director. As a trustee ex officio, I advised them not to get someone young, because a young man probably couldn't stay with it for thirty years. They brought this up again when they hired me, and all I could say to them was that it is one of the onuses of the board of trustees to decide when to get rid of a director. I don't really know what I'm going to do. Flamboyant promises come out during political campaigns, but, hell, the Museum has a fine structure and its intentions have been clear since it was chartered in 1870. We collect, preserve, exhibit, and educate. My

job is to make the Museum sensitive to its time and to people living in that time. When I see an area where I want to collect—maybe because I see a gap, maybe because a great piece has come on the market—my only standard will have to be over-all quality. I'll have to think very deeply about what the work of art does, not only in its aesthetic nature but in its historical and humanistic nature—how it sums up its time, how it expresses its creator. You build with an eye to having as few gaps as possible, and you try to fill some of your own gaps as well. God knows, *I* have plenty of them—prints, Oriental art, American painting, American sculpture. My expertise is medieval, but I hope that I know quality. Jim Rorimer was a medievalist, but that didn't stop him. From collecting Rembrandts, for example. There's another kind of gap I'd like to bridge, too—the one that exists between museums and universities. The relationship is now one of some suspicion on both sides. Museum people think of professors as too theoretical, dull, chained to an iconographical point of view, immersed in photographs, lacking in connois-seurship. University people think of museum people as dilet-tantes, not well trained and bent toward social activity. In Europe, the museum man is more on the level of the professor. We have good people and we need more. We should have endowed chairs here, and a scholarly journal. We need a firmer foundation of scholarship. The Museum has a great scholarly contribution to make. On the popular side, we have to find a better way to educate the people who come in here—thirty-six thousand on a Sunday afternoon alone. We need some kind of storefront, a place near the door where they can go and, through modern media, be prepared for the task of looking, and for the scope of what we have. In the age of television, the contemplative attitude that people once took before paintings has left us. You don't have to be Marshall McLuhan to figure that out. The way to get people to *see* the paintings now is to

tell them what they're looking at. I'm not a great fan of our
tape-recorded guides. They don't go far enough. I'd like to put
in a system of jacks under each painting, each work of art, of
major importance. There could be a jack for religious sym-
bolism, a jack for quick biography of the artist, a jack for
general history, another for technique. You plug yourself into
the jacks and learn as much as you want to. To set up some-
thing like that throughout the Museum might cost several
hundred thousand dollars, but that's nothing. In the decorative
arts, the hyper-ideal is to show things to people as if they had
them in their hands. That's all I can say. Now I have to go do it.
Gene Moore, who does windows at Tiffany, is coming here to
do a display of Greek gold, silver, and jewels. I'd like to do that
sort of thing throughout the place—use industrial designers,
interior decorators. As a general thing, we should be unobtru-
sive, but in the past we have been so unobtrusive that objects
have suffered for it. Also, we've been criticized for not having
enough shows, and that's right. We're about to do one called
'In the Presence of Kings.' We have twenty-two hundred
objects, from all over the Met, that are known to have been
intimately associated with rulers. About six hundred of them
will be in the exhibition. We have Marie Antoinette's dog
kennel. I'm going to do the tape for the 'King' show myself. I'll
improvise it." He stopped and looked up at Salvador Dali's
"Crucifixion," and an expression of distaste came over his face.
"A remarkable example of modern Spanish painting," he said,
blinking three times, rapidly.

The empty rooms were suddenly filled with the sound of
footsteps, and a group of men and women walked past with an
assistant to Hoving whose name is Harry Parker. "Actors,"
Hoving explained. "They're rehearsing fragments of plays that
they will do in front of paintings: Pirandello in front of Pollock,
'Phèdre' among the Greek amphorae—that sort of thing. People

will just come upon them unexpectedly; nothing will be scheduled. It's Harry's idea. I don't know the point of it, but I know it will work. Come look at this Bingham. . . ." The canvas, by George Caleb Bingham (1811–79), shows two men in a canoe on a smooth river, with a dark lupine animal in the bow, and is called "Fur Traders Descending the Missouri." "This will stack up to any painting done in Europe in that period," Hoving continued. "People have been over-Europeanized. The expatriate influence is still on us. Americans, dissatisfied with American life, went to Europe, and praised what they saw. They had no eye for what had gone on here. Two hundred years from now, people will look all this over and reëvaluate it for what it is. It will all reshuffle itself." He drifted on into the first of several rooms full of modern American paintings, stopped to adjust a cushion on a Mies van der Rohe chair, and looked for a moment out of a window that faced Central Park. Two bicyclists, riding side by side, moved north up the Park drive. "What three things do you like best?" he said, and he turned to face Larry Poons' "Tristan da Cunha," a particularly effective piece of optical art—many pink eggs on a bright-orange field—which cannot be closely observed without a certain optical pain. "Most Op Art is mechanical and not subtle," Hoving said. "This one captures you and draws you within it. Take any still-life painter from the Dutch to Cézanne. They're just putting *things* onto canvas. There's no reason it can't be done this way." He crossed the room to Jackson Pollock's "Autumn Rhythm," which to an unsympathetic eye could appear to be a drop cloth over which a ceiling was painted black, brown, and gold by a man with a shaking hand. "This is a great painting," Hoving said. "It takes a long time to figure out why. You know, the Japanese once did ceramics that they deliberately broke. They would make a crack in a perfect pot. It fascinated them— one haphazard imperfection in something otherwise perfectly

formed. This Pollock has some of that element. It seems haphazard, but the forms are there. Look at that series of ellipses hunched in the center. When I look at it, I don't think. I just look at all the shapes. It's big. Limitless." Then he walked on, past twenty or thirty canvases, and stopped before Charles Demuth's "I Saw the Figure 5 in Gold," which possibly contains as much action as any work that could be done on canvas. The figure 5, repeated twice, emerges out of what appears to be a pattern of architectural fragments, an urban vortex, centered on a bright-red metallic engine that is hurtling who knows where. "In collecting modern paintings, we try to decide what are the best pieces that a man has done," Hoving said. "Then we try to get the absolute best one—the best, without any question, that he has ever done. That's what it's all about." He went over to another window and stood there looking out for a moment before continuing. "I once had a secret wish to become director of the Museum of Modern Art, but I really couldn't be happy in any museum but this one," he said. "I couldn't stand being categorized into one era."

TWO

A Forager

1 9 6 8

Euell Theophilus Gibbons, who has written four books on the gathering and preparation of wild food, once reached through the fence that surrounds the White House and harvested four edible weeds from the President's garden. Gibbons has found light but satisfying snacks in concrete flower tubs in the mall at Rockefeller Center, and he once bagged fifteen wild foods in a vacant lot in Chicago. Foraging in Central Park, he collected materials for a three-course dinner, which he prepared and ate in a friend's apartment on East Eighty-second Street. Gibbons seldom goes out of his way to perform these urban wonders, however. His milieu is open country. He lives and writes in a farmhouse near Troxelville, Pennsylvania, in the center of the state, where thousands of acres of forest rise behind his land and a wide valley of farms slopes away from his

front door. He is a Quaker. He has been, among other things, a schoolteacher. All his life he has been a forager as well, becoming, in pursuit of this interest, an excellent general naturalist. But the publication of his first book, *Stalking the Wild Asparagus,* in 1962, was not so much the by-product of a lifetime of gathering wild food as it was the long-delayed justification for what had, until then, been a lifetime of disappointment as a writer. While moving from job to job and from school to school, he had written sonnets, light verse, short stories, and several kinds of novel, including a Biblical epic, which he abandoned in order to write a whimsical romance about a poor schoolteacher who gives up his profession, buys rural land, builds with his own hands a home made from native materials, and creates the impression that he is a millionaire by purchasing a dinner jacket from the Salvation Army and inviting professors and potentates to black-tie banquets at tables laden with sunfish caviar, cattail wafers, pickled top bulbs of wild garlic, wild-cherry olives, wild-grape juice, blueberry juice, dandelion wine, sautéed blue-eyed scallops, crappies cooked in tempura batter and served with mint and sassafras jellies, day-lily buds with pasture mushrooms, sautéed oyster mushrooms, buttered dandelion hearts, buttered cattail bloom spikes, wild asparagus, scalded milkweed buds, wild salads (made from Jerusalem artichokes, ground-cherries, wild mustard, watercress, wood sorrel, purslane, and greenbriar under wild-leek dressing), hot biscuits of cattail-root flour, Mayapple marmalade, chokecherry jelly, dandelion-chicory coffee, candied mint leaves, candied wild ginger, wild cranberries glacés, candied calamus roots, hickory-maple chiffon pie, and sweet blackberry wine. Gibbons, who was fifty at the time, sent the novel to a New York literary agent he had met, and she soon indicated to him that she felt he was not yet ready as a fiction writer. Tactfully, she suggested that he trim out the plot, characters, and dialogue; she urged

him to reshape the manuscript as a straightforward book on wild food. That was seven years ago. Today, Gibbons is buoyant with royalties. He has followed his *Wild Asparagus* with *Stalking the Blue-Eyed Scallop*, *Stalking the Healthful Herbs*, and *Euell Gibbons' Beachcomber's Handbook*. He is at work on a definitive volume covering every edible plant in North America from the Rio Grande to the Arctic Circle, and his papers—all his sonnets, short stories, notes, novels, outlines, and marginalia —are under lock and key in the Boston University Library, which has established a Euell Gibbons Collection.

Gibbons' interest in wild food suggests but does not actually approach madness. He eats acorns because he likes them. He is neither an ascetic nor an obsessed nutritionist. He is not trying to prove that wild food is better than tame food, or that he can survive without the assistance of a grocer. He is apparently not trying to prove anything at all except that there is a marvellous variety of good food in the world and that only a modest part of the whole can be found in even the most super of supermarkets. He is a gourmet with wild predilections. Inadvertently, the knowledge that he has acquired through years of studying edible wild plants has made him an expert on the nourishment aspects of survival in the wilderness, but the subject holds no great interest for him and in some ways he finds it repellent, since survival is usually taught by the military and he is a conscientious objector. Nonetheless, he has given his time to assist, in an unofficial way, at the United States Navy's survival school in Brunswick, Maine. He has also taught survival techniques at the Hurricane Island Outward Bound School, off the Maine coast. It was in Maine that I first met him—in summer and only briefly—and not long thereafter I wrote to him and asked if he would like to take a week or so and make a late-fall trip in central Pennsylvania living off the land. I apologized that I would not be able to make such a trip sooner than November,

and I asked him if he thought we could find enough to eat at that time. His response was that we could stuff ourselves, if we wanted to, right up until the time of the first heavy snowfall. During the early autumn, through letters and telephone calls, we framed a plan for a six-day trip, in part by canoe on the Susquehanna River and in part on the Appalachian Trail. We decided to start out with no market food of any kind, and we also decided not to take fishing rods or shotguns. With a regimen like that, we clearly weren't going to eat the way Gibbons frequently eats at home, where his *haute cuisine sauvage* depends on liberal admixtures of such ingredients as eggs and butter, and on the advanced equipment of a contemporary kitchen. Mere survival, however, was incidental to our plans. We intended to spend the first couple of days on a survival diet, and then, gradually extending the number of ways in which we would prepare our foraged foods, we planned to introduce, a meal at a time, certain fundamental substances—salt and cooking oil, for example—that we would pick up in country stores. Thus, we would use survival foraging not as an end in itself but possibly as a metaphor, a device through which we would put ourselves in an appropriate frame of mind to recapitulate, in a sense, the earliest beginnings of human gastronomy.

While these plans were taking shape, Gibbons seemed to be full of enthusiasm, so far as I could judge from the letters of a man I scarcely knew, but then it occurred to him that the weather might be forbidding and that one result of his efforts on the river could be a soaking with cold spray. He wrote to say that even though we would almost certainly not go hungry, we might very well find ourselves beset by wind and rain, and perhaps snow. He said, "I wonder if you have considered that a survival trip might involve some pretty acute discomfort, maybe even to the extent that it could be called suffering." He sug-

gested that we forage near his home and do our cooking in his kitchen, forgetting survival in favor of gluttony. I telephoned him and urged him to stay with the plan, saying that the foraging we would be doing, in territory relatively unfamiliar to him, would be a much more interesting challenge for him. He said, for the first time, that he could not be completely certain that we would find enough to eat, explaining that there would be plenty of wild food in that part of the state in November but not necessarily in the specific places where we might happen to look for it. I had the advantage, in this exchange, of complete ignorance, which had given me a reckless confidence. When I pressed for the trip, Gibbons said O.K., he was willing to try it.

In November, I went to Troxelville, and on the morning of the fourth Gibbons and I started by car for the river. He remarked that no Indian, except perhaps a frightened Indian, would ever have set out on such a trip without gathering provisions first, so we foraged the countryside for an hour or two and collected an initial supply of Jerusalem artichokes, persimmons, hickory nuts, black walnuts, and several kinds of mint, which we stored in plastic bags in a pack basket. The weather had become unseasonably raw, and we were under a snow sky, but sunlight came through the clouds at intervals. A wind was blowing. The air temperature, according to an outdoor thermometer we had with us, was just below freezing. The canoe we had, a borrowed one, was an Old Town Guide, and it was strapped to the roof of Gibbons' Volkswagen bus. We planned to put in about fifty miles north of Harrisburg at a point just outside of Selinsgrove. Selinsgrove is a small town where a bronze plaque of the Ten Commandments is set up at eye level on the main street. In a hardware store there, we weighed ourselves on what we were assured was an accurate scale. Gibbons, who was wearing a red jacket, a red bandanna around his neck, a red hat, dungarees, and sneakers, weighed a

hundred and ninety-eight pounds. No one in Selinsgrove gave us a second glance, for we were obviously hunters. In woods by the river as we prepared to shove off, with no guns and a pack basket full of nuts and tubers, a passerby might well have wondered what kind of hunting we intended to do.

Before going onto the river, we ate the first of sixteen wild meals. It was an agreeable cold lunch, and the principal utensil was a hammer. Gibbons set out a mound of walnuts and hickory nuts and a small bucket full of persimmons. "This is the wildest bunch of supplies that were ever taken on a camping trip," he said. His voice was soft and seemed to have traces of a drawl. He picked up the hammer and pounded a hickory nut, using as an anvil a water-smoothed stone. The shell split. With a nutpick, he flipped out two intact halves of hickory meat. He picked up another nut and held it on the stone between his thumb and forefinger, its point at the top; then he tilted it about ten degrees on its axis, explaining that this was the optimum angle. He paused for a moment before he brought the hammer down, then split the nut perfectly. "Indians used to boil these and make a kind of beverage called pawcohiccora," he said. " 'Hickory' derives from that word." He tilted another nut and studied it as if he were about to split a ninety-carat diamond. He pounded it. "Ouch! God damn it!" he said, and he handed me the hammer while he rubbed the end of his thumb. We went on cracking hickories and walnuts for about an hour. To be comfortable, we had stretched out on a narrow beach of smooth stones by the edge of the water, and it was pleasant there in the sunlight, although the breeze off the river was cold, and in the middle of lunch our joints began to stiffen. Gibbons showed me the best way to disassemble a black walnut, reducing it to eighths with seven blows, and while I was having my walnuts he ate persimmons. The persimmons were

soft and sticky—almost but not perfectly ripe. Dark orange and about the size of large grapes, they were full of sugar and tasted something like fresh apricots, but because they were not quite ready they had an astringent aftertaste. Gibbons put three of them into his mouth, chewed them up, and spat out the seeds. "We're going to scatter persimmon seeds from hell to breakfast," he said. "You know, I think I could eat a hamburger now, but not a whole filet mignon." He put his hand back into the persimmon bucket in order to rout his retreating hunger. I was eager to get onto the river while the sun was still fairly high. Gibbons was looking out over the water, and it apparently appealed to him less than ever. "Why don't we stay here tonight?" he said. "Then we can get a good early start in the morning." I pointed out to him that it was only two-thirty in the afternoon. Forlornly, he got into the canoe.

The Susquehanna was about three-quarters of a mile wide, and the water level on that day was so low that in many places the river was only a foot deep. As we began to move downstream, we picked our way among hundreds of islands. Around the small ones the current made rips, where the canoe rocked slightly and picked up speed. Every two or three miles, we came to long, low mountains—Hooflander Mountain, Fisher Ridge, Mahantango Mountain. The mountains ran with level summits to the eastern and western horizons and stood like successive walls before us. When these mountains first folded into existence, Gibbons said, the river was already there, and it cut through the mountains as they formed, creating a series of portals for its own passage. The mountains, when young, were vastly higher than they are now. In the course of aeons, they have almost wholly disintegrated and been carried away by the river. The small mountains that remain today are the foundation stubs of fantastic peaks. As we moved along, we could see the stratification lines in the water gaps tilting one toward

another, and, extending these lines into the air, we could all but see the high silhouettes of the mountains when they were new. The remnants, the forested mountains of central Pennsylvania, with their flat ridgelines, looked as soft as Scottish wool—their trees gray and bare against a background of fallen leaves on rising ground—and the implied mountains of Pennsylvania, miles high between the actual ones, cast a kind of shadow that was colder than the wind on the river. Near the west bank of the river, there was a highway that now and again came into view. Tractor trailers moved in and out of sight, flying streamers of diesel smoke from their stack exhausts. Two or three times, we saw black carriages, drawn slowly up the highway by single horses. These Amish carriages swayed in the wind made by the big trucks.

The paddling had made us warm. The canoe was dry, and the clouds had spread enough to give us a steady afternoon sun. Gibbons saw a promising section of riverbank, and we stopped for a snack—sheep sorrel, peppergrass, and winter cress. "You don't need vinegar with a salad if you've got sheep sorrel," he said, and he moved along until he found some dandelions, which he wanted to have for supper. He dug them up with something that he called a dibble stick. It was actually a dock-and-thistle killer—a kind of spade with an extremely narrow blade. Although we found groves of riparian dandelions, he applied the dibble stick with considerable selectivity, bending over and studying one plant after another, excluding multi-headed dandelions and ramming the stick home when he found single-headed specimens, which have larger integral roots and crowns. "I must say these dandelions look excellent," Gibbons said. "They should be good now. In summer, they get so damned bitter you can't take them." As he put more and more dandelions into one of his plastic bags, his regard for the world became brighter. "Gosh, they're a delicacy!" he went on. When one bag was full, he started on another.

"You act like a man who's finding money," I told him.

"That's exactly it," he said. "That's exactly the way I feel."

Gibbons is a tall man—six feet two. His posture is poor, and he says that this is the result of fifty years of bending to forage. His head is a high and narrow one, with a long stretch from chin to forehead but a short distance from ear to ear, as if he had somehow successfully grown up in the space between two city buildings. His hair is brown, turning to gray, and is wavy. Now, after several hours in the open, it was standing almost straight on end. On the way back to the canoe, he collected a bagful of pennyroyal, and, pointing to a small clump of plants, he said, "That's sage there, but I don't know what the hell we would do with that, since we're not going to cook meat."

On a promising weed near the sage I found a small fruit that resembled a yellow cherry tomato. I asked him if it was edible.

"That's a horse nettle," he said. "It's deadly poisonous."

Covered with beggar's-ticks—as Gibbons calls the small seed-pods that cling to clothing—we moved on downstream, he in the bow, I in the stern. The sun was still bright and the sky blue. "Well, I certainly am glad that we decided to make this trip on the river," he said. "We're not suffering like the early Christians." He paddled on for a while, looking from bank to bank and up at the mountains. At a little after four, he began to sing. We stopped for the night at five.

At that first campsite, which was on flat and wooded ground, four great paddle wheels from steamers long gone from the river were leaning aimlessly against tree trunks, and near them was a colony of ground-cherry plants, close to the water's edge. A small stream that ran into the river there was almost dammed with watercress. We still had daylight, and we cut a pile of cress and collected a peck of unhusked ground-cherries. While Gibbons, in boots he had brought along, was standing in the stream bagging the watercress, he became irritated at the thought of people who fear to take watercress from just any stream.

"People say, 'Is it growing in polluted water?'" he told me. "For gosh sakes, what difference would that make? Your own vegetable garden is polluted when you put manure on it. The important thing is to wash the cress in pure water, or boil it, which we're going to do. We'll have this for breakfast." Ground-cherries, members of the nightshade family, are sometimes called strawberry tomatoes, and they hang from vinelike plants in small tan husks that become lacy with age. The husks are about an inch high, and are shaped and ribbed like Japanese lanterns. Inside each lantern is a berry that is yellow green and resembles a cherry only in that it is smooth and round. It has no pit. It looks like a small tomato, half an inch in diameter. Like many wild foods, ground-cherries are good as hors d'oeuvres, and we ate some as we gathered them. Their flavor is much like the flavor of tomatoes, with a wild, musky undertone. Fifty yards upstream was a swampy lowland where the shoreline was imprecise because it was overgrown with cattails. Gibbons waded in among the cattails, leaned over, and reached down into the freezing water until his arm was submerged to the shoulder. He came up with the leading end of a cattail root, from which a short white sprout was protruding. He broke off the sprout and reached into the water again. The second sprout he found was as short as the first one, and Gibbons was disappointed. "I've seen them eight inches long," he said, and tried again. When he had about ten short white sprouts, he gave up. He calls the cattail the supermarket of the swamps, since it has half a dozen edible parts (not all edible at the same time of year), in a range from the soft green bloom spikes to a rootstock flour that makes excellent drop biscuits. On his way back to the campsite, he paused at a remarkable weed that had a leaf large enough to wrap groceries in. "Burdock," he said, and he dug it up with the dibble stick. As we dug six or seven more, I discovered that burdock is the plant that produces the

spherical bristly burrs I had been picking up inadvertently all my life—the burrs that look like communications satellites and will hang on to almost anything but glass. Just beyond the burdock was a group of plants that looked to me like dandelions, but each one had a dry stalk rising from its center. "Chicory," Gibbons said. "It's getting dark. Let's just take the greens." So we cut a pile of chicory greens, and Gibbons sorted them. He threw away the outside leaves and kept the young and tender ones.

We had a nest of pots with us, and a Coleman stove, which we used part of the time in supplement to wood fires. It was six o'clock when Gibbons began to prepare dinner that night, and the air temperature was thirty-three degrees. While we talked, we breathed out shafts of vapor, which swirled into the steam that was rising from the pots. As Gibbons bent forward intently over his cooking, light flickered up against his face—the benevolent face of a kind and religious man which seemed to have in it, as well, a look that was gleamingly satanic. He said that he thought that in this kind of encounter with nature—or in any other kind of encounter with nature—human beings make a sorry mistake if they feel that nature is something to be conquered. "The product I gather out here means something different to me than food from a store, but I don't feel that I have made nature stand and pay tribute. I know that when I disturb the earth to get these plants I will almost always cause more of them to grow. I don't like to eat Indian cucumbers, because I have to destroy the plants to get them. I don't want to destroy; I want to play the part I am supposed to play in relation to plants. I come to a persimmon tree and the tree is growing something sweet, so I'll eat it and scatter the seed. When I do that, I'm carrying out the role I'm supposed to be carrying out. Nature has many, many balances, and we have to find a balance that includes man. If man accepts that he has to

be a part of the balance, he must reject the idea of the conquest of nature. Whenever I read that phrase 'conquest of nature,' I feel a little depressed. Man is a part of the total ecology. He has a role to play, and he can't play it if he doesn't know what it is—or if he thinks that he is conquering something." While Gibbons speaks, he characteristically averts his eyes from the path of his words, but from time to time, as he reaches a key word, his eyes open wide and focus directly on the listener. He seems to be checking to see that the listener is still there. Light and rapid smiles and frowns follow one another across his face. "The idea that we are engaged in a conquest of nature is a fallacy that is causing all kinds of trouble," he went on. "We're covering the earth with concrete, filling swamps, levelling hills. Some of these things have to be done, but we should do these things with knowledge. The conquest of nature has to stop. When Orientals climb a mountain, they believe that the mountain lifts them, not that they have conquered the mountain. Here. You're going to have to peel your own artichokes. I cooked them in their jackets tonight."

For dinner, we had boiled Jerusalem artichokes, boiled whole dandelions, ground-cherry salad, a dessert of persimmons, and pennyroyal tea. Jerusalem artichokes are tubers of wild sunflowers. They look like small sweet potatoes, since they are bumpy and elongated and are covered with red jackets. The flesh inside, however, is delicate and white. Boiled, it has the consistency of boiled young turnips or summer squash, and the taste suggests the taste of hearts of artichokes. Gibbons said that Jerusalem artichokes are native American plants. Indians sometimes cultivated them. They were well known to colonists, and the word "Jerusalem," in this instance, is apparently an English corruption of the Spanish word for sunflower—"*girasol.*" Gibbons also said he was sorry that Jerusalem artichokes and a number of other wild foods—such as ground-cherries and

wild rice—had been named for more familiar foods. "These things are not substitutes for tame foods," he went on. "They have flavors of their own, and it is not fair to them to call them by the name of something else. These are not artichokes. They're sunflower tubers." With a knife and fork, he laid one open and then scooped up a mound of the white flesh. It was steaming hot. "Boy!" he said. "That goes down very gratefully. Just eating greens, you can get awfully damn hungry. We'll eat plenty of greens, but we need these, too." For a while, we ate without speaking, because the artichokes were so good. Gibbons ran his fork into the root of a dandelion and drew the rest of the plant—a long streamer of leaves—away from a heaping mound of dandelions on his plate. With Italian skill, he rotated the fork until the plant was curled around it like spaghetti. I imitated him, and we both began to wolf down dandelions. Gibbons was a little disappointed. "These dandelions are tough," he said. "Too bad. They get better and better the colder it gets. With this weather, we may get some better ones in the next few days." The dandelions were also somewhat bitter, but Gibbons seemed to find them just right in this respect. Ordinarily, he would have boiled them in three waters, he explained, but he had used only one pot of water this time, because, as he put it, "we're using no salt and we got to taste *something*." If I had been a little less hungry, I think I would have left the dandelion leaves on my plate. The crowns and the roots, however, were mild and delicious. When we had finished dinner, Gibbons said that his hunger was satisfied but that he did feel a longing for meat or fish. "Right now I wish I had a big plate of sea-urchin roe," he said. Then he rolled a cigarette and lighted it, and that seemed to kill off the thought.

I boiled water in the largest pot, dropped a cake of soap into it, and began to wash up the dinnerware. Gibbons rolled another cigarette. He said that he was trying to cut down on his

smoking and that was why he had reverted to a custom of his youth and was rolling his own. He was so good at it—just a turn of his fingers and a fast lick at the paper—that his rolled cigarettes looked machine-made. I asked him how many Pennsylvania Quakers he knew who could roll a smoke like that.

"I'm not a birthright Quaker," he said. "I'm a convinced Quaker. I was born in Clarksville, Texas—in Red River County."

The date of his birth was September 8, 1911. At that time, his father, who was also born in Clarksville, was a blacksmith and a grocer, pursuing both careers in a single store. Gibbons' father was also a dreamer. His horizons were wicketed with rainbows, and before long he would become an irremediable drifter, taking his family with him as he moved around the Southwest, making one fresh start after another—now a carpenter, now a contractor, now a rancher, a farmer, a sawyer, a builder of culverts, a bit-sharpener in oil fields. Gibbons' mother was from Dresden, Tennessee, where she had grown up on a hill farm. Her mother taught her to hunt and to trap and to eat wild greens, wild fruits, wild lettuce, and pokeweed salads. When Gibbons' mother was a little girl, she provisioned her doll house not with mud pies but with wild food. In Texas, years later, she passed along her knowledge to her children, three boys and a girl. Euell, the second child, was by far the most interested. "Red River County isn't like Texas at all," he told me. "It's more like Pennsylvania. There were woods there, and river bottoms, and hills. The whole idea that you could go out into the woods and gather good things was tremendously exciting to me. When I was five, I thought up my first wild recipe. I took hickory nuts and hackberries and pounded them up in a cloth and made a wild confection. Wild food was our calendar—a signal of the time of year. In the spring, we had wild asparagus and poke and all the early greens. Lamb's-

quarters came in the late spring and strawberries in the early summer, then mulberries and blackberries. In late summer, we had purslane, wild plums, maypops—that's a kind of hard-shell passion fruit—and in the fall there were plenty of muscadines, wild pecans, hickory nuts, black walnuts. As it got a little colder, there were persimmons, hackberries, and black haws. Wherever we went, I asked what the Indians ate. We considered all these things delicacies, and we would not have *not* gathered them, any more than we would have let things in the garden go to waste."

I asked what his brothers do now, and he said that both live in Albuquerque, and one is a cabinetmaker and the other is a driver for the Navajo Freight Lines. His mother, who is eighty, lives in Albuquerque, too. His father and his sister are both dead.

Gibbons snapped a last cigarette off his fingers and into the river. A few minutes later, he got into his sleeping bag and began to wrap himself in a new space blanket. He said, "Let's see if we can get through the night without dreaming about food. That will determine how successful we have been today."

When we got up, at 6 A.M., the temperature was twenty-five degrees and there were panes of ice around pools at the edge of the river. The river surface was absolutely smooth, and twists of vapor were rising from it. Families of coot swam in zigzags in the mist. We had a collapsible bucksaw with us. I set that up, cut logs from a fallen birch, and made a good-sized fire while Gibbons got together the materials for breakfast. The first thing he made was watermint tea. I had three cups in quick succession. The cups we had were made of aluminum, and the heat coming through the handle of mine burned my fingers, while the rest of my hand was red with cold. Gibbons said, "In Troxelville, mint is called tea, so you know what they do with

it." The night before, I had been full of compliments for the dinner he had cooked, and now he seemed a little sensitive about the breakfast he was about to serve. He warned me that breakfast is the roughest meal to get through on any survival trip, because that is usually the time when the wild foods are most dissimilar from the foods one is used to at home. He then filled two plates with a medley of steaming watercress, chicory greens, cattail sprouts, and burdock roots. It was, frankly, a pretty unusual breakfast. The boiled watercress was delicious, and the cattail sprouts were sweet and tender. The chicory greens, being even bitterer than the dandelion greens of the night before, were a little strong for that hour in the day. The burdock roots, which he had sliced into discs, were undistinguished in flavor, and tough. "One thing we won't need on this trip is vitamin pills," Gibbons said. "This watercress, for example, has more Vitamin C in it—weight for weight—than there is in orange juice. Spinach is the only garden vegetable I know of that has more Vitamin A than these chicory greens. On the whole, people might be better off if they threw away the crops they so tenderly raise and ate the weeds they spend so much time exterminating. The stinging nettle has more protein than any other leafy material ever tested. Cooked nettles don't sting. Nettle beer is very good." Neither of us finished the chicory greens, and we flipped the leftovers off our plates onto the ground. Gibbons said, "When we throw away garbage, it goes right back into the earth." We ended the breakfast with several handfuls of persimmons, which tasted as sweet and as bland as dates following the bitter greens.

After breakfast, we heard shotgun blasts up and down the river, some quite close, and I said, "What are they shooting at?"

Gibbons said, "Duck, I think."

I began to think of roast duck stuffed with oranges. Gibbons

must have started to think about roast duck at that moment, too. "There's a difference between being hungry for foods that you're used to eating and being just plain hungry," he said, and he added, "I've been both." Then he went off foraging while I cleaned up and packed the gear. When he came back, he was carrying a bag full of winter cress and three bags full of oyster mushrooms. The winter cress looked like magnified watercress, but its taste, Gibbons said, would be altogether different. The oyster mushrooms were gray and floppy and made me think of the gills of sharks. Gibbons told me that he had found them growing on a dead birch and a dead willow, and he said, "When they steam, they smell like oysters."

"How do you tell the difference between an edible mushroom and a poisonous mushroom?" I asked him.

"You can't," he said. "A family in New Jersey died two weeks ago from eating *Amanita verna*—you know, the death angel. A reporter at the Philadelphia *Inquirer* called me up and said, 'How do you tell the difference between mushrooms and toadstools?' You don't. There are too many of them. Some are neither edible nor poisonous. You learn to recognize the edible species. It is exactly like recognizing someone's face; once you know a person, you know that person from all other people. If you came home at night and a woman you had never seen was standing there in your house, you wouldn't think it was your wife. God help you, anyway, if you would. Oyster mushrooms, meadow mushrooms, chanterelles, shaggymanes, puffballs—you get to know each one, and you never forget them. I don't just go out, find a mushroom, eat it, and see if it's going to kill me. I know what I'm looking for."

A boy hunter walked into the campsite. He was about twelve years old, and he was wearing a red cotton parka. A shotgun slanted down from the bend in his right arm. He had short-cropped blond hair. His left hand was bright with blood.

"Hello. What did you kill?" I said to him.

"Rabbit. You get anything?"

"Yes," said Gibbons.

"What did you get?"

"Winter cress."

"Don't you hunt?" the boy said.

"Sometimes," Gibbons told him. "Have you seen any ducks this morning?"

"No, but I shot five coot down there, on the water."

"What did you do with them?"

"What did I *do* with them? I'm not going to wade out after coot. I'm not going to get wet for coot—not when it's this cold."

The boy moved on up the riverbank. Gibbons and I looked at each other for a moment, and each saw all reserves about hunted game crumbling away. We threw all our stuff into the canoe and shoved off. A coot is a ducklike bird—not a delicacy, but edible.

We searched the river for the five dead birds. Perhaps to give his appetite every possible consideration, Gibbons began to refer to the coots as ducks, and he began to shape a menu in his mind that included not only ducks but also freshwater clams. "Watch the bottom," he said. "I want ducks and clams. If we had ducks and clams, we could have clam-and-mushroom stuffing for the duck." So we began to scan the bed of the river as well as the surface. The water was clear and it flowed along over ribs of stratified rock that were partly covered with leaves and algae but not with clams. On the surface all around us were gliding coots but no dead ones. We slanted back and forth in angled patterns down the western side of the river. It seemed impossible, on such a still morning, that we could not see the birds.

"That little kid was lying," I said. "He didn't shoot any coots."

"There's a clam!" Gibbons shouted.

"Where?"

"Right there, God damn it. Stop the canoe!"

We backwatered hard, and then I pried the canoe broadside to the current and jammed my paddle against the river bottom on the downstream side. While I hung on, Gibbons plunged his arm into the water, soaking part of the sleeve of his jacket. When he drew out his arm, he had a muddy half-shell in his hand.

We drifted on, still searching, and we began to feel the chill of the morning. Above us was a mackerel sky, and no warmth was coming through it. The current gradually took us close to the bank, and after we had gone along beside it for a while, alternately drifting and paddling, we came to another hunter, in a semi-blind—an adult this time, all red and brown and crouched and ready.

"Get anything?" Gibbons said to him.

"One pintail duck," said the hunter. "They're scarce today."

"You're telling me," said Gibbons.

We paddled steadily for a long stretch, all but giving up the search, and we began to feel warm. Around noon, the sun broke through. "You couldn't say we were suffering like the early Christians," Gibbons said. "We've got a pretty good sun there now."

"What else could we ask for?" I said.

"A duck."

We shot through a little rip and stopped paddling at the end of it to drift and eat persimmons. While I ate mine, I leaned back on the gunwales, so that the sun could hit me full in the face, and I closed my eyes and spat the seeds into the air. "What were you before you were a Quaker?" I asked him.

"I was raised up a Southern Baptist—no dancing, no card-playing, picayunish piety—and that produced all kinds of problems, many of which I still have with me. That part of Texas

where I first lived was some microculture. Puritanism in theory. Tobacco Road in practice."

The canoe moved quietly around a small island. Two white-tailed deer, from cover in the middle of the island, jumped and ran. When they entered the shallow water of the river, spray flew up from their feet. It happened that there was a deep channel between the island they had left and a much larger island in the center of the river. The deer slowed down, then lost touch with the bottom and began to swim. Instinctively, Gibbons and I took our paddles and made boiling eddies in a race to catch the deer. This was bizarre. What on earth did we intend to do if we caught up with them? Were we going to jump out of the canoe and drown them or knife them in the river? There was no logic, and there had been no second or even first thoughts. But we were both paddling as if our lives depended on it. Apparently, just the sight of all that meat was enough to make us move. For a time, we gained on the deer. Then their feet found the bottom again and they moved a little faster as the water shallowed. Soon they were skimming along over a few inches of water, spray flying. They ran up onto the big island and sprinted along its central ridge. When they had moved several hundred yards down the ridge, they disappeared from sight.

"Lunch?" Gibbons said, and we beached the canoe on the big island. We could find no stones there so we went into the river and picked up two flat ones. For an hour, we cracked walnuts and hickory nuts, exchanging the hammer, and when we were not pounding or picking at the nuts we ate watercress and persimmons. Like people in all parts of the country, we were eating essentially the same lunch we had had the day before, and it was not much of a thrill. We were tired, so we stretched out and propped ourselves on our elbows while we worked. The ground was cold. Over lunch, Gibbons told me this story:

In 1922, his father took the family to the Estancia Valley, in New Mexico, to establish a homestead. The state of New Mexico was ten years old, and was having unpromising beginnings, for a four-year drought of appalling severity had discouraged homesteaders in the state, and many of them were giving up and moving away. Euell's father was a man of such unnerving optimism that he saw the drought as an opportunity. Surely rains were near, and meanwhile departing people were all but giving away their homes and goods. He traded the family car to a defeated homesteader for a cow, a calf, a colt, two mares, a mule colt, twelve hens, farm tools, a set of harness, a wood stove, and an axe. The family moved into a half dugout, which had a dirt floor and, above ground level, was made of logs. Water was carried from a spring several hundred yards away. Euell's father found work with a new company that had been established in the valley salt flats to make salt. This, he said, would be his permanent career. Gibbons remembers that his father described as permanent every job he started. The salt of the valley had not been tested, and cattle died wherever the salt was sold. The company collapsed. The drought continued, and since there was no other work for Euell's father, the mule colt was sold and the money was used to buy food. Soon his father left the valley, on foot, to search for a job, and the mother and four children in the half dugout had no idea where he was going, how long he would be gone, or whether he would come back. The remaining animals began to starve. Euell's mother got sick, apparently from malnutrition. A mare died, and Euell's dog ate the carcass. Wood, out there in the semi-desert, was difficult to find, and Euell, who was twelve years old, began to take posts from an old pole corral a half mile away. The cow, in her hunger, ate yucca and died. Euell skinned the cow and sold the hide in Cedarvale, the nearest town. The chickens ate the flesh of the cow, and the family, who had been living on lard, pinto beans, flour, and syrup, began to eat the

chickens, one by one. When Euell killed the last hen, he found an egg inside it, and for many weeks after that the egg sat on a shelf because no one would be the one to eat it. It was eventually thrown away. Meanwhile, pinto beans had become the family's diet morning, noon, and night. At the sight of pinto beans, they sometimes vomited. About a mile and a half away, there was a house that stood empty. Its owners were to be gone indefinitely, and Euell went there to see if they had left any food. He found the front door swinging in the wind on one hinge. Sandstorms had blown drifts of sand into the house and had knocked a stovepipe chimney from the roof as well. There was no food inside. A few yards from the house was a dugout shelter, and it was locked. Euell thought for a while, then broke in. Inside, he found two hundred pounds of pinto beans.

Outside, his dog began to bark. Euell went out and saw that the dog was concentrating on the stovepipe chimney that had blown off the house. He picked up one end of the chimney and squinted into it. A pair of rabbits was in there, and after he had killed them he began to wonder—for the first time in this strange, dry, and unpromising landscape—about wild food. Soon after the last of the family's livestock had died, there had been some rainfall in the Estancia Valley, and, as will happen in desert country, things were suddenly green. On his way home with the rabbits, he found Russian thistles growing along a fence row, and he also found wild garlic, lamb's-quarters, and wild potatoes. All these ingredients were used that evening in rabbit stew. The next day, Euell put a pack on his back and went to the edge of the valley, where he found puffball mushrooms growing under cedar trees, piñon nuts, and fruits of the yellow prickly pear. He made long daily hikes in search of provisions. He found buffalo berries on the margins of sand hills. He found a way to fish the ground for rabbits—pushing barbed wire into rabbit holes and rotating the wire so that the

barbs would work their way into the rabbits' fur. His father returned, with money, about a month later. Until then, the family lived on the wild food Euell foraged.

Now, on the island in the Susquehanna, Gibbons stopped talking for a few minutes and cracked a number of walnuts. He hunted around for his nutpick, found it, and ate the nuts. "Wild food has meant different things to me at different times," he said. "Right then it was a means of salvation, a way to keep from dying."

I asked him if his family had been able to stay in the Estancia Valley.

"Oh, no," he said. "It was a whale of an unstable situation when I was growing up. But my father finally did homestead a place in northwestern New Mexico, about a hundred miles from Albuquerque, near a town called Cuba. We had four hundred and six acres. It was a very, very small spread, but you had the use of a lot of free range. When I was fifteen, I left home. I didn't run away, I just left. I always sent money home. I worked the wheat harvest in Texas. I worked in a dairy. I worked in boll-pulling fields. I knew carpentry from my father, and I helped build a church. I spent seven weeks trapping on the Red River. With some others, I panned gold. We could get a little bit of color along the Tonque. In Logan, New Mexico, I worked for the LE Ranch, and later for the Bell Ranch. And after that I worked for Blumenshine's near Albuquerque. These were all straight riding jobs—yayuh, a cowboy. Just a general cow nurse—riding fences, working cattle. I spent nearly every day all day in the saddle, but I never was a good rider. I've always said the reason I learned to ride was all that cactus out there—you had no place to fall if you were thrown. I was never badly hurt, though. A cowboy also does an awful lot of digging postholes, stringing fences, fixing windmills. I earned extra money bronc-stomping, and I got pretty good with a rope. I can

still do it. Every once in a while, I lasso a whole bunch of children at once, just to give them some fun. I learned a lot about nature from the Navajos. They were semi-agricultural. They were lean in the spring, and when they killed a horse they ate everything. When I was twenty-one, I caught a freight for California."

As Gibbons finished telling me these things, I found that I was looking at the red bandanna around his neck. His long, spare, unpostured frame seemed suddenly just right for the resigned slouch of a cowboy in the saddle, although that was the last thing I would have imagined before then. And I thought I could see now why he had apparently been so timorous about starting out in the first place. He had had his share of discomforts years ago, and the idea of artificially creating them, or even running the risk of creating them, must have seemed bleak to him. I, for my part, had been sure that Gibbons would take care of the food and that luck would take care of the November weather, so I had been full of energy when we started out, and had thought that I was going to have to rally Gibbons to get him through the trip. What was happening, though, was that I was losing energy now and Gibbons was visibly getting stronger as he settled into the routine, accepted the conditions we had set up, and relaxed in the momentum of fifty years' experience.

A stiff, cold wind began to blow north up the river, and a heavily layered sky closed out the sun for the rest of the day. We wanted to end the river part of our trip six or eight miles downstream, near Clarks Ferry, where the Appalachian Trail crosses the river, and we had planned to arrive there that afternoon. "Well, if we're fixing to get there before dark, we had better get going," Gibbons said, and he got lightly to his feet and walked to the edge of the water. He looked back at me. "Let's go," he said. I had been stretched out on the ground for almost an hour—as he had—and I got up slowly. I felt stiff and

chilled. Gibbons was waiting in the bow, and I got into the stern and shoved off. All afternoon, we pushed the canoe into the cold head wind, and conversation was impossible. When we had covered about a mile, however, Gibbons began to sing:

"When the north winds blow
And we're going to have snow
And the rain and the hail come bouncin',
Then I'll wrap myself in a buffalo robe,
Away out on the mountain."

The dusk was deep when we took the canoe out of the river, at a windswept and deserted picnic ground that had stone fireplaces. As we had planned, I hitchhiked back to pick up Gibbons' Volkswagen, then returned to the campsite. On the way, I stopped in a general store and bought a box of salt, for that evening's meal, and cooking oil, for the following night. The counter was covered with cinnamon buns and chocolate cupcakes, but, oddly, they did not appeal to me at all. What I really wanted was eight ounces of undiluted whiskey; but whiskey was not on our menu, either. Feeling cold and miserable, I went back to the campsite. Gibbons was digging up dandelions in the dark, and he was whistling.

Dinner revived me. Gibbons had found some catnip, and he made catnip tea. He said that catnip is a mild sedative, and I drank all I could hold. We built a high bonfire that whipped in the wind. The dandelions, boiled in three waters, were much better than they had been the night before, and the oyster mushrooms might have been taken from a banquet for the Olympian gods. Each mushroom was at least six inches across and, in the center, nearly an inch thick. As they steamed, the vapor from the pot did seem to carry the essences of oyster stew. Their taste, however, was fantastically like the taste of broiled steak.

The simple ingredients of that dinner—dandelions and mushrooms, no dessert—were splendid in themselves, but they were made transcendent by the presence of salt. This was the first of the kitchen staples that we would introduce, one at a time, during the rest of the trip, and, perhaps a little expansively, we had the feeling that we had repeated the experience of some inspired Cro-Magnon who first thought to crush the white substance and sprinkle it on his food. After dinner, Gibbons rolled a cigarette and said, "What I could sure eat right now is a praline." We planned to introduce sugar at breakfast the next morning (in the car Gibbons had a large block of maple sugar he had made from a neighbor's trees in Troxelville), and his remark about the praline set a pattern that he repeated many times, concentrating his fantasies on kinds of food that were on the horizon of our diet. "Roadside stands sell terrible pralines," he went on. "They use corn syrup. I make pralines out of maple syrup, hickory nuts, and cream."

Unfortunately, Gibbons did not make pralines for breakfast. As unappealing as pralines might have been at that time of day, nothing edible could have been worse than what we had. The meal began with peppermint tea, which was very good in itself and was excellent with chunks of maple sugar in it. The substance of that breakfast, however, was a great mound of hot persimmons, which had been stewed in maple sugar and were now glued together with concentrated maple syrup. We stuffed them eagerly into our mouths, because they looked good, but we found that all the astringency of slightly unripe persimmons seems to be brought out powerfully when they are stewed. They puckered not only our mouths but also our throats. Gibbons observed, without apparent alarm, that he thought that his esophagus was going to close. Nonetheless, he kept shovelling in the styptic persimmons, and I followed his lead. There was enough carbohydrate fuel in the stewed fruit to keep us going

all day, and we needed it. Each mouthful tasted fine on entry but quickly turned into something like a glut of blotting paper, requiring a half dozen forced swallows to squeeze it down. Gibbons had told me that in all his experience of cooking wild food for others no one had ever got sick. In order to preserve his record, I excused myself and went for a walk, taking deep breaths, until I was sure that the persimmons were going to stay with me.

We spent the morning foraging near the river, for Gibbons had become nervous about the Appalachian Trail. "Nut trees bear very little in dense forest," he said. "A dense forest is a famine area. Along a river, sun may get in, but I have walked for miles in dense forest without finding one damned thing I could eat. It is possible to eat the inner bark of trees, but there's almost nothing else." A short walk into a valley west of the river calmed him completely. This was dry, brown, beautifully autumnal pheasant country, with corn stubble in the open and the clustered stalks of the summer's weeds fringing ditches, streams, and fields. In such fringes, Gibbons is truly happy, for more concentrated foraging can be done in them than in any other kind of area north of the tropics or far from the sea, and for sheer concentrated provender the only comparable areas in the United States are the food-laden zones between high and low tide. About a quarter of a mile from the Susquehanna, a small rivulet ran along one side of a cornfield and then under a blacktop road. The curving plow of the farmer had spared a fifth of an acre in the angle where the stream met the road, and there we found wild mustard, lamb's-quarters, chickweed, wild spearmint, catnip, winter cress, dandelions, and groundnuts. Gibbons ignored the first three, because they were past their prime. We almost ignored the dandelions, too, since we had had so many, but Gibbons dug up a few with the dibble stick to see how they were, and announced with excitement that they were the largest dandelions he had ever found. The roots of

these single-headed beauties were more than an inch thick. "This is the best dandelion field I've ever got into," he said as he pried one after another out of the earth. "I've seen *cultivated* dandelions that weren't as big as this!" It was a clear, sunny morning, so we sat down right there and dressed the dandelions, deciding to have crowns for lunch and roots for dinner. The crown is the place where the leaves are joined, at the base of the plant. When the leaves are cut away, the remaining stubble resembles a coronet. We put these into one bag, and we pared the roots, which were about three inches long, and put them into another. The groundnuts in that remarkable place were also the largest he had ever found. They grow below the surface, and are discoverable at that time of year only by thin filament vines that wind upward around the stems of other plants. These groundnuts are in no way similar to peanuts, which are called groundnuts in many parts of the world. Groundnuts of the sort we found are spherical and are sometimes called Indian potatoes. They are connected underground by stringlike roots. Gibbons excavated carefully, and he brought up one, then another, then another, each separated from the next in line by a foot or so of root. His eyes were bulging. Each groundnut was about the size of a golf ball. "Captain John Smith said he found groundnuts as large as eggs," Gibbons told me. "But these are the biggest I've ever seen. You're in on the kill—

"Where the whitest lilies blow,
Where the freshest berries grow,
Where the groundnut trails its vine,
Where the wood grape's clusters shine."

Walking back to the river, we passed a persimmon tree that was four stories high. The persimmons hanging from its branches were so large that they looked almost like oranges. In

fact, some were two inches in diameter. We walked right on past them without a second glance.

"There is interesting wood in a persimmon tree," Gibbons said. "It is in the same family as ebony."

Before repacking our gear and going up onto the Appalachian Trail, we had a light but hot lunch beside the river—boiled dandelion crowns, catnip tea, and walnuts. The crowns were every bit the delicacy that Gibbons had claimed they would be—easily the equal of asparagus tips or young broccoli spears. With vegetables, Gibbons has the touch of the Chinese. Each crown offered an initial crunchy resistance and then seemed to dissolve in a mild but distinguished sea of the flavor essence of dandelion. We took many long draughts of catnip, and we felt good. Sunlight was sparkling on the river. The temperature was in the middle forties. Gibbons began to talk about a tribe of Indians in the Andes. He said that when these Indians travel they take no provisions at all, and they go for three or four days on coca leaves that they chew as they move. He paused for a moment, shaved some maple sugar into his catnip, stirred it, and said, "They live on nothing but the cocaine—and their own energy. It's rough. They get thin. They're using up their own bodies when they're doing it." He drank some more catnip. "Of course, we're getting plenty of energy from this sugar," he went on. "When I tapped the trees, I made spiles out of elderberry stems and sumac stems. I cooked the sap right there in the woods, in two old bake pans. I've made sugar from the sap of red maples, silver maples, Norway maples—hell, yes—and from walnut trees, butternut trees, sycamores, black birches. This? This is sugar-maple sugar. This is living. In the Sudan, there are certain Nilotic tribesmen whose diet is insufficient and consists almost wholly of cornmeal. They start the day by eating their ration of cornmeal as fast as they can, so it will digest more slowly and prolong the feeling of being full. Let's get going."

The Appalachian Trail rose and fell in long, untiring grades through the mountains, among hardwood forests that were not at all dense and where sunlight, on that first afternoon, sprayed down through the trees. The ground all around us was yellow and red with dry leaves, and the clear sky was a bright pale blue. Along the edges of the trail for hundreds of yards at a stretch were colonies of ground pine and wintergreen. We stopped to collect wintergreen, and soon after we moved on Gibbons began to sing a song about making love to a turtledove. I said to him, "This is the best famine area I've ever been in." He then began to talk about fried chicken, fried pork chops, fried potatoes—for we were going to break out the bottle of cooking oil that night and fry things for the first time. We stopped at a log lean-to that had a stone fireplace in its rear wall and, against the side walls, permanent bunks whose wooden frames were covered with heavy sheets of steel mesh. Behind the lean-to was a brook.

We collected wood and started our fire. The temperature fell rapidly after the sun went down. The night was going to be clear and cold, and we kept the fire high. By seven, when Gibbons had the two frying pans out and was beginning to sauté dandelion roots in one and sliced groundnuts in the other, the temperature at the open end of the lean-to was below freezing and the temperature at the closed end was almost a hundred degrees. The distance between these extremes was eight feet. Gibbons seemed at home there, cooking, with his face baking and his back freezing, and the dinner he served was outstanding—wild-spearmint tea, piles of crisp dandelion-root tidbits, and great quantities of groundnuts so skillfully done that they seemed to be a refinement of home-fried potatoes. Having fried food was an appealing novelty. We were hungry, and we ate as rapidly as Nilotic tribesmen, without conversing. Gibbons looked up once and said, "The Smithsonian has a very good man on starchy roots." Then he went on eating.

Afterward, Gibbons made another pot of spearmint tea, and he built up the fire so that it glowed all around him as he sat on a corner of his bunk and told me that he had been a tramp and a Communist—first the one, then the other—in the nineteen-thirties, in California and the Pacific Northwest. "California was a poor place for wild food. I gathered some purslane, lamb's-quarters, and black walnuts. And out near Needles I once got some prickly pear. There was not much wild stuff in California that I recognized. I foraged cultivated foods from fields and shops." His first view of the state was over the side of a coal car, which he left at San Bernardino in March, 1933, hopping another freight to Los Angeles. Calling himself by the name of a friend in New Mexico, he signed in at Uncle Tom's Transient Center. "I had a road name. Lots of bums had road names. At Uncle Tom's, you got a number, and that was that from then on. But there was no work in Los Angeles. There were too many bums there. After so many days, you had to leave. I went to the railroad yards and found a train of reefers—refrigerator cars—that had been made up to go north empty. There were hatches on the tops of the cars. I raised a dozen of those hatches and men were crammed in under every one of them. I finally had to sit on the top of the train. When we left L.A., men were all over the top. There were probably a thousand guys on that one freight."

In Ventura, Gibbons stayed at the Sally (Salvation Army), and in Lompoc he begged toffins (semi-stale baked goods) from a friendly baker. He found a preacher in Lompoc who had the same size feet he had, and he built a chicken coop for the preacher in return for a pair of shoes. The preacher was so astonished at Gibbons' willingness to work hard, and at his skill as a carpenter, that he gave him the shoes and two dollars and fifty cents. "Everything was green in Lompoc. It was April. The sun was shining. Lompoc was my heaven, and I didn't need any other one. There were no more jobs, and I had to move on."

He caught a freight to Surf, where he joined up with a Mexican and a Spaniard, shared his toffins with them, and spent five cents of his two-fifty on a measure of coffee, which he brewed in a No. 10 can. He slept in a bindle (bedroll) and carried it on his back during the day. "I was a bindle stiff, like the others. I had a blanket with me, and a pack made out of an old tin breadbox." He rode a freight to Santa Clara and arrived on Good Friday, a day of luck. A butcher gave him a pound of hamburger, and at a packing plant he was given a bag full of prunes—"huge prunes that sold for five cents apiece in Southern Pacific Railroad dining cars." He found artichokes in Santa Clara fields, and while he was walking along a road near the artichoke fields a car driven by a woman stopped beyond him and a small boy got out, ran back, and gave him a fifty-cent piece, telling him that it was an Easter present.

Gibbons paused to say that he apparently developed in that era what some people who know him well have called his "hobo instinct." Few American hoboes of the nineteen-thirties knew much about wild food, he said, but he acknowledged nonetheless that there are hobo overtones in his approach to his specialty—his excited way of seeing wild plants as wild coins, and his affection for roadside foraging. He said, "There is nothing I would rather do than eat my way through a roadside ditch."

At times, in California, Gibbons lived in ding camps. " 'Ding' is the hobo word for bum. When you go bumming, you go dinging." In the ding camp at San Jose, he took a course in Spanish, and he worked in the camp variety show as a blackface minstrel, a juggler of vegetables, and a trick roper. The San Jose troupe travelled to other camps—in Sacramento, Oakland, San Francisco—and also played in theatres, where Gibbons got three dollars (tops) for an appearance. "The thing that broke that up was marijuana smoking. About half the guys in the troupe were hay burners. Five cents a stick."

"Were you a hay burner?" I asked.

"No, I never was a hay burner."

Gibbons pushed the logs in the fireplace closer together. "I went to a few Communist meetings with men from the transient camps. We would hear lectures on the labor situation and put money in the collection plate. But my left-wing activities really began after I got a job as a laborer for Continental Can in San Jose. I met a girl there who was a party functionary—she was subsidized by the Party. I fell in love with her. I had a little one-room shack I had been living in, and she moved in, and we painted it white. There were fig trees beside it, and we gathered walnuts, prunes, oranges, figs, and lived on those. I sold newspapers to make dimes, and I wrote leaflets for the Party. We worked to organize Continental Can, and we finally got them out on strike. After the plant settled the strike, we were fired. They wanted the agitators out, and we were agitators. To tell you the truth, my Communism at that time was all mixed up with my love affair. I was not a member of the Party. She was a militant Communist. I was in love with her, but she was not in love with me. I was just convenient—I wrote leaflets. I finally got tired of living with Karl Marx, and in the summer of 1934 I caught a freight. I ended up in a ding camp in San Luis Obispo, where they had hot showers."

The camp in San Luis Obispo was on a vast private estate. Gibbons and the other transients built roads and bridges for the owner and were paid by the federal government—five dollars a month, plus tobacco, work clothes, and meals. Gibbons swam in the Pacific, dug clams, caught fish, and began to develop a lifelong metaphysical fondness for islands and the sea. He and other Communist sympathizers—an Englishman called London Fog, an Icelander called Whitey, an American named Sam—drifted together and discussed world revolution. One day, when they were fed sandwiches that consisted of two pieces of bread that had been dampened with gravy, they walked off the job,

shouting, "We want better food!" When Whitey tried to get the whole camp to strike, he, Gibbons, Sam, and London Fog were jailed. They managed to get off a telegram to the San Francisco office of the International Labor Defense, which, in Gibbons' words, was "a non-Commie organization that was to the left of the American Civil Liberties Union and defended many Commies." An I.L.D. lawyer came to help them. They were given suspended sentences, with the provision that they leave San Luis Obispo County. Gibbons went to Seattle and joined the Army.

When his hitch was done, he worked in Seattle and Puyallup (near Tacoma) as a carpenter, a surveyor, and a boatbuilder. He formally joined the Party and became a district organizer, or "messenger boy from higher up to the local level." There were about fifty members in his district. He worked with front organizations like the American League Against War and Fascism, and he picketed Japanese ships that were hauling scrap iron out of Seattle. "We picketed the ships because we thought scrap iron would go into munitions and come back at us." He married a girl named Ann Swanson, and they had two sons. (One of them is now an electrician in Albuquerque, and the other is an airman in Vietnam.) Gibbons and his wife caught crayfish in Washington lakes and sold most of the catch. They also gathered and sold dewberries, and, just for themselves, they collected salmonberries, blackberries, raspberries, salal berries, serviceberries, sea urchins, crabs, clams, mussels, moon shells, lamb's-quarters, purslane, wild mustard, and camass ("very much a local wild food, a sweetish and smooth-flavored bulb"). During those years, he gave more time to his political activity than to his work, and more time to wild food than to politics. When the Russians attacked Finland in 1939, he resigned from the Party. "I couldn't jump through hoops. It was the peace-keeping part of Communism that had interested me. I wasn't

working for any foreign power. I was working to improve things right here. When the Russians attacked Finland, it was as if the Quakers, now, suddenly decided to support the war in Vietnam." With the coming of the Second World War, he went to Pearl Harbor, as a civilian but without his family, to build small boats for the Navy.

Gibbons and I stayed up fairly late that first night on the Appalachian Trail, in part because we could feel the curtain of ice-cold air at the front of the lean-to and we wanted to keep the fire going. In the course of a long and digressive conversation, I asked him why he had wanted to become a Communist in the first place, and he said, "A thousand men in a freight train, old women digging in garbage cans—the Communists were the only people who were trying to do anything about it. The Party was legal. I didn't see that it was decent to be anything but a Communist at that time."

"Did you believe in God while you were a Communist?"

"Yes, I guess so. I would have used a different vocabulary then. I believed in a higher right. For that matter, I'd have an awfully difficult time articulating my belief in God right now."

The perforated-steel bunks in the lean-to may have been designed to give maximum ventilation, and therefore coolness, to hikers in summer; at any rate, they gave some sort of maximum that night. Cold came up through each perforation like a separate nail. Around 3 A. M., choosing what turned out to be a warmer place, I took my sleeping bag and went out and lay down on the frozen ground. Gibbons snored right through the night, in comfort, in his bunk. At six-forty-five, when we got up, the temperature was seventeen degrees. Ice in the big pot was an inch thick. The fire was dead, and Gibbons was cheerful. He said, "Well, you couldn't say we're suffering like the early Christians." After we had rebuilt the fire, he asked me to husk a

couple of hundred ground-cherries. I threw the husks into the flames, one by one, and they blazed like ping-pong balls. He, meanwhile, brewed wintergreen tea, which was hot and delicious and left an aftertaste that was clean and fresh. We put in very little sugar, because Gibbons was anxious that the subtle essence of wintergreen not be lost. We ate red wintergreen berries in lieu of orange juice or grapefruit, and they were like small mints and had the same effect as the tea. Then he stewed the ground-cherries, which were flavorful and went down very gratefully, as Gibbons might have put it. That was the entire breakfast, and it was all we needed after the heavy dinner of the night before. We were in the fourth day of the trip, and we had not felt hungry after any of the meals we had had, nor were we likely to from then on, for that noon we were going to introduce flour and baking powder, and, that evening, bacon. Before we left the campsite, I cracked and shelled a cupful of hickory nuts and stowed them away while Gibbons hung a mirror on an eave of the lean-to and shaved, for the first time since leaving home. He tried to comb his hair, which was standing almost straight on end, and he seemed to be in even better spirits than he had been in the day before. He said that he almost felt ready to keep on going, foraging across the land indefinitely.

During the morning, we made a fairly long detour to buy the supplies we needed, and we rejoined the trail just before lunch. Gibbons talked all morning about breads, cakes, and muffins, and he told me that wild-rose-petal jam is outstanding in crêpes. We had lunch beside the trail. Gibbons mixed a batter with the flour and baking powder, and into it he put the cupful of hickory nuts and a large gob of mashed persimmons. Neither then nor as the trip continued did I ever see him measure anything, nor did he once fail in his eye for proportions or in his considerable understanding of the unstable relationships between time and flame. He said not to worry about the per-

simmons in the batter, and he was right. Pan-baked, they gave a
sweet and quiet flavor to the persimmon-and-hickory-nut cakes
he served that noon. We both stuffed ourselves on them and, at
my request, finished the meal with wintergreen tea.

It had been a clear morning, with the temperature going up
into the middle thirties, but now the sky darkened quickly and
a light rain began to fall. We had intended to forage that
afternoon. Instead, we went on to the nearest campsite and
took shelter. We felt smug, because our previous foraging had
more than taken care of our needs; we had plenty of food and
could avoid the cold rain. When we had a fire going and were
getting warm and dry, I asked Gibbons what was the longest
time that he had ever lived on foraged food. His answer was
three years. As we sat there looking out at the rain coming
down through a stand of tall white pines, he told me the story
of those years.

In 1946, he found himself alone in Hawaii without a job and
without much inclination to find one. His marriage had been,
as he termed it, a casualty of the war, and he had learned that
his wife did not want him to return to Seattle. He was some-
thing of a casualty himself, he said, because he had become
debilitated by alcoholism. During the previous five years, he had
built and repaired boats in Pearl Harbor until a time, near the
end of the war, when a hospital ship tied up at the pier where
he was working and medical corpsmen needed three full days to
remove all the maimed young men whose arms, legs, and faces
had been blown away. Soon thereafter, Gibbons became a
conscientious objector and asked to be released from his obliga-
tions to the Navy. He was told that he could work as an
attendant in a mental hospital if he preferred, and he did so
until he complained strongly about the way some patients were
being treated—as when he saw a powerful hose turned on a
man who was locked in a barred cell. Gibbons was fired. He

tried boatbuilding for a time as a private contractor, and failed. After struggling within himself over what seemed to be poor prospects for building a sound future, he decided to shelve the future and become a beachcomber in the South Pacific. He soon found that he might almost as easily have secured an appointment as a United States envoy to Tahiti. It took money and contacts to become a beachcomber in the South Seas. For example, islands that were under the control of the British or the French required all beachcombers to register and to post sizable bonds. Permits were needed for beachcombing on islands under the military control of the United States. Gibbons decided to do his beachcombing in the Hawaiian Islands, where no one cared. He bought classified space in the Honolulu *Advertiser* and described himself as a writer who would exchange yard work and maintenance work for a place to live. A deal resulted, and soon he was living beyond Diamond Head in a hut that had a thatched roof and siding of matted coconut leaves. The hut stood under a kamani tree that had a limb spread of eighty feet and released frequent showers of kamani nuts (Indian almonds). He gathered, among many things, guavas, thimbleberries, ohelo berries, coconuts, wild bananas, figs, dates, wild oranges, breadfruit, papayas, mangoes, fish, crabs, turtles, and panini (the fruit of a Hawaiian cactus). In season, he always had baskets of pineapples in the hut, for Hawaiian pineapples are grown to fit machines and those that do not fit the machines are often left in the fields. He ranged the islands hunting wild pigs, wild cattle, wild goats, wild sheep, and axis deer. At one point, he became so successful at trapping and selling fish and lobsters that he almost lost his status as a beachcomber. He cooked over homemade charcoal and lathered himself with homemade coconut soap. He made swipes, the quick-fermented liquors of the islands—pineapple swipes, panini swipes. And he gave wild luaus, at which people drank,

danced, sang all night, and ate crayfish cocktail, crab salad, broiled lobsters, charcoal-broiled teriyaki venison steaks, wild beef, roast boar, palm-heart salads, avocados, seaweed, guava chiffon pie, passion-fruit sherbet, and mangoes covered with whipped coconut cream—all at a cost to the host of no dollars and no cents. He served the food on banana leaves.

When he had been living in the hut for a couple of years, he applied for admission to the University of Hawaii, and entered as a thirty-six-year-old freshman. He majored in anthropology, studied creative writing as well, and won the university's creative-writing prize. Student life gradually drew him away from the hut and ended his full-time beachcombing. He worked part time for the Honolulu *Advertiser* and made up crossword puzzles in the Hawaiian language, although he could not speak it. "That's no trick," he told me. "There are only twelve letters in the Hawaiian language—seven consonants and five vowels." In 1948, during a summer session at the university, he met a schoolteacher named Freda Fryer, who had come to the islands from Philadelphia. She, too, was divorced. They were married a year or so later. Together, they made an exhaustive effort to find a church they could agree upon, and eventually they decided to join the Quaker Meeting. "I became a Quaker because it was the only group I could join without pretending to beliefs that I didn't have or concealing beliefs that I did have," Gibbons told me. "I could be completely honest. I'm not very orthodox." Before long, they moved to the island of Maui, where they both taught—she kindergarten and he carpentry and boatbuilding— in the Maui Vocational School. Gibbons had been given custody of his two sons, who had lived for a time with his mother in Albuquerque, and the boys joined him in the islands. He gathered more wild food on Maui than he had on Oahu, he told me, for he had more people to feed. He kept a banana calendar. He walked the woods, made notes on the condition of

ripening wild bananas, went home and marked his calendar, and returned for the bananas when they were ripe. He took his wife for long, rugged hikes in the Maui brush. She worried about centipedes and scorpions while he looked for wild pomelos and wild oranges. Week in and week out, he brought home so much wild food that they had to throw at least half of it away.

The rain stopped, or nearly, and Gibbons and I had dinner— huge, steaming mounds of winter cress with interstitial bacon, and stacks of oyster mushrooms. Winter cress is as excellent a green vegetable as there could ever be. It is tender, it has a mild and pleasant flavor that is somewhere between watercress and spinach, and it is in season from late fall until early spring. Italian Americans harvest it voraciously, Gibbons said, but most people don't even know it exists. After dinner, he reached up to a bough of one of the tall pines and gathered several hundred needles. He put them into a pot and poured boiling water over them. After steeping them for perhaps five minutes, he poured out two cups of white-pine-needle tea.

In the morning, at six-thirty, the eastern sky through the pines was orange red. The temperature was twenty-nine degrees. We decided that such a splendid day deserved to start with more white-pine-needle tea. It had in its taste the tonic qualities of the scent of pine, but it was not at all bitter. I had imagined, on first trying it the night before, that I would have a feeling I was drinking turpentine. Instead, I had had the novel experience of an outstanding but unfamiliar taste that was related to a completely familiar scent—a kind of direct translation from one idiom to another. As we stood by the fire drinking the fresh morning tea, Gibbons said that in the pine needles he had used there was about five times as much Vitamin C as there would be in an average lemon. For the rest of that breakfast—the best

one of the trip—we had persimmon bachelor-bread covered with maple syrup (made from the remains of the maple-sugar block) and a side dish of sautéed dandelion roots. "My God, I have enjoyed the dandelion roots on this trip!" Gibbons said. While I was cleaning up the pots, he wandered around in the woods and found a witch-hazel bush in bloom. He called to me to come and see it. Witch hazel sheds its leaves in the autumn, and then, when the forest around it is bare and winter is close, it blooms. Gibbons was excited by the find. He said that a drink of witch-hazel tea was thought by American Indians to be nearly as stimulating as a draught of rum, and he suggested that we have some for lunch. The blossoms are yellow and look something like forsythia blooms. We ran several branches through our fingers and stripped them clean.

Gibbons and I left the Appalachian Trail that morning, and, having recovered his Volkswagen, we foraged overland, slowly and miscellaneously and for the sheer pleasure of it, in a generally southerly direction. He seldom went faster than twenty-five miles an hour, but the ride would have been only slightly more dangerous if he had been driving blindfolded. As the beautiful countryside spread out before him, with all its ditches and field fringes and copses of nut trees in the sun, his eyes were rarely on the road, and he wove back and forth across it, scudded past stop signs, ignored approaching traffic, and nearly overran ten or fifteen tractors. Meanwhile, he read the land as if it were language—dock, burdock, chicory, chickweed, winter cress, sheep sorrel, peppergrass, catnip—and where something particularly interested him he stopped. We had no immediate need of all the things we gathered that morning, but Gibbons, having found them, could not pass them by. He showed me how to winnow dock seed and said that dock is a relative of buckwheat. We sat in a field and ate wild carrots. He found a wild asparagus plant—just so that I could see it, for it was out

of season. We gathered brandy mint, walnuts, winter cress, watercress, dandelions, sheep sorrel, chicory, and the fruits of staghorn sumac. Once, when we were working our way along a roadside ditch opposite a farm, a woman came out of the farmhouse and craftily went to her mailbox (nothing there), the better to observe us at close hand.

Gibbons greeted her, and said, "We're just trying to find out what kinds of weeds grow here."

After she had gone back to the farmhouse, I said to him, "If you had told that lady that you were looking for something to eat for lunch, she would have thought you were crazy."

He said that would not have bothered him, but that he had learned to avoid saying he was looking for food, because when he did so people tended to feel sorry for him and to insist that he go into their houses and have a hot meal.

Angling this way and that on the old crown roads of Adams County, we came, as we had hoped to, at lunchtime, to the battlefield at Gettysburg. We stopped in a wooded cul-de-sac between two pylon monuments to Berdan's U.S. Sharpshooters. The unseasonably cold weather seemed to be gone; the temperature that noon was fifty-seven degrees. The sky was three times as blue as it had been for weeks. There was a warm breeze. Oak leaves rattled in the trees, and the leaves of other trees covered the ground and formed drifts, in places a foot deep. Gibbons went into the woods, picked up a rock that weighed at least seventy-five pounds, and carried it to a patch of sunlight, where we established a walnut-shelling factory—shell buckets, meat buckets, reject buckets—and produced a cupful of walnut meat in twenty minutes. We introduced cornmeal at that lunch, and the menu was black-walnut hush puppies and witch-hazel tea. The hush puppies, hot and filling and pervaded with the savory essence of walnut, made the second-best lunch of the trip (we still had one to go). The witch-hazel tea smelled

like a barbershop, stimulated nobody, but was agreeably mild in taste. Gibbons said that its flavor had a faint hint of eucalyptus and that he didn't like it. I liked it well enough, but after the white-pine-needle tea it seemed quite ordinary. As we were leaving the battlefield, Gibbons stopped beside a long row of cannons and dug up a cluster of wild garlic.

Rain—a really heavy rain this time—came in the middle of the afternoon, and ended the warmth of the day, and the foraging as well. We drove north, intending to stop for the night, and to have our final dinner of the trip, in a state park. We had been riding without conversing for a while when Gibbons cleared his throat and said, "Come listen to this little tale about the lowly, humble snail. He doesn't think, as on he labors, that he is better than his neighbors, nor that he is a little god; he knows he's just a gastropod." He kept going in this vein at some length—"False pride is never his asylum; he knows Mollusca is his phylum"—and then he explained to me that he frequently writes "biological verse," and publishes it in prose form. He also said that some of his serious verse has been published in the *Friends Journal,* and that in his long search for his own phylum as a writer he had tried all kinds of things and had spun some wild tales, such as a novel he once began about spacemen returning to earth after a thermonuclear tragedy and trying to forage wild food in the wasteland. I asked him if he thought he would ever start another novel, and he said he hoped to, but that, even with regard to his wild-food writing, his mind was forever swaying on a shaky fence between confidence and fear. He went on to say candidly that this sort of vacillation was characteristic of him generally, and that he didn't mind telling me now that he had even been afraid to start out on this trip because he had had no confidence that he could bring it off. He said he had been haunted for as long as he could remember by a sense of fraudulence, and thought that he had created failure

for himself time after time in hopeless servitude to this ghost. It had been all he could do to weather the success of his published books, even though he had also been haunted for years by a desire to find himself as a writer. He said he imagined that some kind of desperate restlessness arising out of these cross-winds had made him leave Hawaii in 1953.

From the fall of 1953 through the spring of 1954, he taught at a Friends school in New Jersey, and then he moved to a six-hundred-acre farm in Greenfield, Indiana, where he became a co-founder of what he hoped would be a large agriculturally based cooperative community. "I was hot on intentional communities at that time," he said. "I had studied them, and we had even considered joining specific ones in New Zealand and Costa Rica. In Indiana, I wanted to create a community that would produce its own food." The community started on perhaps too narrow a base, having a charter population of five. The other four were Gibbons' wife, his partner (whose family owned the farm), his partner's wife, and his partner's child. Gibbons developed a truck garden, and explored the area's ample varieties of wild food, but his partner spent all his time raising corn. "The corn was being bought by the government and stored until it rotted," Gibbons told me. "We were getting nowhere, so I decided to go." Before he left, he became concerned about a thirteen-year-old boy whose father and two older brothers were in prison. The boy's future was in the hands of an Indiana court. Gibbons got the court's permission to take the boy with him, and the boy lived with Gibbons and his wife for five years as a foster son. Gibbons spent most of that time at Pendle Hill, a Quaker study center in suburban Philadelphia, where students from all over the world enroll to do private study, to write theses, and to take courses under teachers such as Henry J. Cadbury, a retired professor from the Harvard Divinity School, and Howard H. Brinton, the leading American

authority on Quaker history. Pendle Hill is itself a kind of co-operative community, and Gibbons became a member of the staff, taking responsibility for the maintenance of the grounds and buildings, and cooking breakfast for everyone every day. He also went to Cadbury's and Brinton's lectures and took courses in Bible, literature, social studies, philosophy, and writing. He fondly remembers Pendle Hill as "a hotbed of pacifism and peacemongers." Experimentally, he grew pokeweed in a basement there, in the hope that he could serve bleached poke to the others. They didn't like it.

Gibbons went on to tell me that in 1960 his wife volunteered to support him through her teaching for as long as he needed to write—and do nothing but write—until he was satisfied that he had won or lost his long conflict with that particular genie. "Freda pushes me, and I resent it sometimes, but I couldn't get anywhere without the pushing," he said. "She is quick and simple, and I am complicated. No matter what situation she finds herself in, she can rise to the occasion and do the sensible thing, and, of course, I'm not like that at all. She doesn't like to forage, and when I come home with wild food she sometimes says, 'Euell, could you please leave that stuff on the back porch?' Yet she supported me for two years while I wrote my first book, and it never would have been written without her." They moved from Pendle Hill to an old farmhouse at Tanguy Homesteads, a rural interracial cooperative community near Philadelphia. Within a year, he had produced *Mr. Markel Retires*, his novel about the schoolteacher who retreated into a world of wild food, and another year was required for *Mr. Markel* to be boiled in three waters and utterly metamorphosed into *Stalking the Wild Asparagus*. Gibbons had been hesitant to try a straightforward handbook of wild food, mainly because several of them existed—Nelson Coon's *Using Wayside Plants*, Oliver Medsger's *Edible Wild Plants*, sections of the Boy Scout

Handbook, and, most detailed of all, *Edible Wild Plants of Eastern North America*, by Merritt L. Fernald, Reed L. Rollins, and Alfred C. Kinsey—the same Alfred C. Kinsey who attracted a much wider audience with reports on sexual behavior. Gibbons had never been fully satisfied with any of the wild-food manuals, however. Fernald, Rollins, and Kinsey, in Gibbons' view, had written a "dry list" and may not have tried out some of the recipes they suggested. "I can't believe they ever cooked skunk cabbage," he told me. Gibbons gathered, cooked, and ate everything he wrote about, and he rejected some foods that had been generally reported to be edible because he had found them unpalatable. "I have never successfully eaten arrow arum," he said, to give me an example. "Same with golden club. Both of them prickled my throat and burned my mouth." He sent wild food to Pennsylvania State University for analysis of its nutritive values. He read *The Journal of Lewis and Clark*, *The Journal of George Vancouver*, the observations of Captain John Smith on wild food, and the work of other early observers. He read ethno-botanies of the Iroquois, the Abnaki, the Menomini, the Cherokee, and other Indian tribes. Then, as he wrote, he included his own experiences with the plant he was discussing, gracefully and relevantly weaving his autobiography into his work. When *Stalking the Wild Asparagus* was published, it quickly established him as the master of his field—which shook him up no end.

(I was to make a visit, some weeks later, to Tanguy Homesteads, and to find that while Gibbons was doing his research for the book he was a wild Hans Christian Andersen to the children there. He fed them the foods that he tested in his kitchen, took them fishing and foraging, and one day showed them twenty-five wild foods growing within a hundred feet of a supermarket. Gibbons has been gone from Tanguy for five years now, but the children there still collect meadow mushrooms, still make cattail-flour muffins, and, at his invitation, regularly

visit him in Troxelville in the summertime. "Without the common weed, Euell wouldn't have his career," one child said to me. I also learned that Gibbons had run for Thornbury Township constable on the Democratic ticket while he lived at Tanguy, but his campaign ended in failure.)

Gibbons moved to Troxelville in December, 1963, but he had owned his house there for some years, having noticed in the *Friends Journal* an ad offering, for five thousand dollars, a farmhouse on eleven acres, with a peach orchard and a stream. He has let the peach orchard go wild, preferring the cornucopian wilderness that has now grown up among the old trees. There are a hundred and eleven houses in Troxelville. Most of them are on one street and are as close together as houses in Manhattan, and their fronts abut the sidewalks. Gibbons' house is one of the few that are remote from this compact center. The town looks European, clustered like a walled village, with miles of open land surrounding it. The country is Pennsylvania Dutch, and the people are burghers. "People have a sort of tolerant attitude toward me there," Gibbons said. "However, it took my neighbors a long time to decide that I wasn't completely crazy." (After the trip, I asked a young man in Troxelville what he thought of Gibbons' fondness for unusual foods, and the fellow said, "It's O.K., if that's his interest, but to me a weed is a weed." Several doors down the street, an old man who was sweeping the sidewalk told me proudly that Gibbons had once made violet jelly for the entire town.) Gibbons' home freezer usually contains items like fresh-frozen day-lily buds, frozen seaweed, Birds Eye lima beans, Pepperidge Farm bread, frozen gooseberries, and hickory nuts, which are easier to crack when they are frozen. Next to one another on the kitchen shelves are things like Decaf, Bisquick, dried elder blow, rose-hip jam, and boneset tea. Gibbons pays taxes of seventy-five dollars a year on his Troxelville property, and he also has to pay something called an Occupation Tax. When he told the assessor

what he does for a living, he was listed as a part-time day laborer.

Few people in the Troxelville region are Quakers, Gibbons told me, and many of the old and frequently grand meeting houses in that part of Pennsylvania are now nearly empty on Sundays. He and his wife go to meeting at Bucknell University, in Lewisburg, twenty-five miles away. "In meeting, of course, if anyone is moved to speak he speaks, and college professors are almost always moved to speak," he said. (A couple of weeks later, I asked one of the professors for his view of Gibbons, and he said, "People are supposed to speak when the spirit moves them. Sometimes we think Euell *plans* to be moved. Sometimes he speaks like an anarchist in meeting. He has no faith in existing institutions and says that he has no use for institutions that are killing the spirit of society." Other members told me that Gibbons has "religious depth and insight to an amazing extent" and that "he's been inspired, and he is inspiring at times, but he's not like a preacher preaching down." After meeting, people sometimes thank Gibbons for sharing his thoughts and say to him, typically, "That just spoke to my condition.")

At seven that last evening of the trip, the rain was still humming on the roof of the Volkswagen, and Gibbons and I decided that it would be pointless to try to cook in a state park. As a campsite, we chose instead a motel in Mechanicsburg. After we had registered, we unloaded our luggage, and, in the room, we spread a tarpaulin on the floor and sorted things out. Then we put in a request for ice. When it came, we opened the door only enough to get the ice bucket through the crack, since we were both somewhat self-conscious about the appearance of the room. On one of the beds were several ground-cherry plants, loaded with ripe ground-cherries; a wild carrot; a big, airy, fernlike wild-asparagus plant (a souvenir for me), full of berries; and a deadly poisonous jimsonweed, heavy with seed-pods (I wanted to take that home, too). On a bedside table

were nutpicks and hunting knives. The Coleman stove and the cooking pots were on the bathroom floor, and on the bathroom shelves were salt, oil, wild garlic, and the hammer. Mounds of wild food were spaced out on the tarp. The large outdoor thermometer that we had been using throughout the trip was hanging by a loop of string over the wall thermostat. The temperature indoors was seventy-five degrees. We opened the windows. Gibbons took the red fruits of the staghorn sumac and soaked them and rubbed them in a pot of cold water. After sweetening the water, he poured sumac-ade into glass tumblers, over ice. "This has no food value, but it's a nice sour drink," he said. It tasted exactly like fresh lemonade.

Gibbons set me to work peeling Jerusalem artichokes while he carved chicory crowns. In a market in Gettysburg, we had foraged two porterhouse steaks as a climactic salute to the Susquehanna River and the Appalachian Trail. We had also bought some butter, and the dinner as a whole consisted of buttered mashed Jerusalem artichokes, buttered oyster mushrooms, buttered chicory crowns, porterhouse steak rubbed with the wild garlic of the Gettysburg battlefield, and a salad of watercress, sheep sorrel, brandy mint, salt, oil, wild garlic, and red wintergreen berries. The glistening greens dotted with red berries provided an extraordinary variety and balance of tastes, and I have never encountered a salad anywhere that was more attractive or delicious than that one. The chicory crowns had much sharper overtones than the dandelion crowns we had had, and, while good in themselves, served most significantly to put the steak into relief. The steak was excellent and was made trebly so by the taste of the chicory in apposition to it. Gibbons said, "People have forgotten how to use bitter things."

At breakfast, the penultimate meal, we introduced eggs, and Gibbons made a fine wild omelette containing winter cress, watercress, and wild garlic. We had bacon as well, and penny-

royal tea. Then we packed up and headed north across the mountains toward Troxelville. The first ridge was Blue Mountain, and from it we could see, about fifteen miles away, the level ridgeline of the next one, Tuscarora Mountain. Between these two was a valley so rich with dairy farms and wooded streams that there had to be, somewhere in it, an incomparable lunch. Slowly, we foraged toward Tuscarora Mountain, passing up practically everything—wild mustard, day-lily tubers, bearing hickories, poke, chicory—in a selective search for excellence. We had crossed about two-thirds of the valley when Gibbons finally stopped. From the car, he studied a colony of small plants that were growing beside a barn. "Mallow," he said. "Let's go see if they're any good." Roughly one out of ten of the plants was heavy with seed-bearing discs, and it was these that Gibbons was looking for. Each one was round, had wedge-like segments, and, although it was only a third of an inch in diameter, remarkably resembled a wheel of cheese. Gibbons said that mallow fruits are almost universally called doll cheeses but that around that part of Pennsylvania people often call them billy-buttons. We went over to the farmhouse to get the permission of the farmer, who said, "Those billy-buttons are no good to me. Take all you want." The picking was slow, and we needed about twenty minutes to get a pint of them.

Across the rest of the valley, nothing of particular interest presented itself, and soon we were moving uphill through hardwood forests on Tuscarora Mountain. The climb became quite steep. Going around one hairpin curve, which Gibbons was somehow attending to with his peripheral vision, he suddenly swung off the road and stopped. Below us, on the inside of the curve, hanging prodigally over a ravine, were hundreds of thick bunches of wild frost grapes. They were as densely concentrated as grapes in a vineyard, probably because they had little room to expand into from such a difficult purchase on the

cliffside. The vines were sturdy and about two inches through. They supported us easily, and, out over the ravine, we filled bags and buckets with grapes. Then we drove on up the mountain.

At the summit, there was a turnout area, with a plank table under a stand of oaks. The ridgeline of Tuscarora Mountain is so narrow and its sides are so steep that we seemed to be standing on a wall two thousand feet high as we looked down on either side at villages, rivers, and farms. That day was as extravagantly out of season as most of the preceding days had been, but this time with sunshine and warmth. The temperature there on the ridge was seventy-one degrees. Gibbons lighted the stove and began to cook a large potful of grapes in a little water. He cooked the mallow cheeses in water, too, and as they simmered the fluid around them took on the consistency of raw egg white. "These are the fruits of round-leaf mallow," he said. "If you cook the fruits of marsh mallow like this, the same sort of stuff comes out. The original marshmallows were made from it. Now there is no more marsh mallow in marshmallows than there are Hungarians in goulash." He stirred the doll cheeses in their clear, thick sauce. "I used to do a lot of foraging with a friend of mine who was a vegetarian," he went on. "He was an Oriental, and a vegetarian for religious reasons, and he would not eat eggs, or even gelatin. I once made a Mayapple chiffon pie for him, using seaweed for gelatin and mallow instead of egg whites." When the grapes had simmered for a while, he strained them into another pot, sweetened the juice, and thickened it with flour. After draining the mallow cheeses, he stirred butter into them. Then he served lunch—buttered mallow cheeses and wild-frost-grape flummery. The mallow cheeses were both crunchy and tender, and their taste was more delicate than the taste of any cultivated vegetable I could think of. The frost-grape flummery, deep in color, was quite similar to

a Scandinavian fruit soup, and it was filling. Each of these dishes could have been a flourishing entry on any luncheon menu in any restaurant anywhere at all that noon, but on a mountaintop, with hundreds of square miles of forests and valleys falling away in two directions, they were served in an atmosphere appropriate to the attainments of the greatest living wild chef.

We moved on into the second valley, and followed an indirect route to Troxelville, so that we could stop again and weigh ourselves. From notes, we made sure that we were wearing exactly the same clothes that we had been wearing when we weighed ourselves at the outset, which was not difficult, since we still had them on. We found that I had gained eight ounces. Gibbons had gained two pounds.

Fifty-two People on a Continent

1 9 6 6

Late in 1962, in Kordofan Province in the Republic of the Sudan, two men of the Kababish tribe shot and killed eight members of a tribe called the Meidob. They also stole five of the Meidob's camels and two hundred of their ewes. The killers were eventually arrested, and they were tried, in the shade of a huge tree, by Mohamed el Mubarak Ahmed el Medani, province judge of Kordofan. The judge sentenced them to death, and they were hanged. This was not satisfaction enough for the Meidob, and Meidob tribesmen began to raid, plunder, and kill Kababish. The Kababish struck back just as hard, and it appeared that an eternal feud had begun. Peacemakers from neutral tribes eventually stepped in and suggested that the Kababish pay a thousand pounds to compensate the Meidob for their original loss. The Kababish agreed, but then paid nothing.

Bloodshed continued. So, toward the end of 1964, a great tent was erected in the desert near Malha, a village five hundred miles west of Khartoum, and four thousand square feet of carpeting were placed over the sand inside. In the interest of justice in the western Sudan, nearly a hundred nazirs and sheiks, representing all the important tribes in the provinces of Darfur and Kordofan—an area larger than Texas—sat down together. As nomadic, camel-raising people, the Meidob and the Kababish annually spend time in both Darfur and Kordofan, and the bloodletting between them had long since become an inter-provincial problem. On their rugs in the great tent, the sheiks and nazirs sat in a somewhat parliamentary manner, in eight long rows, four on one side and four on the other, facing across a central aisle. At one end of the tent was a mass of retainers and lower sheiks. At the other end was a long table, behind which sat the principal officials at the meeting. The presiding officer was the military governor of Darfur, Brigadier General Zein el Abdin Hassan el Tayib. Ranged on either side of him were Suleiman Wagealla, civil governor of Kordofan; El Tijani Saad, civil governor of Darfur; Hashim Hassan Abdulla and Youssif el Mufti, district commissioners in the two provinces; Abdulla Mohamed Ibrahim, Kordofan's commandant of police; Ahmed el Sharif el Hashmi, Darfur's commandant of police; Judge Mubarak el Medani; Dafalla el Radi Siddig, district judge of the High Court of the Sudan; and Carroll W. Brewster, of Ridgefield, Connecticut, editor of the *Sudan Law Journal and Reports*, who had come to Malha at the request of Judge Mubarak el Medani, so that the meeting in the desert not only would be recorded but would include someone from the headquarters of the national judiciary, in Khartoum.

The nazirs and sheiks were dressed in tobes and jibbas—the loose, swirling dress of the Arab. Brewster was wearing a bush jacket, tan drill trousers, and a pair of moccasins from L. L.

Bean, Inc., of Freeport, Maine. He is a handsome fellow of upper-medium height, solidly built, with thick eyebrows and sharp blue eyes. In another setting he might have been a striking figure, but in that assembly he was made fairly inconspicuous by the magnificent people about him. No leaders anywhere, in Brewster's opinion, could have more physical presence than the nazirs and sheiks of the Sudan. Nearest to the High Table sat the king of the Meidob, and directly across from him was the nazir of the Kababish. Each was surrounded by several sheiks of his tribe. Across the aisle, they acknowledged one another with predaceous stares.

Brewster, at the time, was twenty-eight. A graduate of Phillips Exeter Academy, Yale University, and the Yale Law School, he had been working in the office of a United States District Court judge in New Haven when, in 1962, he had accepted an offer of employment from the government of the Sudan. While the British governed the Anglo-Egyptian Sudan, as it was called, from 1899 to the end of 1955, there had been virtually no law reports written. In the six years following Independence Day—January 1, 1956—only a few small volumes of law reports had been produced by the law faculty of the University of Khartoum. Sudanese judges, meanwhile, had no other published precedents in Sudanese law. Whereas an American judge has something like twenty-five thousand volumes to turn to for help in coming to a decision, a Sudanese judge, in the absence of law reports, had little more to rely upon than his university education, a personal file of the cases that he himself had previously decided, and his sense of fair play. Sudanese judges had to depend almost entirely on the second and third of these resources, because legal education in the Sudan is based upon rote study of English lawbooks, and cases involving inhabitants of Kent or Cambridgeshire tend to have little relevance to cases arising in, say, Blue Nile Province or Kor-

dofan. With no way of putting their hands on one another's previous decisions, judges in different parts of the Sudan were deciding things differently. Lawyers were in the habit of collecting their own cases in private files. But there was no court reporter, no organization, no central ganglion for the recording of developing events in the law. Meanwhile, with the country only a few years old, any judicial decision of importance was potentially a basic element in the common law of the Sudan. The government recognized the need for an ordered record, and reasoned that a well-trained American lawyer, familiar as he would be with law reports, could establish a system of collecting and editing, which could be taken over, after two years or so, by Sudanese successors. By the end of 1964, Brewster had spent more than two years collecting law cases from every part of the country. He had already published the two volumes of the *Sudan Law Journal and Reports* for 1961 and 1962, which was all that he had originally come to the Sudan to do. He had, however, by then become not only enthusiastic but evangelistic about his work, and before he gave it up he would also publish volumes for 1963, 1964, and 1965. In all, he produced some fifteen hundred pages, covering every important judicial opinion that was handed down in any Sudanese court during those years.

Brewster first heard of the position in the Sudan through the administrators of a program that has been developed at the Massachusetts Institute of Technology and is designed to place highly qualified young men in just such specific civil-service jobs in Africa. Over the past six years, this unusual international effort, called the Fellows in Africa Program, has sent fifty-two carefully selected people to that continent. About a quarter of them have been lawyers, and the rest have had graduate degrees in management or business administration.

Brewster had arrived in Khartoum on September 1, 1962, to

become the only foreign member of the Sudanese judiciary. It happened to be the steamiest time of the Sudanese year, with the daytime temperature averaging around a hundred and ten degrees, but Brewster wanted to show that he was worthy of his hire, and within six weeks he had read two thousand cases from files in Khartoum, seeking decisions that were significant enough to publish. He read not only 1961 and 1962 cases but also every case he could find that had been decided since independence, and when he came upon particularly important ones, he included them in the reports he edited. Next, in order to further his sophistication in Sudanese law, he went through the judiciary files hunting for cases that had been decided during the Anglo-Egyptian years. When he found opinions by British judges that seemed to have continued relevance in the modern Sudan, he referred to them in the reports as well. Writing headnotes and critical annotations to accompany the judges' opinions, he contributed about twenty thousand words of his own to each volume of the *Sudan Law Journal and Reports.*

The law of the Sudan is written and recorded in English, but trials are conducted in Arabic. Within six months of his arrival, Brewster had learned enough colloquial Sudanese Arabic to enable him to go almost anywhere without much of a language problem. By this time, he had fairly well filled himself in on all the vintage law cases he could find in Khartoum. He had also turned up everything of interest in the private collections of judges and lawyers there. The principal remaining sources of material were the files of the various provincial courts, from which he would get more than half of the cases he eventually used. He wrote to more than a hundred judges asking for the records of old cases. Only one judge responded, and he sent only one case. So Brewster began to travel, usually in a British Commer truck from the government motor pool—a high-slung vehicle with oversized tires and exceptional durability, built to

endure the deserts and semi-deserts of the area. The Sudan is the largest country in Africa, and two miles out of Khartoum, in any direction, the roads become informal. Brewster went to all the district and provincial courts—to capitals like Ed Damer, in Northern Province; El Fasher, in Darfur; El Obeid, in Kordofan; Wad Medani, in Blue Nile; Malakal, in Upper Nile; Juba, in Equatoria; and Wau, in Bahr el Ghazal. Returning from Juba to Khartoum, he rode a thousand miles down the Nile in a stern-wheeler. Because he was a member of the judiciary, he was put on a private deck and accommodated in a mosquito-proof enclosure equipped with a desk and writing supplies. The boat moved through the great swamps of the Sudd, where nothing but papyrus was visible to the horizon in every direction, while he edited the law reports of the Sudan.

Brewster's travels were not simplified by the fact that thousands of people had been killed as a result of the apparently insoluble conflict between the northern and southern peoples of the nation. The difference between the north and the south of the Sudan is the difference between deserts and rain forests, between Arabs and Negroes, between Muslims and either Christians or pagans. It is also the difference between descendants of slave traders and descendants of peoples who had been the victims of slave traders. American newspapers often describe the trouble in the Sudan as a religious conflict between Muslims and Christians, but basically, Brewster decided, the enmity is rooted in the racial domination of the Negro south by the Arab north. In the main, though, his work was not affected by this unrest.

In some of the outlying courts he visited, files were beautifully kept, but in most courts he discovered that the records of bygone cases had been irreverently tossed onto the floors of back rooms or into closets or other crannies full of dust and grit. Sorting through piles of records, he frequently found that the

principal exhibits in the old cases had been stashed away with the judges' opinions. The stacks of paper were lumpy with knives, spears, and swords, often crusted with dried blood. "I found it a hundred per cent engrossing to sit down in some law court way out in the desert and read through the records of all the legal disputes that had taken place in that area since independence," he said later. "Eventually, I read all the cases decided by the High Court, all the cases decided by the province courts, and almost all the cases decided by the district courts between January 1, 1956, and the end of 1964."

As often as he could, Brewster sought out nazirs, sheiks, and other tribal chieftains, who sit as judges in the native courts and actually try four out of every five cases heard in the Sudan. His reports include few cases from these native courts, since the more professional courts take over at the appeal stage, but he needed to understand the native courts and tribal magistrates if he was to understand the process of law in the country. Now, at the gathering near Malha, he realized that, with the exception of Judge Mubarak el Medani, no one present knew more of the sheiks and nazirs in the tent than he did. Seated next to the king of the Meidob and his surrounding sheiks, for example, was Nazir Mohamed Temsah, of Kordofan. Brewster had known Mohamed Temsah for two years and had frequently been a guest in his house. Only two nights before, in fact, Brewster, Judge Mubarak, and Judge Dafalla el Radi Siddig had been camped in the desert when another party of travellers approached them and they heard Nazir Mohamed Temsah's tympanic voice call out, "El Car-role!" This was Brewster's first name in Arabic. The nazir and Brewster embraced vigorously for three or four minutes, then began to catch up on the news:

"You are welcome."

"You are welcome and so are your people."

"How is your health?"

"Thanks be to God, well."

"God bless you."

"How is your health?"

"Thanks be to God, well."

"God bless you."

"How are your camels?"

"Thanks be to God, well. How are your camels?"

"Thanks be to God, well. How are your cattle?"

"Thanks be to God, well."

And on they went, through every living thing that could possibly be of importance to either of them. Mohamed Temsah, whose name means Mohamed the Crocodile, is the nazir of the Dar Hamid, a tribe of two hundred thousand people. Brewster had first met him at Bara, in Kordofan, where Mohamed Temsah was acting as one of three judges in a multiple-murder case. The nazir had cemented their friendship by inviting Brewster to breakfast one morning and giving him the raw liver of a sheep that had just been killed. Brewster had eaten it as if it were a boiled egg. Mohamed Temsah had been the first to call him El Car-role.

Nazir Hassan el Tom Ali el Tom, of the Kababish, staring brutally at the king of the Meidob, was also a friend of Brewster, who had visited his portable palace. Just beyond Nazir Hassan el Tom sat Nazir Mohamed Fadlalla Eleazar, of the Kowahla, whom Brewster had also known for the better part of two years. Brewster and the Nazir Mohamed Fadlalla had first met near the oasis at Umm Badr, when Brewster had gone to that part of the Sudan to attend a trial. The nazir, his grass hut surrounded by a sea of camels, worth hundreds of thousands of dollars, had sat Brewster down on a priceless rug and offered him a bowl containing more than half a gallon of camel's milk. Brewster drank it all. The nazir then offered him the entire raw liver of a camel, which had been torn out of the

camel's interior no more than a minute earlier. Brewster picked it up in both hands. It weighed about five pounds. Holding it like a slice of watermelon, he ate it in half an hour, while Nazir Mohamed Fadlalla and half a dozen other men watched him appreciatively. To wash down the camel liver, the nazir gave him a cup of water from the oasis. Brewster, who had never seen an oasis before, had imagined something other than the shallow mud lake at Umm Badr, which was full of camels and cattle, standing knee-deep in mire. The water in the cup was grayish-brown. He drank it down. The nazir embraced Brewster and decided that he was *shadeed*, a word that means virile, robust, courageous, indomitable—in sum, like a nazir. He took Brewster outside, sent him off on a camel for a tour of the encampment, and later took him back inside and gave him another half gallon of camel's milk. This time the milk had been flavored with onion juice. Brewster and the nazir talked about all kinds of things, from the Egyptian troops in Yemen to the news coverage of the B.B.C. And the nazir wanted to know all that Brewster could tell him about the Negro revolution in America.

Next to Nazir Mohamed Fadlalla Eleazar, in the tent at Malha, sat Sheik Gasmalla Fadlalla Eleazar, his brother. There was something enviable about Gasmalla Fadlalla, and this, as Brewster had learned earlier, was that he had only two responsibilities in the world—to look brave at all times and to be overpowering in the eyes of women. His brother was the leader of the tribe, which was a one-man job. Sheik Gasmalla Fadlalla enjoyed the glories of sheikdom without having to bother with the work. He had a rich sense of humor and a commanding air of abandon. Writing home about him, Brewster noted, "He has three wives and countless concubines; and he looks brave as hell to me. So I guess he is successful in life." Like his brother the nazir, Sheik Gasmalla Fadlalla was impressed by Brewster's

gastronomic good taste, but he worried—or, anyway, he said he worried—that Brewster would perish on returning to American food.

At one time or another, Brewster had encountered many of these camel-raising western tribesmen in Khartoum as well as in the provinces, and one such meeting had been a memorable reunion with Nazir Mohamed Fadlalla. Khartoum is the payoff point on the annual nomadic circuit. Once a year, the tribes trek to Cairo to sell their camels—a round trip of about twenty-two hundred miles. Modern monetary policies being what they are, the tribesmen can no longer get Egyptian gold in return for their animals but have to accept a credit from Barclays Bank. After returning to the Sudan, they stop off at Barclays branch in Khartoum, where they are paid in Sudanese pounds. The tribesmen are fairly original in the way that they collect and divide their money. The nazir and nine or ten of the principal sheiks arrive outside the bank, and the sheiks sit down on the sidewalk while the nazir goes inside with a suitcase. After a while, the nazir comes out, opens the suitcase, and takes out thick packets of Sudanese ten-pound notes, heaving one packet after another into the laps of the sheiks. When the suitcase is empty, he goes back into the bank. The tellers fill the suitcase up again. The nazir returns to the sidewalk and deals out more money to the sheiks. After the nazir has made four or five trips between the sidewalk and the bank, each sheik has in his lap the capital on which his particular subdivision of the tribe will live for the coming year. Some Sudanese in Khartoum look down on this as the behavior of unspeakable rubes. Brewster defends the tribesmen, who, he says, "have the great qualities—courage, honor, imagination. They are a noble race of men. Anyone who shows them the slightest bit of condescension appears to them to be a fool." He was therefore embarrassed for some of the clerks in the judiciary one day when Nazir Mo-

hamed Fadlalla, having just tossed several hundred thousand dollars to a sidewalkful of sheiks, stopped at the judiciary to call. The nazir was, admittedly, pungent. As he moved up the stairs, he called out, "El Car-role! El Car-role!" in a voice that nearly levelled the building. Some of the scrubbed urban clerks in the judiciary had quite noticeably recoiled. Brewster asked them to serve tea for all and to come meet Nazir Mohamed Fadlalla Eleazar. He says that they soon recognized what a great man the nazir was.

Now, looking over the assembled sheiks at Malha, Brewster also reflected that at one time or another at least half of them had given him sheep. Whenever he visited a sheik, he would be given a sheep, or two or three sheep, as a sign of the sheik's respect for the judiciary and as a token of hospitality. Brewster had, in fact, classified many of the sheiks present as one-sheep sheiks, two-sheep sheiks, and three-sheep sheiks. Sheik Gasmalla Fadlalla, for example, was a two-sheep sheik, and Nazir Mohamed Temsah was a three-sheep sheik. Brewster had gratefully taken the sheep with him as he continued his journeys, eating them on subsequent nights with various travelling companions. Nazir Mohamed Fadlalla Eleazar was in a category by himself. He had killed a camel in honor of Brewster, and was therefore a one-camel sheik. There was also a sheik in the tent who, when he had first seen Brewster, a year or so earlier, had rushed up to a judge whom Brewster was travelling with and, pointing at Brewster, asked if the British were back. Any number of the sheiks present had entertained Brewster over bowls of *marissa*, a tribal beer that has the color of oatmeal, the consistency of milk, and the impact of gasoline. Brewster never developed much of a taste for *marissa*, but he had been eager to try it, because, he explains, "Practically every criminal case in the Sudan begins, 'The defendant had a bowl of *marissa*. . . .' "

If Brewster had a remarkable breadth of acquaintance among

the nazirs and sheiks, he was no less familiar with the judges and provincial governors who were sitting beside him. He had been a travelling companion of both judges and a guest, from time to time, in the home of Judge Mohamed el Mubarak Ahmed el Medani. The other attending judge, Dafalla el Radi Siddig, had only recently returned to the Sudan from Yale, where he had taken his LL.M. at the Yale Law School. Brewster had persuaded him to go there, had arranged a scholarship for the purpose, and, through the United States Embassy in Khartoum, had obtained travel money for him. When Brewster arrived in the Sudan, no member of the Sudanese judiciary had been to an American law school, nor were any interested in going. The quality of American law, he felt, had been misevaluated there, largely because of a general prejudice, on all levels, against American education. However, Brewster had given Judge Dafalla el Radi Siddig a copy of Justice Benjamin Cardozo's *The Nature of the Judicial Process*. The book altered the judge's opinion of American law. He decided that a year at Yale would be a fine idea, and he became the first of eleven judges for whom Brewster has obtained scholarships for the study of law in the United States.

On the first day of the gathering at Malha, nothing much happened except speeches by sheik after sheik. The gathering of the tribes, quite obviously, was less fratricidal than fraternal, as might have been expected in an assembly where the peace-makers outnumbered the disputants fifty to one. The speeches of the sheiks were marvels of syntactical architecture. The sheer splendor of the rhetoric—far though it may have strayed from the point of the conference—was so irresistible that the glint of murder gradually died out of the eyes of the Meidob and the Kababish. A genealogical-minded sheik delivered the day's most effective argument when he said how unthinkable it was that

deep friction should exist between these two brotherly tribes, since the king of the Meidob had actually been named for the father of the nazir of the Kababish, and the brother of the nazir of the Kababish had been named for the grandfather of the king of the Meidob. A hum of approval ran through the tent. The point had the magic of a great discovery. Everyone had more or less known it, but until then no one had thought of articulating it. The air was mellow as the first day's session ended, and it seemed clear that the peacemakers would be able to proceed quickly to a formal agreement. The content of this agreement was what particularly interested Brewster. Beyond fulfilling his duties as a representative of the judiciary and an adviser to the officers and judges, he was there to record the conference for the *Sudan Law Journal and Reports*. It was not the sort of thing that one would expect to find in a law report, but he felt that in the Sudan it was important to have a written precedent showing how an inter-tribal feud could be settled.

Each night during the conference, which lasted a week, Brewster ate with a different sheik, and each night a ram was ceremonially laid out before the guests, its nose pointed toward the east. After its throat had been cut, the guests would ritually step over it on their way in to dinner. The meal would begin with *maraa*, a first course analogous to oysters or shrimp. *Maraa* is the raw lungs, stomach, liver, and other entrails of the just-killed ram. Brewster developed a taste for *maraa*, but, in general, he preferred what followed—the rest of the ram, beautifully roasted—and it often disappointed him that his hosts pressed so much *maraa* upon him that he was quite full by the time the mutton was served. After dinner the first evening, Brewster joined an audience of about two thousand people listening to the songs of an entertainer known as a Flatterer, who sang lyrics he invented on the spot to describe, one after another, the notables before him. Coming to Brewster, he sang, "Tonight

here is El Car-role, who came all the way from America to work for the judges, and he eats *maraa* and rides a camel like an Arab and climbs a mountain like a goat." This sort of thing apparently plucked right at the main string of the desert sense of humor, for it filled the air with laughter.

The following morning, when all the nazirs and sheiks had assembled in the tent as before, the presiding officer asked Nazir Hassan el Tom Ali el Tom, of the Kababish, when he intended to pay the thousand pounds that he had once agreed to pay to the Meidob. Everyone looked at Nazir Hassan el Tom Ali el Tom, who stood up, and, offering no comment, reached into the folds of his garments and drew out a packet of money that might easily have been mistaken for the manuscript of a very long novel. Skimming a hundred ten-pound notes off the top, he laid them on the table before Judge Mubarak el Medani. Then he stepped across the aisle and shook hands with Melik el Tom Mohamed el Sayah Jami, King of the Meidob, and he did so with such grandeur that one might have thought it was the Meidob, and not the Kababish, who had been forced to pay up. Then began a great debate, which resulted in the agreement that Brewster had come to record. "The debate was so magnificently eloquent that it cannot be adequately described," Brewster wrote later. "Sheik Ibrahim Ali el Tom, uncle of Nazir Hassan el Tom, was spokesman of the Kababish. He stood there, the folds of his white robe rolling over his shoulders and crossing in front, his face black as coal, his eyes permanently bloodshot, his posture straight, strong, and relaxed, his gestures modest and firm—altogether a mighty appearance. He spoke clearly, making each point carefully, giving illustrations where they helped."

The agreement that eventually evolved dealt mainly with lost and stolen animals, since incidents having to do with animals had been a principal cause of friction. "For example," Brewster

noted, "if a Meidob loses a camel and believes it to be in the Dar (or territory) of the Kababish, he organizes a *fazaa* (a *posse comitatus* on camelback) to track the animal. The *fazaa* must get permission of a representative of the Kababish, at the tribal border, to enter Dar Kababish. With permission secured, the *fazaa* continues to track the camel. If the track enters a village and does not leave, the leader of the village must pay the price of the animal, or produce the thief. Once a track leaves a village, the village is no longer responsible. When the discussion had reached this point, I suggested a method to mediate disputes should it not be agreed that a particular camel's track left a village. My suggestion was brushed aside. Trackers are so skilled that no one had ever heard of such a dispute. I later learned of a case in which a camel was traced and found two months after it made its tracks. And I have since heard a tracker describe a camel, from its tracks, as female, unloaded, pregnant, and blind in the left eye—because grass had been nibbled on the right." The agreement also provided, among other things, for combined tribal courts to try cases involving members of both tribes, and it set up rules whereby each tribe could water and pasture its animals in the other tribe's Dar. All in all, it was a document worthy of two tribes whose leaders had been named for one another's father and grandfather. It appeared, in detail, with commentary, in the 1964 *Sudan Law Journal and Reports*. After a hundred and twenty relatively small claims had also been heard and settled, the gathering at Malha dispersed slowly, for it takes one Arab at least ten minutes to say goodbye to another, and each of a hundred sheiks had to bid farewell to the other ninety-nine. "*Maasalaamah, Allah ya berikfik. Maasalaamah . . .*"

Long before Brewster went to the Sudan, the job that needed to be done there had been carefully scouted, and a painstaking

search had been conducted for appropriate candidates to fill it. What sets the M.I.T. Fellows apart from other American scholars, observers, volunteers, and technical assistants who have gone to Africa in recent years is that the M.I.T. Fellows have been taken on as actual employees of various African governments, not as mere advisers or consultants, and—a matter of equal importance—the African governments have paid them the full going rate for beginning civil servants. This usually amounts to something under three thousand a year, and, with a liberal splash of Ford Foundation money, M.I.T. makes up the difference between that sum and the kind of starting salary that a young man with an LL.B. or an M.B.A. can expect these days in the United States. The program also takes care of moving and travel expenses—a sizable item, especially for those who take wives and children to Africa, as more than half of them have done. All this expense is considered necessary to make the jobs as attractive as possible to the best talent, but those who run the program do not in any sense want to offer the Africans a gift. The criterion is that a government must want a man badly enough to pay for him. Most Americans in Africa are responsible to the United States government or to some American university or organization. The M.I.T. Fellows, as salaried civil servants, are responsible only to the governments that employ them. They regard M.I.T., for the most part, as a kind of specialized employment agency, and while the Institute keeps in close touch with them, it does not attempt to control their work. As Assistant Secretaries, say, in African governments, M.I.T. Fellows have often negotiated across the table with representatives of the United States, and their loyalty to their employers has proved remarkably strong.

It is hardly surprising to find that a program resulting in a highly creative use of both money and talent did not have its origin in the ruminations of a committee. It is, in fact, almost

wholly the product of the mind of one man. His name is Carroll Wilson. He is a tall and quiet man in his mid-fifties, with quick, dark eyes. He has the title of professor, and he conducts a number of seminars in the Institute's Sloan School of Management, but he is not really a college professor in the usual sense. For one thing, he has no advanced degree, and, for another, he did not join the M.I.T. faculty until 1959, after more than twenty years in government and private industry. He is a believer in the value of a restless career—if necessary, at the risk of financial uncertainty—and his own considerable number of former roles, commitments, projects, and enthusiasms have, in a sense, culminated in the Fellows in Africa Program, which probably could never have come into existence without his accumulation of friends and his easygoing familiarity not only with governmental leaders on several continents but also with the various Comstock Lodes that support such programs. Wilson's career actually began at M.I.T., where he joined the administrative staff after his graduation, in 1932. The revelation that, as an undergraduate, he went around Cambridge in a raccoon coat and a Cadillac phaeton astounds his present colleagues, who regard him as an eminently reserved and rational man, with a manner that is the antithesis of flamboyance. "The coat and the Cadillac are not to be taken as a particular indication that I had any interest in social life," Wilson says. In any case, he knew enough people to be elected an officer in the student government and, in that capacity, he came to know the men who ran M.I.T.—most notably the physicist Karl Compton, who was then its president. In Wilson's senior year, Compton reorganized M.I.T., establishing four major schools—science, engineering, architecture, and the humanities—and creating the post of assistant to the president, to be filled by a new graduate. He gave Wilson the job. In the office next to Wilson he installed Vannevar Bush, who had

been a professor of electrical engineering and was now the dean of the engineering school and a vice-president of the Institute. "Bush and Compton were a marvellous team," says Wilson. "Compton was interested in new things and new ways of doing them. He said 'How?' rather than 'No.' He saw the merit in things. At times, he was naïve. Van, on the other hand, was a tough hombre who did tough jobs." Compton gave all those around him the feeling that they possessed an almost limitless capacity for moving ahead—a confidence that a good idea could always be turned into something tangible.

In 1940, when Bush went to Washington to run what became the Office of Scientific Research and Development, he made Carroll Wilson his executive assistant. When the war ended, Wilson, then thirty-five, became secretary to a board of consultants, including David Lilienthal, J. Robert Oppenheimer, and others, that first sketched out a United States atomic-energy program. When the Atomic Energy Commission was finally created, he became its first general manager. He served for four years, through a tangle of security cases, loyalty hearings, and internal battles between Lewis Strauss and his fellow-commissioners, and into the era of the hydrogen-bomb debates. After nine years in private industry, he was invited to join the faculty at M.I.T. While he was thinking the invitation over, he went to Africa as a travelling observer for the Council on Foreign Relations, of which he had long been a member. The Council had been given a Carnegie grant enabling selected members to go to Africa and look and learn. Travelling through the center of the continent, Wilson began to wonder how all the new nations then approaching independence were going to be able to manage the business of government without trained administrators in the middle and lower strata. Even when knowledgeable people were available on the top levels, there simply were not enough qualified candidates for all the lesser

jobs, and these were the ones that involved most of the day-to-day responsibilities and decisions. The idea for the Fellows in Africa Program began to form only vaguely on that trip, however. Returning to the United States, Wilson accepted the offer from M.I.T. and started off with a seminar called Government Policy and Business Decisions. He had sixteen students, all of whom were enrolled in the graduate program of the Institute's School of Industrial Management. A couple of them, who wanted to find jobs overseas, asked him if there wasn't some quicker and better way to do it than by joining the overseas division of some huge American company. Wilson knew what they were talking about. "I was somewhat oppressed by the difficulties young people faced on long ladders of progression," he says. This, of course, was even truer of domestic jobs than of overseas ones. Educated young people have often considered the assignments given them by big organizations to be roughly equivalent to cutting out the backs of cereal boxes. "During the war I saw people doing just terrific things at a youthful age," Wilson goes on. "The structured quality of American business nowadays makes it hard to find a fast track for young talent." He asked the students in his seminar how many of them would want to go to work in Africa if he were to arrange it. Twelve of the sixteen raised their hands. Some of them said later that they had done so almost wholly because Carroll Wilson thought a job in Africa was a good idea. "I went to the Ford Foundation," he says. "I outlined the program. I asked for travel money for job hunting. And I asked them to agree to support the program if it developed. Damned if they didn't say yes."

Wilson went straight off to Tanganyika and looked up the Minister-designate of Finance, in whose home he had spent an evening the previous summer. Tanganyika was only a few months away from independence. Wilson arranged two jobs in the Treasury in Dar es Salaam. He found another promising

post in the Uganda Development Corporation, in Kampala, and five more in Nigeria. Returning to Cambridge, he picked for each job the man he thought best suited to it. "We don't want missionaries," he has said. "We have always shunned the uplift type." In the following years, as the program expanded, Wilson kept returning to Africa to look for opportunities in new places, and he found them in Sierra Leone, the Ivory Coast, Ghana, Kenya, Togo, the Somali Republic, Zambia, and the Sudan. He even placed three men on the French-speaking, British-governed, operettic island of Mauritius. In considering jobs and countries, one criterion he established at the outset was that the political environment should be, in his words, "sufficiently interesting and rewarding." It didn't have to be tranquil, but for contributions of the sort his M.I.T. Fellows could make, it needed to be less unsettled than it was in the Congo, for example. He rejected other countries for other reasons. "In Malawi, I went to see Dr. Hastings Banda," he said recently. "Everything is decided by Dr. Banda. He didn't understand the program at all. He thought I was trying to sell him the kind of technical experts who select contractors." Wilson thought it would be pointless to look for jobs in Addis Ababa. "Hell, there are four thousand Americans in Ethiopia," he says. "They cancel each other out." Although Liberia, free since 1847, was hardly a newly independent nation, Wilson went to Monrovia to see if the Liberians could use any of his men. "It was the most depressing place I've ever been," he says. "Black colonialism at its worst." He quickly concluded that there was nothing for the M.I.T. Fellows there. In the main, former French territories were also unpromising, because their governments frankly did not want Americans. Africans in former French colonies tend to think and act like Frenchmen, just as Africans in former British colonies—often in spite of themselves—tend to think and act like Englishmen. Wilson felt, too, that when a Ministry or some other institution

offered a job to an M.I.T. Fellow, the institution had to prove that it had an important job to do. Finally, he considered the man who would be an M.I.T. Fellow's immediate boss. If he didn't seem to be the sort who would give ample responsibility to a subordinate, Wilson stopped right there.

On one of his first trips to Nigeria, Wilson met J. Daniel Nyhart, a Harvard Law School graduate who was spending two years in Africa on a grant to study development banks. When Wilson meets a potentially useful man, he moves quickly. Before Nyhart quite knew what had happened to him, he was on the faculty of M.I.T. helping Wilson run the Fellows in Africa Program. Partly because of Nyhart's influence, lawyers were added to the program, and the sources of new Fellows were widened to include the Harvard and Yale Law Schools. Fellows have also been recruited from the Harvard Business School, and, more recently, from the business schools of the University of Chicago and Indiana University. From the beginning, Wilson saw the program as a kind of pilot project, intended to help African governments fill what he has described as the "talent vacuum" in the years immediately following independence. The Sudan became independent in 1956; Ghana in 1957; and Togo, Nigeria, the Somali Republic, Mauretania, Mali, Niger, Chad, Senegal, Upper Volta, Dahomey, Gabon, and the Republic of the Cameroun in 1960. Sierra Leone, the Ivory Coast, and Tanganyika (now Tanzania) emerged in 1961, Uganda in 1962, Kenya in 1963, and Zambia in 1964. Wilson's program, beginning, as it did, in the autumn of 1960, could not have been more perfectly timed.

The jobs have been concerned, in the main, with economic development. For example, Michael Payson, with two Togolese colleagues and a U.N. economic adviser, conceived and wrote an economic-development plan for Togo. One of the specific

projects fostered by Payson, who is the son of a Maine legisla-
tor, was Air Togo, a new national airline, backed by private
American investors. He almost literally got it off the ground.
The line had one six-passenger Beechcraft, with a fairly monoto-
nous schedule—Lomé to Sokodé and back. Air Togo has since
extended its route a hundred miles to Sansanné-Mango, but
that will be it, for Togo will then be covered. The country is
three hundred and forty miles long from its northern border
to the Bight of Benin, and less than eighty miles wide. Arriv-
ing there in 1961, Payson soon became fairly close to President
Sylvanus Olympio, for whom he wrote speeches and articles.
Olympio also had him prepare the documents through which
Togo joined the World Bank, the International Monetary
Fund, and the International Development Association. In 1963,
just after Payson had concluded his M.I.T. tour and left the
country, Olympio was assassinated. When Payson returned
some weeks later on an assignment underwritten by the United
Nations, Air Togo offered him twenty thousand dollars a year to
become general manager. He went back to M.I.T., however, and
is now working on his Ph.D. there.

James Stoner, who is also working toward a doctorate at
M.I.T., was from 1961 to 1963 Project Development Officer in
the Ministry of Commerce and Industry in Dar es Salaam. The
most remarkable thing he did there was to handle the final
negotiations with the Italian oil combine, E.N.I., for the con-
struction of a refinery. The deal was the single most prickly
domestic political issue at the time, and Stoner, who was twenty-
seven, put it together, shuttling from Ministry to Ministry and
then to meetings with the Italians. The agreement, in his
words, "had some teeth in it for the country." Other things he
did were less momentous but, perhaps, more interesting. One
development problem involved a meerschaum-pipe factory.
"Meerschaum is a mineral deposit found in old ocean beds,"

Stoner explains. "The word is German, and means 'sea-foam.'
Technically, the stuff is a hydrous magnesium silicate. If you go
to Turkey, the Turks will tell you that they have the only
meerschaum deposit in the world. But there are extensive
deposits under the Amboseli Plain, on the Kenya-Tanganyika
border. The Tanganyika Meerschaum Company, Ltd., was in
trouble and asked for the government's help. Our govern-
ment—that is, the government of Tanganyika—took a position
in the company, a fairly substantial one, but nonetheless a
minority position. Sometimes the government amazed me. The
Tanganyika Meerschaum Company was completely on the
ropes; it would certainly have failed if the government had not
come to the rescue. Our problem was: What is a government's
role as a shareholder in a private company in which it does not
hold a majority interest? I suggested that the government take a
more active role. Tanganyika Meerschaum is now doing very
well. It provides jobs, uses local material, teaches usable skills,
and makes a quality product. It makes money, too, although
not much. You can get a Tanganyika Meerschaum pipe in
Cambridge, Massachusetts." Stoner grew up in Bronxville and
in the District of Columbia. He went to Antioch College and to
M.I.T. "The other project I worked on most was the Lake
Manyara Hotel," he recalls. "It was under construction, and its
funds had dried up. It had been started by a white hunter, on a
bluff overlooking the Rift Valley. Lions sleep in the trees there.
The white hunter's name was Russell Bowker-Douglass. After
he started his hotel, the trouble in the Congo came up, and that
shot the white-hunter business all to hell. Also, Bowker-
Douglass had a heart attack and after that couldn't do much
white hunting anyway. The government of Tanganyika had
already bought some shares in his hotel, and now Bowker-
Douglass wanted to sell us more. The problem was how hard a
bargain to drive. If you shaft somebody who is down"—the

former voice of the Tanganyika Ministry of Commerce and Industry here becomes somewhat ungovernmental—"then other people know they're going to get shafted, too. If you are too easy, you look like a clod. My Ministry had to battle with another Ministry over this. We felt we should help the white hunter. We did, in the end, and I guess I felt pretty good about it. I felt moral. The hotel has been expanded twice since then. The whole thing was good for Tanganyika. It showed that the government would help a private investor who was hurting. And the hotel itself was important to the country as part of the tourist circuit—you know, Kilimanjaro, Ngorongoro Crater, game parks . . ."

The island of Mauritius, forty miles long by thirty miles wide, is several hundred miles east of Madagascar, out in the Indian Ocean. Rand McNally desk atlases do not even show it. Seven hundred thousand people live there. One of them, until a short time ago, was Robert Norris, of Marshalltown, Iowa, who served as one of two investment officers in the government-controlled Development Bank of Mauritius. Norris went to Grinnell College, the University of Stockholm, and M.I.T. His wife is Swedish, blond, and quite pretty. She taught Mauritian women about birth control and herself gave birth to a child while she was there. "A development banker needs the foresight of an economic planner, the financial wisdom of a commercial banker, and the patience of a university professor," Norris says. He should know. Anyone who could move even a small development project forward on Mauritius could probably create a Tennessee Valley Authority almost anywhere else. If the island asks a question of the cosmos, it must be: How many conflicting races, nationalities, religions, and political philosophies can exist on the head of a pin? The richest people on the island are the French, who make up three per cent of the population.

They have been there for three hundred years, growing sugar, which brings in ninety-eight per cent of Mauritius's income from abroad. Hurricanes blow harder in Mauritius than anywhere else—a hundred and seventy miles an hour—and sometimes they blow down the economy in a few minutes. Another three per cent of the Mauritians are Chinese, half of them Roman Catholic, who stay behind closed doors and work twelve hours a day in hole-in-corner businesses. They are suspicious of everyone else, and everyone else is suspicious of them. About two-thirds of the people are Indians—half of them Muslim, half of them Hindu, all of them socialistically inclined, and all of them filled with hatred of the French. A quarter of the people are Creoles—a term that in Mauritius means descendants of some eight hundred thousand African slaves who were brought in by the sugar barons. The slaves' blood has mixed with all the colors of man, and the Creoles are strikingly good-looking people. A small group—too small to be expressed practically as a percentage of the population—are English. They are running the island. Mauritius has been a British possession since 1814. There are thirty-three newspapers in Mauritius— Mandarin newspapers, Cantonese newspapers, French newspapers, and one English newspaper. The Mauritian calendar is a checkerboard of public holidays, twenty-three in all, including the Queen's Birthday, Chinese New Year, Guy Fawkes Day, Id-el-Fitr, and All Saints' Day. (All this against a backdrop of jagged mountain peaks, gushing waterfalls, deep-green vegetation, and fertile red-earth plains.)

The Development Bank of Mauritius would like to create new industries and widen the base of the island's economy. One problem is that in business enterprises the Mauritian races almost never mix. The Coca-Cola bottling plant, for example, was started by a Franco-Mauritian, so Coca-Cola, on Mauritius, is a white man's drink. The Pepsi-Cola plant was started by a

Muslim Indian. On Mauritius, Pepsi-Cola is a black man's drink. There is one inspiring exception to the commercial immiscibility of the Mauritian races: The brewery, although it was built by a Franco-Mauritian, was from the start listed on the Mauritian stock exchange. Every sort of person bought shares. Everybody drinks the beer. Norris's chief contribution to Mauritius was to effect the establishment of a vegetable-oil mill that would be similarly pan-Mauritian. It may turn out to be the second-largest industry on the island. It was originally the joint concept of a Hindu landowner and a Franco-Mauritian sugar baron. Only a banker from a place like Iowa, working for the Mauritian government in a supra-political organization like the Development Bank, could have arbitrated the negotiations for such a partnership. Norris brought it off. The project has attracted investors from as broad a base of the population as the brewery did. The oil will be extracted from peanuts—or groundnuts, as they are known in Africa—that are being planted between rows of sugar cane, and so when Mauritius becomes independent it may not be starting out with what bankers call a monocrop economy.

The most noticeable characteristic of the M.I.T. Fellows in Africa is a contagious identification with the governments of which they are a part. They use "we" and "our" in any sentence referring to their respective countries, and they go on using these pronouns for months and even years after they return to the United States. Henry Thomas, a Princeton and M.I.T. graduate, wrote an impassioned letter back to M.I.T. from his desk in the Uganda Development Corporation, in Kampala, complaining that United States foreign aid to India was crippling the economy of Uganda, because India had been Uganda's best customer for raw cotton and now the United States was selling its own surplus cotton to India on more

favorable terms. A couple of passages from some of Thomas's other letters to Wilson show what has become of the Africa of H. M. Stanley and Allan Quatermain. "Went out after elephant over the weekend," he wrote on January 24, 1961. "All we shot was wart hog. Almost had a nice-sized kongoni, but, after an hour's tracking, had to give it up. Only other item of news is that I've been moved out of the Development Division and into the Executive Division, at the same time assuming the role of personal assistant to the chairman. . . ." A few months later, Thomas wrote, "I am quite pleased to report that I hit two oribi at fifty yards. First one killed instantly. I'll be having oribi steak tonight. Next weekend I'm off, with camera this time, after buffalo on our cattle ranch. Seems the tsetse fly is getting bad and they have to drive the game across the river. All this week and last we've been working furiously preparing a Development Loan Fund application. We're going to try to get them to guarantee a debenture issue on the New York market." Thomas, who is now with the International Finance Corporation, an affiliate of the World Bank, also described quite concisely the swift and ramifying way in which nearly all the young men in Wilson's program have taken to their African situations. "There is immediate responsibility here," he wrote soon after he arrived in Kampala. "Already I'm authorized to countersign checks drawn against a loan we're about to make to three engineers who want to expand into building native fishing boats, a very good and viable project. On Monday, I visit the Ministry of Mines in connection with a loan application for expansion and renovation of a tin mine (not so hot). I'm making little progress with our scheme to set up a soluble-coffee plant but am about to launch an African shoemaker on the dizzy road to success. The shoe factory will make fifteen pairs a day. In all, I can say that this is one hell of an interesting job. Still no signs of kalaazar, hyperpyrexia, schistosomiasis, diphthe-

ria, elephantiasis, trypanosomiasis, or yaws. Health and spirit strong. Good supply of whiskey." Thomas was twenty-five when he wrote that. If, instead of going to Uganda, he had gone to work for, say, the Chase Manhattan or the First National City Bank, it would have taken him at least five years to work his way up to the point where he could countersign a check, let alone shoot an oribi.

Once, when Wilson was passing through Entebbe, the United States Ambassador to Uganda complained to him about Douglas A. Scott, Princeton '56, Harvard Business School '61. "He acts as if he were working for Uganda," said the Ambassador. "He is," said Wilson. After thinking it over, Wilson decided that this was about the highest compliment his program had ever received. In Entebbe and Kampala, the bureaucratic word for native takeover of government positions is Ugandanization. Scott, who is tall and squarely built, and who grew up in Western Springs, Illinois, never managed to look particularly Ugandan, but in a sense he became as Ugandanized as the government itself. "We are part of the 'we's'," he once said, "and the American government and the U.N. are part of the 'they's.'" Scott worked in the Ministry of Economic Affairs and in the office of the Prime Minister. He was almost solely responsible for bringing in experts from other parts of the world. For instance, the United Nations Technical Assistance Board allocated about five hundred thousand dollars to Uganda for technical assistance over a two-year period. An expert costs about eighteen thousand a year. Scott had to figure out how many experts he could afford and then draw up a list—two hydrologists to study a lake basin, four broadcasting technicians, one fisheries expert, and so forth. The reason for requesting a fisheries expert was that Uganda had about four hundred small fishponds, and it was thought that if more fish could be raised in them, Ugandan children would benefit considerably from the

added protein in their diet. Carp do well in these ponds, so Scott made a specific request for a carp man, and the United Nations eventually found him one, in Israel. Scott had a nutritionist on his list, too, since about seventy-five per cent of the children in Uganda had worms, malaria, or stomach parasites. All experts did not come through the United Nations. To set up the basic framework of a national livestock industry, Scott had to decide which cattle-producing country to call upon. "Quite frankly," he says, with a note in his voice which suggests that he feels he may have done something un-Ugandan, "we turned to the United States for this."

In January of 1964, a three-man mission from Kenya arrived in Washington to negotiate a loan with the World Bank for the purpose of increasing the size of Kenya's tea industry. Kenya had been independent for about a month, and, as it happened, this was the first Kenyan mission to have come to the United States since Independence Day. Two of the men in the mission represented the tea industry, and one represented the Kenya government. The government man was Michael Roemer, of Bakersfield, California, who at the time was a Planning Officer in the Treasury in Nairobi. Though he was only twenty-six years old, he was quite experienced by then in finding the right sources of aid for Kenya. "The key to my job in the Treasury was the thinness of the organization," he explains frankly. "I was the lowest form of civil servant in the office, yet I was only one remove from the Permanent Secretary. Things were not only thin vertically, but horizontally, too. Only three people, of whom I was one, were doing development planning, development budgeting, and foreign aid. My function was to make sure that about four million pounds a year in aid was forthcoming. My boss—the man between me and the Permanent Secretary— was a very busy man. The dog work, the actual project ap-

praisals, would be done by me. We would sit down and decide how much money we needed, then find eligible projects. The appraisals were sometimes difficult. In Kenya, statistics didn't exist, and we had to invent a lot. Then we made application for loans."

The Kenya government's tea scheme was a kind of compromise between a large, efficient, central operation and one that would fulfill the political objective of encouraging small farmers. Tea is ordinarily a plantation crop—primarily because the leaves have to be processed within a few hours after they are picked. But the last thing Kenya wanted was more plantations. So the government created the Kenya Tea Development Authority, to build processing plants in the middle of clustered acreages of small tea growers. "The World Bank was the obvious source of money," Roemer says. "We thought it would be attracted to our project, because it was a nice tight one with a high return. We wanted to save the United States Agency for International Development for other things. Also, the U.S.A.I.D. likes hardware—even more than the World Bank. It also likes people to use its money to buy equipment in the United States. The United States is not a producer of tea equipment. The World Bank, for that matter, is not so big on agricultural schemes, either. It likes visible construction, visible results, sure things. A dam is fine. A road is good. A railroad is great. You can buy the equipment overseas, so the import content is high. However, in the Kenya Tea Development Authority the World Bank could get its finger on one organization. It liked this. A World Bank project-appraisal team spent a couple of weeks in Kenya, and then, not quite fast enough for us but pretty fast for the World Bank, they invited the Kenya government to send negotiators to Washington. When a representative of a small country gets to the United States, he does a lot of things other than his principal mission. I completed

arrangements for us to join the World Bank and the International Monetary Fund. I also made contact with A.I.D. I never ceased to marvel at the incongruity of my being there." Roemer eventually became so interested in economic development that he decided to become an economist. He had graduate degrees in both engineering and management, and now he is at M.I.T. getting a doctorate in economics. "I once thought that when I came back from Africa I would take a job in industry, but Africa broadened me enough so I was no longer interested in pure industrial pursuits," he says. "Jobs I could have had before I left were no longer interesting to me. This is both a strength and a failure of the program, I think. It creates dissatisfied people."

Roemer's successor in Nairobi is also an M.I.T. Fellow—something that Wilson has tried to let happen as infrequently as possible, since one goal of the program has been that its members be replaced by Africans. Michael Dixon, of Salt Lake City, Yale '62, Harvard Business School '64, demonstrated his familiarity with the intricacies of the Kenya government by showing up at the M.I.T. program's annual conference wearing a zebra-skin tie. He explained that Prime Minister Jomo Kenyatta wore a London School of Economics tie and Dr. Julius Kiano, the Minister of Commerce and Industry, wore a zebra-skin tie, and that he was a follower of Dr. Kiano. He went on to deliver a talk that showed him to have become as sophisticated in the field of foreign aid as Scott, Roemer, Thomas, and others who had preceded him in East Africa. "Aid from Peking is the simplest of all," he said. "They just credit a million pounds to your account and let you spend it any way you want. The World Bank is a little more difficult in its approach. . . ."

Professor Wilson has made trips to Africa each winter to hunt for good jobs. Nonetheless, some of the positions he has

lined up have inevitably fallen very wide of their promise. "If I find someone who is really stuck, I can often move him on or help him," says Wilson, who moved Robert Norris, for example, to Mauritius from Ghana—where the basically one-man government of Kwame Nkrumah seemed reluctant to give the M.I.T. Fellows any real work. Often a man whose original assignment has come to nothing will improvise a useful job to do. Tom Farer, for instance, arrived in Mogadiscio, the capital of Somalia, to find that he had no job at all. He was supposed to be legal adviser to the Foreign Ministry, but his contract had become lost in the bureaucratic machinery of the new government and consequently had never been approved. Farer saw the Prime Minister quite often, and on these occasions the Prime Minister would say, "Something must be done," but nothing was done. If Farer had gone home or been moved elsewhere, Somalia would have lost a considerable man. Wilson, in seeking lawyers for his program, had reasoned that the best young lawyers are chosen to be clerks for judges. From the Harvard and Yale Law Schools, therefore, he obtained lists of recent graduates who were clerking for judges. A high-honors graduate of Princeton and a former editor of the *Harvard Law Review*, Farer had been clerk-designate for Judge Learned Hand. After several unpromising weeks in Mogadiscio, Farer came to know General Mohamed Abshir, commandant of the police forces of Somalia—a five-thousand-man corps, which, says Farer, "is something like the F.B.I., the C.I.A., the Royal Canadian Mounted Police, and ordinary traffic cops, and then some." General Abshir, in more than twenty years of service, had been trained by the British and further trained by the Italians. He could speak English, Arabic, Italian, Somali, and Swahili, and when Farer met him he had just returned from a year of study in the Woodrow Wilson School of Public and International Affairs at Princeton. Largely as a result of his admiration for the

General and the regard that the General developed for him, Farer went to work for the police. First, he taught a course in criminal procedure and evidence to a class of junior officers, for in lesser crimes Somalian police serve not only as investigators but as prosecutors. He also taught criminal law. With another man, who was working as United Nations adviser to the Somalian police, he devised changes in the Somalian rules of procedure, which were based on Anglo-Saxon examples and did not always prove practicable in Somalia. According to one rule, for example, an accused person had to be brought before a judge within forty-eight hours—a difficult feat if the arrest happened to have been made two or three hundred miles by camelback from the nearest judge. "In that instance," Farer comments, "an effort to protect individual rights made the law unenforceable." The simple solution was to amend the code so that travel time did not count. With Abshir's permission, Farer began to teach the riot police karate. Selecting the ten most athletic-looking men in the two-hundred-man squad, he got up every morning with them at six and instructed them in Bando, the Burmese form of karate, which he had learned from a Burmese graduate student in the United States. Sports in general were not widely popular in Somalia, and Farer decided that something should be done about that, too. In 1963, Somalia had sent a team to the New Emerging Forces Games— a kind of underdeveloped Olympics—which were held in Jakarta. Somalia, in this milieu, had proved to be about as underdeveloped as it is possible to be—which was not surprising, since there were hardly any schools in the nation and no other organizations of the kind that usually foster sports. Farer therefore started something comparable to the Police Athletic League, beginning with sports that required very little equipment, such as basketball, track, and soccer. Moreover, he got the General to recommend a one-hour sports period each day

throughout the police system, because he thought it would be good for Somalia if the police and the civilians around them were to compete with one another on the athletic field.

Farer found Somalia to be a kind of natural democracy, despite the illiteracy and poverty of its people, most of whom saw so little money in their lifetime that the nation had no measurable per-capita income. Last spring, in an article in *Africa Today*, Farer wrote that although widespread literacy and moderate affluence are two of the classical prerequisites for democracy, "I know of few countries where the democratic process seems so vital." He continued, "One reason is the rooted egalitarianism of Somali life. It is pervasive. Even in that most hierarchic of institutions, the military, it persists. I taught a law course for the paramilitary police to men ranging in rank from sub-inspector through four higher ranks. I never witnessed the slightest sign of rank consciousness. This lack explains in part, I think, the absence of that divisive rancor within the officer class and between noncommissioned and commissioned officers that afflicts the armed forces of many countries and produces the endless succession of military coups for which such countries are notorious." Farer, who is now with the Wall Street law firm of Davis, Polk, Wardwell, Sunderland & Kiendl, has edited a book containing ten essays by members of the Fellows in Africa Program. "The Management Fellows do the concrete jobs," he has said. "But lawyers, picking up threads on their own, sometimes find more glamorous things to do."

Michael Christian, for example, a graduate of Harvard and the Harvard Law School, is currently working in the office of the legal secretary of the East African Common Services Organization, in Nairobi. This organization administers things like customs, income taxes, railroads, harbors, telephones, telegraph systems, and airlines jointly for Kenya, Uganda, and Tanzania. At an M.I.T. Fellows in Africa conference, Christian told his

colleagues about one fairly glamorous thread that he had recently picked up. Gold smuggling, he said, had become a big thing in East Africa. Gold from the Congo was moving through outlets in Nairobi and Mombasa in lots worth as much as a couple of hundred thousand dollars, and the smugglers were so adroit that the authorities were having trouble making arrests. Earlier in the year, an informer had sold the customs office information about the position of one smuggling exchange. "They needed a sort of stupid-looking American to go in and offer to buy this gold," Christian said. "I was the natural choice. Excited by *Goldfinger*, I got right into the middle of it before I began to realize that I might get hurt. I went into the den of thieves, as it were, and there was this wonderful, wonderful man who had about seventy-five thousand dollars' worth of gold. He had diamond rings on every finger. I was introduced as an American missionary from Tanganyika. Beforehand, I had told a customs officer, 'Don't be so stupid—nobody would ever fall for that.' And he said, 'If you look at our records, you will see that American missionaries are the natural choice as far as who is doing the big smuggling these days.' All I had to do was get my money out and get him to put his gold on the table. Then the police, in plain clothes, who were all around the place, could swoop in. Once you've put out seventy-five thousand dollars' worth of gold on a table, it isn't going to be moved. One guy could grab one bar and start running, but once it is all out on the table you are in business. I failed miserably, because I was given only ten thousand pounds in real cash, the rest in fake money. He kept wanting to see the money before he would put out all his gold. I would put a little of my money out, and he would get a little gold out there, but I never could get him to put out the rest. I kept saying to him, 'Look, I don't know who you are; I don't know who all these people are around here. I'm alone in this country. I want to buy the gold,

and I want to see it before I put my money on the table. I want you to put it right out there. Bring it from wherever you've got it.' He looked at me, you know, and, his fantastic face representing every crime in the world, he said, 'Sir, you're a man of God. You must be able to tell an honest face.' "

Christian, who is twenty-seven, explained to the conference that as part of his more usual duties he appears in court to defend the East African Railways. "Sometimes, there is a slight accident—never caused by the railway," he said. "Our engines get involved in collisions with other people's vehicles, which are negligently handled on the roads." He is the only American lawyer in the area. "I've never even seen an American court, except a traffic court," he said. "As a young lawyer in New York, you would get into court only in order to hand a motion in, or maybe take care of some little preliminary points, but I've been lucky enough to appear before the Supreme Courts of Kenya, Uganda, and Tanzania."

The summer conference at which Christian related all this was held in Sorrento, in a hotel built on a cliff high above the Bay of Naples. The first M.I.T. Fellows in Africa conference took place in Entebbe, which is set on a peninsula in Lake Victoria, but not even this background looked very exotic to people who had just spent a year in Africa. So, for the enjoyment of all, including half a dozen African officials who are invited each year, the conference was moved to Europe; it has been held in Évian and Mallorca, among other places. Wilson leaves details like conference sites to an assistant named Constantine B. Simonides, an imaginative Greek, educated at M.I.T., Boston University, and the Harvard Business School, who looks after much of the program's week-to-week administration. If the program itself is an admirably creative use of foundation money, Simonides' deployment of funds to provide

splendid settings for the conferences is, in its way, just as creative. Simonides likes lofty Xanadus clinging to precipices. He once chose a hotel in Athens, inevitably on a cliff edge —this one four thousand feet above the Attic plain. The language at the conferences sometimes gets heavy enough to walk on. The management types, generally dominant because they are the majority, offer even their most casual thoughts in terms of infra-structures, parameters, input, feedback, capital-output ratios, social overhead capital, and macro-economic approaches, while the lawyers, certain that their own armored rhetoric is as inspired as Shelley's, curl their lips.

The Fellows' wives accompany their husbands to these deluxe gatherings, and they have more than earned their way, for nearly all of them have worked at full-time jobs in Africa. Many have taught at schools or universities. One, a virologist, set up a tissue-culture division in the Central Pathology Laboratory in Dar es Salaam. This basic diagnostic process had not existed there before. Another, working as a secretary for several government Ministers, sometimes wrote letters in one Ministry in the morning, then crossed the street to another Ministry and answered her own letters in the afternoon. Still another taught psychology, pharmacology, bacteriology, and biology to fifty students. One worked as a small-loans officer, one as a nutritional consultant in pediatric clinics. Still another, whose name is Marian Schwarz, taught English literature in a college in Kaduna, Northern Nigeria. She also offered a course in West African history—the first ever taught in the college. Meanwhile, her husband, Frederick A. O. Schwarz, Jr., was revising the laws of Northern Nigeria. Schwarz, the great-grandson of the man who founded the most celebrated toy store in the United States, was educated at Harvard and the Harvard Law School. His title in the regional government of Northern Nigeria—F. A. O. Schwarz, Assistant Commissioner for Law Revision, Pupil

Crown Council, Inspector of Prisons—had a ring of Gilbertian hyperbole that belied the seriousness and importance of his work and the brilliance with which he performed it. During the ten years before Schwarz's arrival in 1961, Nigeria had been gradually evolving from a unitary political system toward a federal system with regional and national governments, similar to the political structure in the United States. Schwarz's job was to go through all the thickets of enacted legislation and to separate what was federal from what was regional. He then drafted amendments to the regional laws where necessary, in order to make them conform to the federal constitution. Moreover, although Schwarz was officially styled the Assistant Commissioner for Law Revision, there was in fact no Commissioner. He did the job by himself, ultimately writing three volumes of revised regional laws. He also prepared thirteen major amendments of the laws of Northern Nigeria, which required passage by the regional legislature. In one instance, having found that the region—under a law known as the Peace Preservation Ordinance—had the power to jail people without a trial, Schwarz prepared an amendment eliminating that power as unconstitutional. In another, he revised the Newspaper Act, whereby the region had what he felt to be an unconstitutional power of censorship over the press. He prepared an appropriate amendment. Of the thirteen amendments he wrote, twelve were passed verbatim and became part of the law of Northern Nigeria. He was twenty-six at the time.

Considered among these individual histories, the experience of Carroll Brewster in the Sudan seems to be less an accident of place and character than a product of the program that took him there. If Brewster, as much as anyone, illustrates the height of the possibilities of Professor Wilson's idea, he also illustrates the reasons for its general success. Brewster's accomplishments

in the Sudanese judiciary would never have been possible if he himself had not become, in a sense, Sudanese. His admiration for the people of the Sudan began with his own superiors and expanded through all ranks, classes, and tribes. More than anything else, he was impressed by the Sudanese preoccupation with character. In a stranger, he observed, the first thing a Sudanese would look for would be evidence of courage, honesty, and honor. Brewster, for his part, is frank and unself-conscious, open, full of humor, more than a little romantic, and always ready to move with enthusiasm into something new. He is the kind of person who sees the stories in the lives around him. Just as Africa at present is an amalgam of past and future, of tribal rites and development banks, Brewster in Africa was a transitional figure, with a trained twentieth-century intelligence and the spirit of a nineteenth-century explorer. After graduating from Yale in 1957, he had gone on to King's College, Cambridge, where he read history. Returning to the Yale Law School, he had become an editor of the *Yale Law Journal.* If, in a way, his African experience could be compared to a passage of H. Rider Haggard unexpectedly appearing in *Foreign Affairs Quarterly,* in other moments it might have been a page from *Foreign Affairs Quarterly* slipped into an edition of H. Rider Haggard. Among the things that Brewster came to understand and accept was what it means today to be a white man in the Sudan—to be considered, on sight, a notably inglorious being, presumably ungracious in manner and without morals or principles. This preconception was something he had to try to overcome, and he found that if he forgot his disadvantage even for a moment, he was vulnerable. Because he was the only white man in the judiciary, his career there would have been thought of as remarkable even if he had achieved far less. As it happens, however, he became so much a part of things that members of the Sudanese judiciary still regretfully mention the exact date—

December 7, 1964—on which he left the Sudan. "The judiciary was a wonderful place to work," Brewster says. "The Chief Justice, Mohamed Ahmed Abu Rannat, respected the independence of every man there. It is an exciting thing to work in a place where you set your own standards." His words acquire a kind of reverential sonority when he speaks of Chief Justice Abu Rannat. "Although it can be said about most institutions that generate speedily and effectively into greatness, about no institution can it be more truly said than about the judiciary in the Sudan that it is the lengthened shadow of one man," he reported at one M.I.T. summer conference. "The first Chief Justice of the Sudan, like the first American Chief Justice, has such great qualities of mind and character as are necessary to the gigantic task he has been called to perform. . . . The loyalty and devotion he commands in the judges under him is reflected in the phrase I have so often heard from high and low when a piece of his work, a decision he has made, or advice he has given, are discussed: '*Raies el Kadaa aazam ragil, Wallahi aazam fi Afrikia*'—'The Chief Justice is the greatest man, by God, the greatest man in Africa.' Anyone could walk in off the street and, without going past a secretary, present his grievances to the Chief Justice of the Sudan. I, like everyone else who worked for him, would have jumped in front of a train for the man."

Brewster differed from many of the M.I.T. Fellows in Africa in that his work depended to a very large extent on a precise and subtle understanding of the country he worked for. What his Sudanese colleagues most admired about him was his facility in coming to terms with the complexities of Sudanese law, which is partly Western, partly Muslim, and partly tribal, and is more a braid than a synthesis of these elements. "There was also tension between the common law of England and the civil-code law system of Egypt," Brewster explains. "The country

had, after all, been the Anglo-Egyptian Sudan." In Personal Law (marriages, divorces, wills, and so forth), a case in the Sudan is decided according to the law or custom by which those involved have lived. If they are Muslims, for example, the case is decided according to Sharia, the law of Islam. If they are Christians, English law is usually applied. If they are non-Muslim tribesmen, they are judged by tribal law. Thus, in Brewster's *Sudan Law Journal and Reports* for 1962 there is an article on customary law among the Aweil District Dinkas—law that is as much a part of the Sudanese legal system as any set of formal statutes. Dinka marriages are reckoned in cows much as American marriages are calibrated in carats. A forty-cow wedding is what in America would be called a big wedding. The size of a Dinka wedding can be a determining factor in legal problems that may arise later, most notably in cases of divorce, where the alimony reflects the original bride price. If a man commits adultery with another man's wife, he must pay her husband eight cows and two bulls. The Dinkas have another custom that is without a Western counterpart. After a woman has been found guilty of adultery for the fourth time, she is considered a harlot and no one owes her husband anything. If a man seduces an unmarried girl, it costs him only one bull. If she conceives a child, the price changes to one cow. The Dinkas believe that immorality on the part of a woman causes her death. The parent or guardian of a girl who dies can collect one bull from every man who admits to having seduced her.

There are countless tribes in the Sudan, each with its own customs, almost all of which the law respects, but at times a judge, creating the new common law as he goes along, reverses a decision of a native court in the interests of what he considers higher justice. The *Sudan Law Journal and Reports* notes, "The responsibility of an accidental death is traced by Dinkas far beyond the limits allowed by European standards. The Dinka

view is that the person who caused a series of incidents to take place which directly led to an accidental death is partly or wholly responsible for that death." A few years ago, in Yei District, a Dinka was sitting in a tree when another told him a joke. The man in the tree laughed so hard that he fell out of the tree and died of a broken neck. The man who told the joke was accused of murder. He was tried in a native court and convicted of culpable homicide. He appealed. The decision was reversed in a province court.

"About eighty per cent of all cases in the Sudan are decided according to local custom—unrecorded African common law," Brewster has estimated. "In certain tribes, a certain word will be enough of an insult to constitute grave and sudden provocation. In a country in which possession of water can be a matter of life or death, it is within the law to shoot a person who is found stealing water from the hollow trunks of the great tebeldi trees, which, as reservoirs, can hold as much as two thousand gallons. In most parts of the country, it is quite easy to try criminal cases, since all you have to do is ask the man whether or not he committed the offense, and he will tell the truth, even if it means his life. Mothers will testify against their sons, brother against brother. Westerners believe that they control their environment. Sudanese believe that their environment controls them. Some of the trickiest problems in Sudanese law involve the ownership of land along the Nile. You cannot understand a Nile land case without understanding how the river behaves. As it rises and falls in its annual cycle, fertile land in the riverbed is arable for seven or eight months, then disappears again beneath the water. One year a particular tract may fail to reappear, and the owner loses his land. Five years later, land appears again in that same place. Does the old owner still have rights to it? If he is dead, who does have rights to it? Perhaps an island has vanished under the flood. It reappears a

quarter of a mile downstream in slightly different form. Does the owner of the lost island own the new one?" Along the Sudan's seventeen hundred miles of the Nile, from Nimule to Wadi Halfa, these questions are decided by local custom, which may vary from town to town. The banks of the Nile also occasionally tend to swing back and forth, and, according to the custom that prevails in most places, as the riverbanks move, so does riverbank land. Everyone's property swings with the river. Even people whose land is some distance from the water are affected when the channel takes a turn in their direction. Properties near and far move like connected pieces of armor, in concert with the unpredictable water.

Some Sudanese believe in the existence of ghosts, and they also believe that ghosts have power to kill. "As an excuse for murder, anyone could say he thought he was killing a ghost," Brewster says. "There was a case like that in El Obeid. A wanted to make love to a woman, so he told B, who was also interested in her, to leave. B left. After a while, A left, too. B returned. B killed the woman. He testified later that he had concluded from the way she looked—all covered with dust and with her hair sticking out in every direction—that she had turned into a *baatiya*, or ghost, and he killed her in self-defense. The judge decided that he knew she was a woman. He was hanged. Can you imagine a Yale-trained lawyer being confronted with this set of facts? There was a *fekki* in El Fasher who sold a man a knifeproof charm. A *fekki* is, in a way, like a witch doctor or a medicine man. He is actually a purveyor of charms. The *fekki* in this particular case told his customer that if he wore his new charm no knife could kill him. The man picked up a knife and plunged it into his heart, killing himself. The *fekki* was charged with murder. He was acquitted, but he *was* found guilty of taking money under false pretenses."

Brewster once wrote about such cases:

A judge considering a case like this, or a *baatiya* case, must have some psychological understanding of the nature of the illusion. A judge handling the land-law problems of the riverine peoples must understand the rudiments of agriculture and the social organization that underlies present agricultural methods. These problems in customary law are problems that the common law has never faced before. The common law of the Sudan is now beginning to handle these cases and will be able to handle them successfully only if the judges are given the very broadest liberal education. In the Faculty of Law at the University of Khartoum, law is not thought of as a social instrument. I encouraged Sudanese judges to go to American law schools, where courses were available in related disciplines—subjects like sociology, economics, psychology —and, more important, where the approach to law was broad enough to utilize concepts from these neighboring fields.

It is hardly surprising, considering all the other ways in which Brewster exceeded his contractual responsibilities to the government of the Sudan, that he should have found time to give a course at the University of Khartoum. Using the cases he had collected, he taught criminal law to a class of forty or so students. About half did passable work, in Brewster's judgment, while eight did good work and two did superior work. "One of these wrote two examinations for me that would have received an A in criminal law at Yale," he says. "He was fat, pleasant, shy, and unkempt. He loaded his underlip with a mixture of snuff and tobacco, thus considerably limiting his ability to recite, but he handled the trickiest situations with compassion, power, and imagination."

On the morning of November 23, 1963, the day after the assassination of President Kennedy, Brewster was something over two hundred miles east of Khartoum, in Khashm el Girba, on a long journey through the east and north. He went into a

small store to buy provisions for a trip he was about to take down the Atbara River to the province court at Ed Damer. At this store building, which was made of mud and camel dung, members of the Hadendoa tribe liked to buy DDT, the only substance they had ever known that had the chemical power to subdue all the living creatures in their long and spectacularly billowing hair. The Hadendoa were Kipling's Fuzzy-Wuzzies, who broke the British square. They still wear three-foot swords as part of their conventional dress. Brewster bought enough food to last him for several days, and when the storekeeper had finished writing out the bill, he filled in its edges, all around, in black. Brewster asked him why he was doing that. The man looked up, surprised that Brewster did not know, and Brewster saw that he was crying. "*Aazam rajil fi el aard mate el ne-hardah,*" the storekeeper said. "The greatest man in all the world is dead today." Going down the river, Brewster was stopped in village after village by tribesmen of the Hadendoa, who would hold their hands open and apart, in the sign of death, and then step forward and embrace him. Much the same thing happened among the other tribes he visited. "Each night, a sheik produced a transistor radio for me to hear the news," Brewster wrote home. "An old Bisharine tribesman said to me that the true catastrophe was that Kennedy's son was so young, for it would be a long time before he could be the true leader." The schools of the Sudan closed. Business stopped. Nazirs and sheiks wept before their people. In Khartoum, the Chief Justice did not sleep for three nights.

Toward the end of his stay in the Sudan, Brewster could think of few Sudanese who had seen as much of the country as he had. Upon arriving in a new community, he would stay in the home of a province judge or a resident magistrate, where he would have coffee and talk, then have some more coffee and talk some more—almost always for a full day before literally

getting down to cases. The judges he stayed with were frequently quite young, about a third of them being in their twenties. In the Sudan, a graduate of a law school decides at the outset whether he will be a judge or a lawyer. After several years of apprenticeship, a judge is sent out to a provincial town—usually a place where he has never been and doesn't particularly care to stay. He spends two years there. Brewster tried to put a little spirit into the young judges wherever he went. "Let's get into my truck and go out and visit a chief," he would say. It was, after all, part of their job to supervise tribal courts.

As a member of the Sudanese government, Brewster was not a regular member of the American community in Khartoum. He did not, for instance, have the privilege of using the American swimming pool, beside which other Americans would sit and eat hot dogs and potato chips flown in by jet from New York. Once, at a party, Brewster was talking with William Rountree, the United States Ambassador to the Sudan, and Rountree asked him what he had been doing that day.

"Swimming," said Brewster.

"Oh? Where?" Rountree asked, a little sensitively.

"In the Nile."

It is the official view of the United States Embassy in Khartoum that Nile water can kill.

"Brewster," said Rountree, "as an ambassador and a diplomat, I have sent a lot of bodies home during my career. I don't want to send yours."

"Mr. Ambassador," said Brewster, "if I die here, I want to be buried here."

Brewster drank the Blue Nile from the Ethiopian border to Khartoum, and the White Nile from the Ugandan to the Egyptian frontiers. "Living with the Sudanese, you weren't about to drop tablets into the water all the time," he says—a somewhat surprising statement in the light of the fact that his

mother happens to be Clinical Professor of Pediatrics at the New York University School of Medicine. Brewster's father, who died in 1952, was a Wall Street lawyer.

Brewster grew exceedingly fond of Khartoum, which is built inside the point of the V made by the confluence of the White and the Blue Niles, with Omdurman across the White Nile. Whenever he had a visitor from the United States, Brewster would seat his guest on the back of a Vespa he had acquired and proudly show him the city: the tomb of the Mahdi, whose forces killed General Charles George Gordon; the palace where Gordon died; the battlefield at Omdurman where the British avenged Gordon. He would take his guest to dinner in the Mogrun Gardens, at the point where the Niles meet, drink Camel beer from the Blue Nile Brewery, and watch the lights come on across the river. There are two hundred and twenty thousand people in Khartoum. In the Suk, the vast bazaar, the leopard skins were the cheapest in Africa—according to Brewster, who developed into an unabashed promoter. While running through the products of the Sudan, from dates to groundnuts, he would say, "We also produce gum. We are the world's largest producers of gum arabic. We produce long-staple cotton, too. It is grown in the Gezira—more than a hundred miles of irrigated land in the wedge between the Blue and the White Niles. When the British left, they said there would soon be no more Gezira, but the Sudanese have nearly doubled the cultivated area. It is the largest economic institution in the underdeveloped world. Half a million people under one management." Sudanese conversation, he found, was occasionally weighted with abuse of the British, but he noticed that if Americans were to fall in with what the Sudanese were saying and add unkind words of their own about the British, the Sudanese would turn on them. Colleagues of Brewster in the judiciary would emit streams of vituperation against the Eng-

lish, yet Brewster knew that they wanted nothing so much as to be able to send their sons to English schools. "They even act like Englishmen on the tennis court," he says. "They hate the English and they love the English. The Sudanese government— whose members are almost all Mohammedans—pays a substantial sum each year to maintain the British cathedral in Khartoum. Some people—the Chinese among them—probably make the mistake of not realizing that colonialism was a two-way relationship."

Premier Chou En-lai was in Africa in 1964, and a Chinese circus toured the continent at about the same time as a kind of added attraction. When it appeared in the National Theatre in Omdurman, most of the people in the judiciary went. The circus was excellent, and the audience was carried away by it. As a climax, a small bicycle went wheeling across the stage ridden by twenty-one Chinese at once. There was a great gasp from the crowd. Halfway across the hall from Brewster, a Sudanese lawyer stood up and shouted, "Brewster, will you recognize them now?"

Brewster says that Chou, in Khartoum and elsewhere, kept telling the crowds, "We black people have to stand together!" In Khartoum, a reception was held for Chou, and members of the government filed past to shake his hand. When Brewster reached him, Chou looked up, and, adjusting smoothly, said, in English, "Good evening."

"A *salaam aleikum*," Brewster replied cordially

By contrast with the north, the southern Sudan, because of the continuing civil strife, had the reputation of being a much less pleasant place in which to travel. Murders there have been frequent, ubiquitous, and wholesale. As a representative of the government, Brewster would sometimes be assigned a bodyguard carrying a rifle. He was not terribly concerned for his own

safety, however, because the southerners seemed to be sympa-
thetic toward white men. White missionaries, whom the gov-
ernment had deported from the Sudan a couple of years before,
had given most southerners what education they had, and had
also given them their Christian names. As often as possible
Brewster travelled without a guard. He was alone one morning,
driving along a dirt track in Yei District, and he stopped his car
under a tree to have breakfast. He believed that the only way he
was likely to get killed was by happening to come suddenly
upon an armed group of rebels and surprising them into
opening fire, so he liked to keep himself quite visible. While he
sat under the tree that morning, he became aware that he was
being approached by a line of children—perhaps thirty of them,
coming from a village a quarter of a mile away. Walking two
abreast, they were singing. As they drew nearer, first the tune
became clear to him, and then the words:

". . . dwelt a miner, 'Forty-niner
And his daughter, Clementine.
Oh, my darling, oh, my darling,
Oh, my darling Clementine,
Thou art lost and . . ."

As the children formed a large circle around his car, they
finished "Clementine" and went on to sing "Greensleeves."
Brewster was probably the first white man they had seen since
the missionaries left, and they had come out of the village to
sing to him because they associated him with the people who
had taught them the songs. "In Khartoum," Brewster says,
"there was always a rumor that I was collaborating with the
southerners, partly because I loved them so much."

It was a debate on the problem of the southern Sudan, held
by the Students' Union of the University of Khartoum, that

touched off the revolution whereby, in late 1964, the military government that had been ruling the Sudan was replaced. The police, in trying to stop the debate, killed a student. Riots followed, and then a general strike. The military government dissolved itself. As joyous mobs streamed through the city, there was one white face among them—Brewster's. The terrible problem of the southern Sudan was not solved by the departure of the military government, of course, but the men who then came to power—doctors, lawyers, farmers, teachers—seemed to be dedicated to resolving the nation's difficulties by democratic means. As a gesture in this direction, the new government made Clement Mboro, the leader of the Southern Front, its Minister of the Interior. Mboro was a close friend of Brewster's, and Brewster was the one person who met him at the airport when he arrived in Khartoum to assume his post. Hillary Paul Logali, a southern leader who was at Yale studying economics on a scholarship arranged by Brewster, was called back to become the Sudan's Minister of Works. The civil war has by no means ended. The more uncompromising southern leaders continue to operate from outside the country, and not long ago a race riot caused hundreds of deaths in Khartoum.

In his last letter from the Sudan, Brewster wrote, "One who has witnessed the courage, thoughtfulness, and forcefulness of most of the leaders who made the revolution a success cannot but feel great hope now." When the government fell, the Chief Justice, despite the fact that he had always maintained a strong line of demarcation between himself and the military, was compelled to resign. Brewster's own work in the judiciary went on, and it did not come to an end even with his departure, at the end of 1964. From the office of his present employer, the New Haven firm of Gumbart, Corbin, Tyler & Cooper, he published the *Sudan Law Journal and Reports* for 1964 and for 1965. With them, his law reporting for the Sudan ended.

"A Sudanese judge will edit the reports and will maintain whatever standard I set," he says. "The job of the expatriate lawyer is finished out there. Before long, the job of the expatriate will be finished in Africa."

When the Fellows in Africa Program began, many of the first group, setting out in 1960, went to work for holdover white civil servants. The present group is working almost entirely for Africans. "Our major purpose there has been to work ourselves out of a job," Professor Wilson says. "We are not going to overstay our time." Meanwhile, the Ford Foundation has expanded the idea, and M.I.T. is one of three participating schools in a new program that sends young men to Latin America. "In Africa, what we did was just go out there and do a hard job, something that might not otherwise have been done," Carroll Brewster said after he had mailed off the galleys of his last *Sudan Law Journal and Reports.* "None of us went over there to do political jobs. We went over there to do subpolitical jobs. Here and there, someone has left some law reports, or a new tax code. The program has not changed the face of Africa. We've been only fifty-two people on a continent."

Before leaving the Sudan, Brewster established a permanent program whereby two or three Sudanese judges would go to American law schools each year. The judges have done well. Three who have completed their work at Yale have all made better than B averages. One of them—Abel Alier, Yale Law '63—is a Bor District Dinka and was the first southerner to become a member of the Sudanese judiciary. Brewster feared that Abel Alier would suffer terribly from the winter temperatures in New Haven and advised him to acquire plenty of blankets. "Dinkas don't need blankets," said the judge. He survived. When he returned to the Sudan, he resigned from the judiciary to become the No. 3 man in the Southern Front, a

political party that has been attempting to achieve southern autonomy through persuasion, in contrast to the more widely publicized southern rebels who have been attempting to do so by force. Brewster also obtained a Yale scholarship for El Amin Mohamed El Amin Tatai, the young judge whom he trained to succeed him as editor of the *Sudan Law Journal and Reports.* "El Amin differed from many Sudanese," says Brewster. "He would admit when he did not understand something. I don't like to make generalizations about the African Mind, or the Sudanese Mind, or the Underdeveloped Mind, but there is this thing about facing a new problem: Rote teaching doesn't prepare you for it. There is so much tradition in the family and in the tribe that new ideas and problems tend to throw an African. I tried to help El Amin understand this. He now tackles problems with enthusiasm rather than dismay. He is back in the Sudan now, and one more Anglo-Saxon name is gone from the governments of Africa—mine."

Twynam of Wimbledon

1968

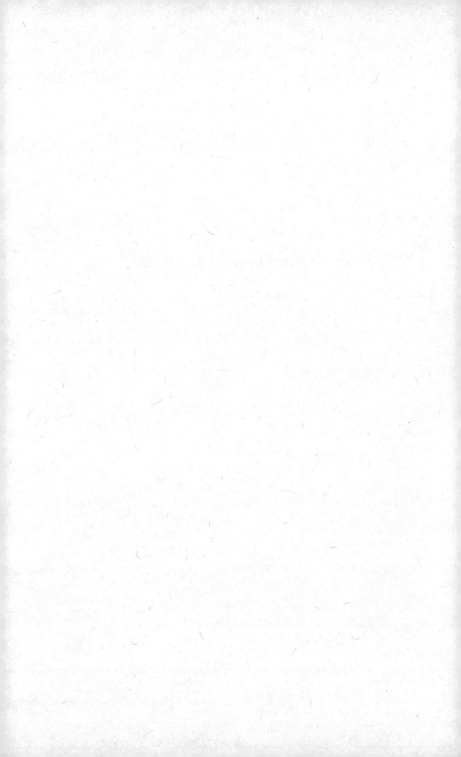

A weed—in the vernacular of groundsmen in England—is known as a volunteer, and there are no volunteers in the Centre Court at Wimbledon. Robert Twynam, who grows the grass there, is willing to accept a bet from anyone who is foolhardy enough to doubt this. Twynam's lawn—nine hundred and thirty square yards, one-fifth of an acre—is the best of its kind, and Twynam has such affection for it that he spends a great deal of time just looking at it. He takes long, compact walks on the Centre Court. At times, he gets down on his hands and knees and crawls on it, to observe the frequently changing relationships among the various plants there. Twynam keeps a diary for the Centre Court ("February 4: very sunny spells, Centre Court fine," "February 5: cooler, little sun, Centre Court O.K."), and, in the words of one member of Wimbledon's Committee of

Management, "Mr. Twynam regards each blade of grass as an individual, with its own needs, its own destiny, and its own right to grow on this blessed piece of lawn." Twynam has been at Wimbledon forty-four years. Nearly all the greatest stars of tennis have played under his scrutiny, and—while he knows a great deal about the game—his appraisals of all of them seem to have been formed from the point of view of the grass. "When Emmo puts his foot down . . ." Twynam will say, in reference to Roy Emerson, of Australia, "when Emmo puts his foot down, he is stepping on forty or fifty plants."

"Wimbledon," of course, is a synecdochical term: over the years, the All England Lawn Tennis and Croquet Club has become known by the name of the borough in southwest London where its present courts were established in 1922. Similarly, the term "Centre Court" applies to more, at Wimbledon, than the principal tennis court there and the lawn on which it is lined out. The term refers as well to the stadium that has been built around the playing lawn. The stadium remarkably resembles an Elizabethan theatre, for it was built in the shape of a great dodecahedron, with its courtyard open to the sun and its grandstands roofed over. The groundlings, who sit low and near the grass, in the so-called Open Stands, are unsheltered from the sun and the rain, but the rich and the royal sit high and under the roof. When the grandstands are empty, the roof returns an echo of any sound that is made in the stadium.

Working alone on his hands and knees somewhere between the baselines, Twynam raises one hand and affectionately slaps the surface of the lawn, which is so firm that the echo is like the sound of a rifle. It is the third week of June, and the Wimbledon championships will begin in a few days. "This court brings the best out of the players," he comments. "They can make the ball speak, here on this court. The ball sometimes comes through so fast it sizzles. We've had some terrific battles

here." The lawns of Wimbledon are his in more than a professional sense, for his own home is within the tennis club's compound, and tennis lawns are around it on three sides. His house has casement windows and a steep slate roof. Red roses grow up its walls. Twynam, his wife, and their children are the only people who live within the boundaries of the All England grounds. At the edge of the grass of the Centre Court is a Lightfoot Automatic Electric Refrigerator, in which—for consistency of bounce and other, more subtle, reasons—tennis balls are chilled up to the moment that they are put into play. The Twynams kept their butter and milk in the refrigerator in the Centre Court until recently, when they bought a fridge of their own.

When Twynam describes tennis players, he is less likely to call them touch players or power players than to call them toe-draggers, sliders, or choppers. A right-handed toe-dragger will inscribe a semicircle in the lawn, with his right toe, as he serves; and by the end of a long match these crescent ruts can be so deep and distinct that they almost seem to have been burned into the ground. "They dig their toes. They drag their toes," Twynam says. "Once they get underneath the surface, away they go. Nothing will hold it." Understandably, Twynam prefers to see non-toe-draggers defeat toe-draggers in Wimbledon championships, but things do not always work out that way. The preëminent toe-draggers of this century have been Jean Borotra, Robert Falkenburg, and Jaroslav Drobny, each of whom won the Men's Singles Championship. Borotra won it twice. "Borotra was the worst ever," Twynam says. "He used to cut the court to pieces, he did. He dragged his toe something shocking. He was so awkward on his feet. He used to dig up the turf with his heavy great shoes and make shocking big holes. The Bounding Basque they used to call him. He slid a lot, too, as you can imagine." A slider runs to get into position, then

slides a yard or so before executing a shot. "Of course that's what gets on the old court, you know," Twynam goes on. "They all slide to a certain extent, but the *great* players don't slide much. I mean, they know where the ball is coming, don't they? These foreign players do a lot of sliding. Czechs. French. Austrians as a rule are heavy-footed, too. One or two Americans used to slide. Falkenburg was a slider. He was one of our worst enemies all around. But Emmo never slides. Rosewall never slides. Don Budge never slid. Kramer never slid. Budge Patty—a gentleman player, he was. He played beautiful tennis. He never slid. He never dragged his toe. He was a genteel player, a nice player. He beat Frank Sedgman for the championship in 1950." A chopper, after losing a point, temporarily uses his racquet as an axe. There have been so many choppers at Wimbledon that Twynam sees no point in drawing up a list. The effect of the chopping is almost always the same—a depression in the lawn five inches long and an inch deep. When this happens, or when a slider takes a serious divot, play is interrupted while Twynam goes onto the court to repair the damage. He fills holes with a mixture of clay and grass cuttings; and when he replaces divots, he applies fresh clay, then a cupful of water, then the divot itself, which he sutures into place with matchsticks while the crowd and the competitors look on—an operation that usually takes three minutes.

Throughout the Wimbledon championships (known to the Wimbledon staff as The Fortnight), Twynam is close to the Centre Court and is prepared to go into action. He sits on a folding chair in the passage—between the Royal Box and the West Open Stand—that the players use to get from the club-house to the court. He places the chair very carefully beside the sloping wall of the grandstand, at the point where he can be as close as possible to the court without allowing his head to protrude into the view of the spectators, or paying customers, as

he prefers to call them. Since he is five feet five inches tall, he can get quite close. From time to time, he nips into his house for a cup of tea or something to eat, where he continues to watch the Centre Court, on B.B.C. television. On the saltshaker he uses are the words "Say little and think much." If anything goes wrong on the court, it is only a half-minute walk through his garden and past the Court Buffet, past the Wimpy hamburger kiosk, and into the stadium. The appearance he makes as he moves into the view of the crowds is prepossessing. He looks like a Member of Parliament. His hair is handsomely groomed, wavy, and silver gray. His mustache is sincere and reassuring, being just halfway between a handlebar and a pencil-line. His face, which has strong and attractively proportioned features, is weathered and tanned. He is trim and in excellent condition—nine stone five. He wears a gray suit, suède shoes, a white shirt, a regimental tie.

Twynam is not a horticulturist or a botanist or a herbarian, and his approach to the growing and care of his grass goes some distance beyond science. He is a praying man, and at least part of the time he is praying for the grass. Last June, three days before The Fortnight began, he left all sixteen of Wimbledon's lawn-tennis courts uncovered, for he wanted to take advantage of what he believed would be a brief but soaking rain. Imprudently, he did not even get out his tarpaulins against the possibility of a heavier storm. After the rain had been falling steadily for ninety minutes, he began to worry. The courts could absorb only two hours of rain and still be in perfect condition for the opening matches. "If it had gone longer, I would have been in serious trouble," he said afterward. "I got down on me knees and prayed, I did. I got down on me knees and prayed." The rain stopped almost precisely two hours after it had begun, and the lawns were in perfect condition on opening day. Some

nights, out of consideration for others, he prays that it will rain, but not until ten-thirty—"when everyone's gone home from the boozer," he explains. "A drop of rain, no more—just to give it a drink, just to cool the grass." The Wimbledon lawns are top-dressed from time to time with miscellaneous loams, and the new soil is eventually pressed into the old with rollers. When asked if the courts are periodically checked to see that they are level, Twynam says, "Oh, no, bloody fear. We haven't got the time. We trust in the good Lord. They're pretty good for level, considering they get such a banging about." Only once every five or six years is the earth of Wimbledon tested for its pH factor. At last count, it was between 5 and 6—slightly acid.

In a drawer of a small chest in Twynam's sitting room are copies of important texts in his field, such as R. B. Dawson's *Lawns* and I. G. Lewis's *Turf*. Twynam has his personal pantheon of great figures in grass. The late William Coleman, one of his predecessors as Head Groundsman at Wimbledon, trained him and remains to this day something of a hero to Twynam, but not on the level of Sir R. George Stapledon, of whom Twynam speaks with obvious reverence ("He went into this lawn culture in a big way, you know"), and whose name is apparently the greatest one in the annals of English turf. It was Stapledon who developed the superior modern strains of English grasses. There is a passage in *Turf* in which I. G. Lewis writes, "At a seaside town on the west coast of Wales the first steps towards better grasses for this country were taken by a man in whom profound belief mingled with immense vision—a combination which in all ages has been recognized as the precursor of genius. Aberystwyth was the seaside place and R. George Stapledon the man. With the results of a wide survey of grassland in this country uppermost in his mind he set out, as others of his native Devon had set out centuries before, on a journey of discovery. Stapledon, however, sought new grasses not new lands." These books in Twynam's drawer are used more as talis-

mans than as references. Twynam does not use them in his season-to-season work. Some years ago, he regularly read a journal called *Turf for Sport*, but found it so redundant he gave it up. He does have a look, now and again, at the *Groundsman*, but his way with his lawns is not so much planned or studied as it is felt. He has his experience, his sense of the weather, and a crew of twelve, and his lawns are acknowledged by tennis players from everywhere as the best in England and the best in the world.

The men in Twynam's crew, for the most part, are middle-aged and even elderly. Around all of them there is an atmosphere of individuality suggesting that no pressure or persuasion could cause them to wear white monkey-suit uniforms or soft rubber shoes, and they don't. Players are forbidden to go on the courts in anything but flat-soled tennis shoes, but the men of Twynam's crew walk around on the lawns all day in street shoes with sharp-edged leather heels. Typically, they work in their shirtsleeves, with the cuffs turned halfway up their forearms, and now and again they hitch up their braces as they mow or roll the lawns. Most of them have been at Wimbledon for decades, but they appear to have been pulled in off the street for an afternoon's work. For thirty-seven years, it was Twynam himself who lined out the courts ("If the lines are dead straight and the corners are true, it's a picture; it's not everyone can line a court out—to get it really spot on"), but he has recently turned this responsibility over to John Yardley, a tall sharp-featured man with a good eye and a steady hand.

Twynam likes to point out that two standard rules of lawn care are "Do not use a heavy roller" and "Do not roll too often." "These rules are always broken at Wimbledon," he says. According to *Turf*, "Occasional rolling with a light roller is permissible, but very heavy rolling packs the surface and prevents healthy root growth." A similar warning appears in *Lawns*, which goes on to say, "For spring use the roller seldom need be

heavier than 2 cwt." Twynam and his crew use something ten times heavier than that. They call it the Old Horse Roller. In season, they use it every day, and it weighs two thousand five hundred pounds. They drag it around by hand. No power machines of any kind are used on the Centre Court, and only for certain brief autumnal procedures are power machines used elsewhere at Wimbledon. The Old Horse Roller is equipped with shafts, in which a horse, its hooves padded, was once harnessed, but the horse was phased out long ago and now John Yardley gets between the shafts and four other men drag or shove the roller to help him. They heave like galley slaves. The work is hard. Fights occasionally break out. One day last June, the Old Horse Roller was reversing direction, slightly overlapping its previous path, when one old man got his feet tangled up in the feet of the man next to him. The second man, whose age was about sixty, raised a fist, loudly called the first man a bleeding bastard, then hit him hard, knocking his hat off. The first man, who appeared to be at least seventy-five, hit back. Yardley turned in the shafts and bawled them out. They calmed down, the hat was retrieved, and the Old Horse Roller began to move again. By mid-June, the turf of Wimbledon is packed down so firmly that the daily rolling has little effect. "What the roller does is put a polish on," Twynam said. "The court is firm enough as it is, but the roller makes a nice gloss on the top of the grass."

The lawns are mowed every day in the springtime—with hand mowers, of course. Power mowers frog and rib the courts—"frog" and "rib" being terms for various unkempt results—and, moreover, power mowers cannot be as finely adjusted as hand mowers. The height of the grass at Wimbledon is three-sixteenths of an inch. The mower that keeps it at that level is a sixteen-inch Ransome Certes, which has a high-speed, precision-ground ten-knife cylinder, makes a hundred cuts every thirty-six inches, costs forty-one pounds twelve and six, and hums with

the high sound of a vacuum cleaner while it moves. It throws its cuttings forward into a hooded catching device, the design of which causes the over-all machine to look very much like an infant's perambulator and the crewman who pushes it to look like a grandfather in St. James's Park. In the early spring, the courts are cut diagonally. In mid-spring, they are cut from side to side; and as The Fortnight approaches, the cuts are made the long way, end to end. Cutting the long way, the lawnmower is always pushed in the exact swaths that were cut the day before, and it always moves on each alternating swath in the same direction that was followed in earlier cuttings. The effect of this, to an observer at one end of the court, is that the lawn appears to be made of an enormous bolt of green seersucker, the alternating stripes being light and dark. If, in making the cut, the mower was going away from the observer's point of view, the cut appears light. If the mower was moving in the observer's direction, the cut appears dark. The light cuts and dark cuts have no influence on the bounce of the ball, but they follow the line of play and thus remind the players of the direction in which the ball is supposed to be hit.

"Grass grows at night, you know," Twynam says. "With a little warm rain, you can practically hear it growing." He puts his hand on the court. "Feel that. This hasn't been mowed for a day. Feel that little wisp on it." If the weather is warm and humid, the grass will grow as much an an eighth of an inch overnight, but it usually grows much less than that, and the tips that the mower shaves off the grass are often so small that Twynam refers to the aggregate as dust. Sometimes, after the Centre Court has been completely mowed, the removed cuttings can be held in the palms of two hands.

Somewhere in almost any English newspaper story of an opening day at Wimbledon, a poetic reference is made to the

appearance of the lawn itself ("The turf was green velvet," said the *Times* of June 27, 1967). This gratifies Twynam less than one might imagine, for green velvet is the last thing he is trying to grow, and an edge comes into his voice when he describes groundsmen who develop their lawns for cosmetic effect. "These lawns at Wimbledon are not made to look at but to play on," he says—and as long as the lawns are alive and healthy he doesn't care what color they are, including brown. "Other courts are greener than these," Twynam goes on. "This is hard-growing, natural green. There's no nitrogen or phosphates or sulphate of ammonia forcing this green up. Grass that is forced up may look greener, but it is weaker and softer. Overfeed grass and you're not making good base grass. All you're doing is mowing. If you force-feed it, it gets all pappy and there's no guts in it. If you don't give it *any* fertilizer, you're asking for trouble, but don't give it much. One ounce per square yard. Grass doesn't want forcing. Let it grow hard. Leave the grass to struggle for itself. The deepest roots only go down about two and a half inches anyway. If we were to fertilize just before The Fortnight, use a seven-hundredweight roller once a week, and mow to a quarter of an inch, we'd have lovely green beautiful lawns. But we haven't fertilized these courts for three months. These are not ornamental lawns. This is a true hard surface for lawn tennis. This is hard-growing grass. And as soon as it grows, we go down and cut it off. These lawns are not here to be looked at. The world championship is played here." Whatever the reasons, the lawns of other front-line English tennis clubs—Roehampton, Queens, Hurlingham, Beckenham—do not have quite the same texture as the lawns of Wimbledon. Billie Jean King, of California, who has won the three most recent Ladies' Singles Championships at Wimbledon, says that the other English courts she has played on "are not half as good" as Wimbledon's. "The bounce varies in the other places," she

explains. "One time the ball may skid, another time it may stand and float. But not at Wimbledon."

In Australia, grass courts are very good, and most players, Mrs. King included, say that the Australian surfaces are almost as good as Wimbledon's. Roy Emerson, who won Wimbledon in 1964 and 1965, goes further than that. He thinks that the center courts at Brisbane, Sydney, and Adelaide are the peers of the Wimbledon lawns. "The turf is good in Calcutta, too," Emerson says. "Wimbledon, Adelaide, Brisbane, Sydney, and Calcutta—that's the story on good grass courts throughout the world. Other than that, grass courts are pretty bad. Forest Hills is nowhere near it—very bad." Emerson's reverence for Wimbledon may have been reduced slightly in 1966, when, defending his title, he sprinted after a stop volley and—by Twynam's description—"got his racquet tied up in his pigeon toes, bowled over once, and finished up in a ball under the umpire's chair, tangled up in the microphone cables." In the accident, Emerson injured his shoulder, and as a result he lost the match and the chance to win Wimbledon three years in a row. "Wimbledon is fast and hard," Emerson says now, "but Wimbledon is sometimes a little slippery. The first couple of rounds, the courts are a bit green. There is still a lot of juice in the grass. In Australia, there is a bit more heat. The grass is hardier and isn't as slippery."

"I've seen football players hurt worse than that—with their ankles hanging by the cleats—get up and score goals!" Twynam says, remembering Emerson's accident. "It was a shame, that—when Emmo fell. Emmo is as pigeon-toed as a coot, like Frank Sedgman, but he usually has good footwork. He gets the feel of the lawn straightaway. He likes a court really fast. He likes the ball to come through. He's very quick. Emmo is a real machine. And he never makes a mess of a lawn. If Emmo sees a place kicked up, he goes out of his way and treads it back."

Developing a reasonably good tennis lawn in England is not the difficult feat that it is in, say, the United States. The English atmosphere, with its unextreme temperatures and its soft reliable rains, makes the English land a natural seedbed for grass. At Cambridge, typically, there is a meadow behind St. John's College, on the west bank of the Cam, where cattle graze during much of the year, and where crocuses come shooting through by the thousand in March. Each year, the crocuses are mowed down, the grass is cut short, the cattle are driven to other meadows, posts and nets are erected, courts are lined out, and all kinds of dons, bye-fellows, and undergraduates play tennis there. In another part of Cambridge, beside the university gymnasium, is a patch of lawn that basketball players ride their bicycles across all winter long on their way to and from the gym. In the spring, the same lawn is sometimes used for exhibition tennis matches on an important scale. Some years ago, when Vic Seixas was preparing to defend his Wimbledon championship, he played an exhibition match against Tony Trabert on the lawn beside the Cambridge gym. In England, grasses riot on the earth, obviously enough, but what happens after that— the ultimate quality of the playing surface—is a matter of the groundsman's style. Seixas, who at forty-three was still competing in the Wimbledon championships in 1967, describes the Wimbledon turf as "cement with fuzz on it." Seixas lives in Villanova, Pennsylvania, and plays at the Merion Cricket Club, near his home. He says that the grass courts at Merion— and at Forest Hills and other American tennis clubs—are soft. "We don't have a proper conception of what grass should be," he goes on. "In American clubs, hardworking ground crews produce nice-looking lawns, but that's all they are—nice-looking. The turf has to be hard for the ball to bounce. In our country, the ball just dies. It's like playing it on a cushion. And in the soft ground you get holes and bad bounces. A bad grass court

favors a weaker player and makes luck more important than skill. The Wimbledon people obviously feel that it's a very integral part of the game that the ball bounce properly. Surfaces cannot get much faster than at Wimbledon. The smoother the surface, the more the ball will shoot off it. Remember, though, the problems are greater in our country. I can't make grass grow in my own lawn."

For many years, before they were given their present house at Wimbledon, Twynam and his family lived in a small maisonette flat on the Kingston By-Pass, in Surrey. His back garden, which was sixteen feet wide and twenty feet long, was turfed with "a bit of old rough grass," which he mowed with no especial fidelity, since he cared nothing about its botanical origins or its earthly destiny. He has always concentrated on Wimbledon. He was born within a mile of the Centre Court. His father was a construction foreman from Connemara, who had crossed to England at the age of eighteen, and while still a very young man had attempted to emigrate to the United States. For obscure reasons, he was kept at Ellis Island for a number of weeks and then sent back to Britain. "I wouldn't have let him in, either," Twynam says. "He was the biggest bloody rogue that ever set foot in this country." When Twynam was two, his father left home and did not permanently return. Twynam was the youngest of six children. He went to school until he was fourteen and then tried working as a messenger for the General Post Office. He wore a pillbox hat and a black mackintosh, and he went around Chelsea and Battersea in all weathers on a red bicycle. He hated the hat, the coat, Chelsea, Battersea, the bicycle, and the weather, so he applied for a job as a ball boy at Wimbledon. The All England Lawn Tennis and Croquet Club had full-time, resident ball boys when Twynam joined the staff —a luxury that the club gave up many years ago. Dressed in the

club's colors, bright green and mauve, Twynam spent three years retrieving faulted serves and put-aways, and then he was promoted to the ground crew.

"I ball-boyed for Vincent Richards, Jean Borotra, Henri Cochet, Bill Tilden, Sidney Wood, Alice Marble, Helen Wills Moody," he said one evening in June, while he was enjoying a walk on the Centre Court. "Wills Moody was playing here when I first came, in the final, here on the Centre Court. Light and dainty, she was. I've never seen a woman take a divot. Alice Marble was tall, blond, strong, and manly—but no damage. Like Althea Gibson—a bit manly and not all that interesting to watch. Suzanne Lenglen was light, like a bloody ballet dancer, and never disturbed the courts at all. Helen Jacobs was a bit heavy-footed, but not bad. Mrs. Susman—Mrs. J. R. Susman—was the only 'worst enemy' we've ever had among the women. She used to drag her toe terrible when she served— terrible mess—oh, shocking. She used to scuff and slide. Slide on her right heel, drag her left toe. Always sliding she was, Susman. Women play tennis now like men did years ago, but they seldom hurt the grass. Billie Jean is light on her feet for a big girl. Maria Bueno is so light—a very dainty thing, she is."

The evening was quiet, in the extended twilight of the late spring, and the walk was long and helical. As Twynam moved around the court, he stopped from time to time—for no apparent reason—to stare at the turf in the way that some people stare into a log fire. In one of these moments, he said that he himself had once played in the Centre Court—but only briefly, and forty years ago, with another groundsman. "It was just a knockup," he said, "but it was an odd experience, really. You seem like a lonely soul, stuck out here on your own in the vast arena." He opened a packet of cork-tipped Player's Weights and lighted one. During the Second World War, he said, he was a Leading Aircraftsman in the Royal Air Force, and he spent four years in control towers, "talking in" planes. In Poona, in the

State of Bombay, to defeat boredom during a rest period, he organized a group that cleared an area in a grove of mango trees and built a red-clay tennis court. Until 1955 or so, he used to play tennis forty-five minutes a day, with other groundsmen, at Wimbledon, never sliding—or so he says—and never dragging his toe. The Wimbledon ground staff has its own tournament, and it has always been a professional tournament, for the winner receives, in addition to a fine silver trophy, a merchandise voucher that is convertible into goods in London stores. The competition is therefore without nonsense. Ball boys are used, and, as Twynam describes it, "We have a chap in the chair taking the umpire duty. There are baseline judges. The players wear flannels, slippers—no pure whites. Some wear a bloody collar and tie." Year after year, in the nineteen-thirties and nineteen-forties, Twynam got into the final, but he always lacked whatever it is that draws a player together in a championship final and gives him the thrust to win. But 1952, the year of Frank Sedgman, was also the year of Bob Twynam. In the ground-staff final, he defeated William Collis, and won his only Wimbledon championship. "I had quite a decent game in those days," he said. "But now, at fifty-seven, I'm retired a bit. My game is going down." About a dozen times a season, he plays with his son, Robert, who is fourteen and in grammar school. He has two other children. The oldest, Jennifer, is thirty-two, and is a draftswoman; her husband is a draftsman. The other, Tessa, is twenty-one and sings, dances, and does pantomimes in a travelling cabaret show. Twynam said that he and his son now almost always play on one of Wimbledon's ten hard-surface courts, where the ball bounces higher than on turf and the action is slower. "Yes, these grass courts are too much for me now," he admitted. "I watch the ball go by."

Each year, the opening match of the Wimbledon championships is traditionally played between the men's defending

champion and some unfortunate and usually obscure fellow whose name happens to be paired with the champion's in the draw. The match is little more than ceremonial—no test for either the champion or the court. In 1966, for example, Emerson, the defender, was paired with one H. E. Fauquier, of Canada, and Emmo defeated him 6–0, 6–1, 6–2. In 1967, the defending champion was Manuel Santana, of Spain, and the player that came up opposite Santana in the draw was Charles Pasarell, an undergraduate at U.C.L.A. Because Pasarell happened to be an American, his role as the customary opening-day sacrifice was an ironic extension of the humbled status of American men at Wimbledon, for men's tennis in the United States had declined to such a remarkable extent that in 1967, for the first time in thirty-nine years, no American player was seeded in the Men's Singles Championship. All this only moderately interested Twynam. "That should be a good match," he said, "because the court will be in A-1 condition."

The draw was published during Overseas Week, as the Wimbledon staff refers to the seven days immediately preceding the tournament. During Overseas Week, tennis players from about fifty nations come to Wimbledon, unstrap their enormous stacks of racquets, and have at each other from eleven in the morning until deep in the evening, trying to effect ultimate refinements in their styles before the meeting that is regarded by all of them as the world-championship event in the sport. They practice—usually two-on-one—on the courts outside the stadium. No one ever practices on the Centre Court. Twynam walks around among them, watching the lawns and the weather. Given the imminence of The Fortnight, Overseas Week is a surprisingly relaxed and easygoing time, full of chatter and casual gossip. The players all know each other as if they had spent the past ten years in the same small boarding school, and,

in a sense, they have. "They love these courts. They would sleep on them if you let them," Twynam says. "They love to come to Wimbledon. If they can't make it, it breaks their hearts. They come back with their children. The atmosphere is so beautiful here." The grounds are small, only fourteen acres, and narrow walkways intersect among the tennis lawns and tea lawns. Paul Scarlets climb posts of larch that are set parallel to the baselines of the courts. Other roses, of every known color, climb the brick columns of the Members' Enclosure, where straw parasols shade white tables around a fountain pool with lilies and goldfish. "Harrods supplies the goldfish," Twynam observed one day. "Nice goldfish, but expensive." In the air were the scent of roses and fresh-cut grass and the sound of tennis balls like the sound of popping corks. Red and blue hydrangeas growing in boxes spilled over balconies in the ivy-covered walls of the Centre Court. In the background, a church spire emerged above thickly foliaged trees and above solid, suburban, detached but propinquant houses. "That's St. Mary's Church, the Wimbledon parish church," Twynam said. "Lew Hoad was married there." An Australian on Court 9 hit two drives into the tape at the top of the net. "You hit the ball over the net and into the court," he said to himself. "That's page 1, line 1." An American girl on Court 8 shouted at herself, "What's the story with my backhand?" English players kept calling "Sorry" to one another. "Sorry." Twynam saw a girl beside one court with oranges in her hand. "South African," he said. "If she's got oranges in her hand, she's a South African." Santana, practicing with Vic Seixas and Charlie Pasarell, drilled one past Pasarell at the net. "You're out of your mind," said Pasarell. Santana grinned toothily. Other remarks were flying around in Dutch and Danish, German and Polish, Serbo-Croatian. Twynam wandered off to one corner of the grounds and onto the croquet lawn. He

said that on Sunday afternoons elderly members play croquet, two at a time. They wear all white, like the tennis players. Twynam tapped the croquet lawn with one foot, and said, "Make a nice nursery for the tennis lawns, wouldn't it, this?" Looking back across the courts, he said, "They're all first-class tennis players here. There are no rabbits here. We don't do this for love, you know. There's no jiggery-pokery. Nothing's too much trouble to cater to the players. They have medical services, masseurs, doctors, free rides to London. They can have anything they want, as long as they're playing tennis. They've got to play good tennis. We must take care of paying customers, not just friends who come in and look around and pay nothing. These players come here to play tennis. Even the second-rate players play good tennis here. This Wimbledon is not run for love. We English want the money, you know. We're a tight nation, we are. Any penny that's going, we'll have it."

There was a lot of talk in the London papers and on the Wimbledon courts during Overseas Week about the possibilities of the open tennis championships that have since become a reality. Twynam's only comment was that he wondered if the professionals would be up to competing with the amateurs at Wimbledon. "Many of the pros have been away from Wimbledon for years," he said. "They have played most of their professional games on wood and clay, and they'd find a vast difference here. The actual name of this tournament is The Lawn Tennis Championships on Grass. I wonder if the pros could stand the pace."* He paused a moment and then said he

* Of the four semi-finalists in the first open Men's Singles Championship at Wimbledon (1968), two were amateurs. One of the others had only quite recently become a professional. The professionals advanced to the final. Rod Laver, a veteran pro, was the winner. Later in the year, at Forest Hills, the first United States open lawn tennis championships were dominated by amateurs, and the winner of the Men's Singles Championship was Arthur Ashe, an amateur.

was going to have a look at the Centre Court. On the way there, he went through a private entrance and past the Gentlemen's Dressing Room. Then he opened the double doors through which all competitors must pass on their way to the Centre Court. Above the doorway, in large letters, is a fragment from Rudyard Kipling: "If you can meet with Triumph and Disaster and treat those two impostors just the same . . ."—words that might ask too much of a pro.

In the stadium, Twynam made a close inspection of the turf. He pressed his fingers down on the dense, elastic surface. "Feel the fibre," he said. He withdrew his hand, and the turf sprang back. "The court is as alive as the players are," he went on. "There is an inch of fibre between the surface and the topsoil. Claw it. Claw it. See? There's something there to wear." About two feet down, he said, are the tops of tile land drains, set in a herringbone pattern in the local clay. Ten inches of clinker is above the drains, and over that is an inch of fine ash. Above the ash is ten inches of light and loamy topsoil, and in the topsoil are the roots of the lawn. When the surface of the lawn is looked at from a distance of inches, the differences among the various grasses there become pronounced. Some areas were lighter in shade than the grasses around them and were noticeably tinged with gray, in contrast to the flaring shamrock green of their neighbors. "The light patches are *Poa pratensis*," Twynam said. "Smooth-stalked meadow grass. The gray color is seed heads. One must mow close to get them. By rights, we don't want smooth-stalked meadow grass anymore. The greener patches are Chewings fescue and American browntop—better pedigrees than the *Poa pratensis* now. The smooth-stalked meadow grass is coarse and doesn't make as good a mat as the fescue and the browntop. But it's been here for years. It's self-sowing—and it comes up in these pale-gray patches. We'll phase it out before long. You get a better game of tennis on the

browntop and the fescue. The fescue comes up into a tuft, and
we mow it right down to the basal level. That forces the grass
prostrate and makes it mat. The American browntop is shallow-
rooted but hard-wearing. Americans have done a lot for lawns,
you know. It's all Americanized. This browntop is actually what
they call Oregon browntop. If you were a keen lawnmaker
yourself, you'd use these strains. But you don't get a first-class
lawn in two or three years. It takes twenty or thirty years to get
a real lawn down. There's also a bit of creeping bent in here,
but that's about all. One or two bastard grasses come in, like
a bit of rough-stalked meadow grass, a bit of rye grass, a little bit
of Yorkshire fog. They blow over, you see. But we pick them
out. Yorkshire fog is bloody awful. Prickly. Spiky. Hairy. . . .
Volunteers? Parsley piert, plantain, and pearlwort are about all
you get in here. We don't let them stay. . . . The only hard
thing about this job is, you can't change your court over. The
court is static. All the courts are static. We can't move them
up or back or sideways. The lines are always in the same places
and have been for forty-six years. Same toepieces. Same base-
lines. Same no man's lands. Same run-ups in the service areas.
We get the same problems in the same places every year. In the
autumn, on the other courts, we put in new turf—pieces one
foot square from our own nursery—along the baselines and the
run-ups. The Centre Court baselines and run-ups are almost
always resown. The last time we turfed in here was six years ago.
We oversow the rest of the court with seed, after pruning the
roots with a hand fork and letting in some air and light. This
year, we'll be using eighty per cent Dutch Highlight Chewings
fescue and twenty per cent Oregon browntop. Then we give it
a light top-dressing with a heavy loam, then a light roll, and it's
ready to start germination—we hope. In November, we solid-
tine the turf with potato forks, making deep holes two inches
apart. Then we top-dress it again, with a ton of medium-to-

heavy loam. Luting, it's called. The new soil is spread with a lute, a rake that has no tines. Extra-thick top dressing makes a firmer surface. The soil falls into the legs made by the potato fork. We never hollow-tine here—just a matter of opinion. The top-dressing soil comes from the Guildford area, here in Surrey, and it's a decent bit of stuff. Mow the grass once or twice in late autumn and it stays a half inch high until spring. You like a good winter, to lift up the roots. A good winter is a cold winter, what they call an open winter. It lifts the roots up and aerates them. The Centre Court is the hardest one to keep in good shape. It is shaded from the sun. Frost stays longer in here. There is less freedom of air. But in the spring we get a good top growth. It's called a good braird." He plucked a bit of brown-top, or common bent grass, out of the turf and turned it slowly in his hand, describing its flat, hairless, spear-shaped leaves, its short rhizomes and stolons, its notched, blunt-topped ligules. Hunting around awhile, brushing past whole colonies of the predominant grasses, he finally came up with a plant he was seeking, its blades like stiff bristles, infolded and bluntly keeled, its ligules blunt, and its auricles rounded like shoulders. "There you are," he said. "A bit of creeping red fescue."

On Saturday afternoon, forty-eight hours before the championships began, four women members of the club—Mrs. C. F. O. Lister, Mrs. W. H. I. Gordon, Mrs. P. E. King, and Mrs. N. M. Glover—played on the Centre Court for an hour and twenty minutes so that Twynam, with this light rehearsal, could sense the timbre of the lawn. While the ladies—in pure white, of course—made light but competent movements around the court, driving long ground strokes at one another, Twynam said that a similar ritual occurs every year. "It gets the court knocked in a bit," he explained. "I watch them to see how the ball really does come up, you see. Then, if necessary, we can

get the surface padded down a bit. It's coming through quite well, considering the wet we had yesterday. I've been looking for bad bounds, but there have been none. No trouble at all. It's coming through quite good."

That night, the court was covered. Twynam and his crew have an enormous tarpaulin—eight thousand sixty square feet. Winches at either end of the court raise the canvas, between spars, until it is high above the grass, looking like a vast pup tent. Air can circulate inside. Mildew won't form beneath the tent, as it will, sometimes, under a flat tarp. The crew can get the tent up in fourteen minutes. If rain comes during a match, they just drag it over the lawn, flat. Sunday morning, they removed it, then mowed, rolled, and marked the lawn. The white lines, put down with a forty-year-old machine, are made of pulverized chalk, called whiting. Lime is never used. It would burn the grass. The court was covered again at noon. At 7:30 A.M. on Monday, the opening day, the court was uncovered. It was mowed again, rolled again, and—although it hardly appeared to need it—marked again.

The gates of the grounds were opened, and the crowds came in. Fourteen thousand five hundred people came into the Centre Court. Twynam looked them over. "From grocers' boys to kings we get here," he said. The sky was a mixture of clouds and blue. "The court is all right," Twynam said. "The court's O.K. We gave it a half hour's slow roll longways this morning, that's all. It could have had a little more rolling, but the players will pat it down, I hope." He set his chair in his accustomed spot, adjusting it so that the top of his head would not quite coincide with the slope of the adjacent wall. Santana and Pasarell walked past him. Pasarell, his hair falling over his forehead, looked sleepy and impassive. Santana's dark eyes were bright and he was smiling. Applause greeted them, and they began to warm up. Both are fairly large but not impressively or even athletically built. In the way they moved, how-

ever, and in the way they hit the ball, they showed, even in warmup, why they were there. "When they win Wimbledon, they win the world," Twynam said. Santana once worked as a ball boy at a club in Madrid. His family had no money. To finance a tennis career, he found a sponsor, and now he has become a national hero in Spain. He is the first Spaniard who has ever won at Wimbledon, and the first tennis player ever to be given an award that the Spanish government annually makes to the nation's outstanding athlete. A touch player, he has been called a genius with a racquet, a stylist, a virtuoso, and a master of many shots. He has been said to have thirty-seven shots known to the game and two that no one has ever heard of. He has seven different forehands. When Santana—at the end of the court near Twynam—began to serve in the match with Pasarell, Twynam said, "Santana is a scientific player, very steady. Watch him now, though. Watch his right foot. He drags his toe something shocking, he does." Santana lifted the ball high and swung through for his first serve. His right toe, never coming off the ground, moved in an arc toward the baseline and scuffed up the grass. After six or eight serves, Santana had made a light but distinct crescent in the lawn.

Twynam looked at the sky, which was thickening a little but not seriously. "All in all, the Lord has done pretty well for us," he said. Pasarell got ready to serve. Pasarell's father, who is chairman of the board of Philip Morris de Puerto Rico, was once tennis champion of the island. So was Charlie's mother. Charlie grew up in a beautiful house in San Juan and learned his tennis under Welby Van Horn, at the Caribe Hilton. He is very strong, and the dimensions of his game consist of power and more power. He is technically moody, given to flashes of brilliance, and when he is playing well and is fired up he is a beautiful tennis player and almost unbeatable. But his game can fall apart quickly. He relies on speed, the hard ball, the rush to the net. He has four shots: one forehand, one back-

hand, one serve, and one volley—boom, boom, boom, boom. If he could give Santana any game at all, it would be a contest between power and style. As Pasarell was about to serve, Twynam said, "Watch this one now. Watch his foot." Pasarell tossed the ball into the air and swung through. "See how he lifts that foot?" Twynam went on. "See how he puts it down flat? He's all right, he is. First-class. He doesn't drag his foot."

Santana broke through Pasarell's fourth service and soon led 5–3. Lovely, puffy clouds were now moving swiftly overhead. "They're all right, but I'd sooner see a nice blue sky," Twynam said. "Beggars can't be choosers, I suppose." The scuff line under Santana's toe was becoming a small rut. "Shocking," Twynam said. "But the court can take it." Pasarell broke back through Santana's service, and the first set went to 8–8 before Pasarell broke through again. He won the set, 10–8.

Taking his time during the next change of ends, Pasarell walked slowly to the umpire's chair, towelled himself, and looked at the sky. Returning to the court, he spoke to himself. "Come on, Charlie," he said. He said this aloud to himself about once a game, all afternoon. He won the second set, 6–3.

The sky had gone gray, and several minutes later a pouring rain fell. "I'm no God," Twynam said. "I can't stop the bloody weather." His crew had the net down and the court covered in sixty seconds. The rain lasted seven more minutes. The cover came off, the net went up, and, less than ten minutes after play had stopped, the match was under way again. "It all has to do with the paying customers," Twynam said, after directing the operation. "If there was no one watching, we wouldn't give two hoots. Let's have another four or five hours of sunshine, God. Be good to us, please." Three minutes later, the sun broke through and patches of blue appeared in the sky. Santana won the third set, 6–2.

It appeared that Santana had found his touch and had

turned the match around. Pasarell, however, seemed stronger in the fourth set than he had been all day. He was leading, 4–3, when more rain began to fall. "This has never happened for donkey's years, this," Twynam said. "It's bad for the public, bad for form." Twynam, as it happened, was referring not to the rain, for his crew has covered and uncovered the Centre Court as many as eight times in one afternoon, but to the match itself. In the ninety years of the Wimbledon tournament, no defending champion had ever lost on opening day, and it appeared that the defending champion was in danger of losing now. Fourteen minutes after the new rain had begun, the sun was out again and there were wide blue patches of sky in the west. Breaking Pasarell's service, Santana tied the set, at 5–5. "Come on, Charlie," Pasarell said as he missed the shot that blew the tenth game. Santana won the eleventh, Pasarell the twelfth. Then, in the thirteenth game, Pasarell broke Santana's service. "He's a bit of a rawboned American, but he's getting there," Twynam said. A few minutes later, in bright sunshine, Pasarell chased a lob, running toward the baseline, and Santana moved up to the net. Pasarell stopped, turned, and drove the ball past Santana to win the match, 10–8, 6–3, 2–6, 8–6.

"What did you expect?" Twynam said. "He didn't drag his foot."

FIVE

Templex

1 9 6 8

CUSTOMS

Temple Hornaday Fielding was thirty-two—a free-lance writer married to a literary agent and living in New York City—when he went to Europe in 1946 to collect information for the first of the guidebooks that were to make him the most widely consulted travel writer in history. His book, *Fielding's Travel Guide to Europe*, did not tell people what to see. It told them—in earnest dedication to the comforts and pleasures of the travelling creature—what to spend, and where. Fielding was soon operating virtually without competition as counsellor to the millions of American tourists who have traversed Europe in the postwar years, and his closest competitors became, as they have remained, scarcely visible behind him. Therefore, it has been Temple Fielding who, in large part, has directed the great flow of American tourist dollars to Western Europe. For some

twenty years, he has sprayed money in whatever direction he has chosen, and, needless to say, he is looked upon as a kind of national hero in any number of European countries. He has been decorated frequently, and as he approaches an airport in the course of one of his long annual trips, he slides into his lapel the colors of the highest order he has yet received from the country upon which he is about to descend. He is feared as well, for his disapproval can shrink a business and his wrath can kill one. But he does not hunt things down so much as he hunts them up. He wants to praise. He wants to find things that he can recommend. And when he finds them, he leaves new fortunes behind him. Towns and whole regions—Zermatt, for example, and the Algarve coast of Portugal—have grown rich on booms traceable to his words, and all over Europe there are storekeepers, restaurateurs, and even artists who owe their extraordinary prosperity to him. In Paris not long ago, four little American girls went with their mother and father to a glove shop that is recommended in Fielding's book. This was in the off season, but the place was stuffed with large North American ladies, and more were pressing in at its doorway. The little girls were determined to get the gloves they had come for, which were on display in the shopwindow, so they pressed in, too, with their mother, until they had all disappeared from view. Their father wandered off. In another store, where one middle-aged Frenchwoman was quietly shopping, he saw gloves identical to the ones that his children were fighting for a few doors away. Some years ago, Fielding met an English painter who had ample talent but no money, and who travelled around on a bicycle—the only vehicle he owned. Fielding admired the painter's work very much. He said so in the *Travel Guide*. And now the painter—who will readily say that he owes everything to Fielding—goes around in an automobile that cost him twenty-five thousand dollars.

In his younger days, Fielding slept with some frequency in pensions and cheap hotels, but he is now fifty-three and he has slept in his last fleabag. He stays in the most expensive hotel suites in Europe, and not long ago, characteristically, he blew seventeen hundred dollars in five days at the Bristol in Paris. In some other ways, he has not evolved as much as one might expect. Since 1951, he has been a year-round European resident, yet he speaks no language but English. His home for nearly all of that time has been in Formentor, on Mallorca, but, in the words of a Spaniard who is one of Fielding's closest friends, Fielding "cannot make a Spanish sentence." The Spaniard repeats, "Not one sentence. He cannot say three words. It is not given to him. I have been with Temple at times when he has gotten up to try to give a speech of thanks to a group of Spanish people. When this happens, I look at my shoes. I stare at the floor. I die." Except during scenes like this one, Fielding speaks in English wherever he is, and he would do so by choice if he had a choice to make, for he tries to keep himself at all times in the position of the usual American tourist facing European situations and unable to speak the languages of the Continent. He speaks very slowly, syllabically, precisely, and he explains that this is the result of a professional lifetime of trying to make himself understood to Europeans.

Fielding really worries about Americans who travel in Europe. "Please watch your step at Orly," he warns in his book. "The flooring is as slippery as a Marseilles gigolo." When his readers send him letters complaining that they have been cheated in European shops, Fielding goes after the shopkeepers. He writes letters. He makes personal visits. Needless to say, he gets results. He takes on hotels, airlines, whole towns and cities—any place or group that mishandles a "guidester," as he calls the people who carry his book. On their behalf, he has even used private detectives, at his own expense, in an effort to

bring to light suspected malpractices in businesses that cater to tourists.

Since its first edition, the *Travel Guide* has grown from a hundred thousand words to seven hundred and twenty-five thousand, and Fielding's personality is evident on almost every page. About a thousand pages after the beginning, for example, there comes a moment when the author introduces nine minor characters in one sentence: "At Son San Juan Airport and the Palma Harbor in Mallorca, Don Joaquín Torrebella, the *Jefe*, is the soul of Iberian grace and hospitality, while the sunniness of Spain is reflected in the warm and gentle kindness of Don Jaime Canudas, Don Juan Sard, Don Rafael Tauler, Don Miguel Suau, Don José Pérez, Don José Lopez, Don Sebastián Llobera, and Don Angel Gómez Torregrosa." These men are the only European customs inspectors mentioned by name in the *Travel Guide*, and the port of entry they work in is the one nearest to Fielding's home. To bring this small fact wriggling into the light is not an exposure of something discreditable. Fielding has probably been more direct with customs men around the world than has the average reader of the *Travel Guide*, and he is certainly not clandestine. A transatlantic liner once steamed into Fielding's bay bringing two cases of Myers's rum to Fielding, and on another occasion a United States warship of the Sixth Fleet left its squadron and dashed in to Formentor to deliver to Fielding two deck chairs from Hammacher Schlemmer. Or so the stories go.

If Don Joaquín Torrebella and his eight hidalgos were to stop Fielding and make a search of his travelling effects, possibly they would start with a large raffia basket that looks something like a shopping bag. The basket and its standard contents go with Fielding around Western Europe on all his annual trips, which ordinarily last for five uninterrupted months. In it Fielding keeps a bottle of maraschino cherries, a bottle of Angostura

bitters, a portable Philips three-speed record-player, five records (four of mood music and "one Sinatra always"), a leather-covered R.C.A. transistor radio, an old half-pint Heublein bottle full of vermouth, and a large nickel thermos with a wide mouth. He keeps the thermos filled with ice, and the vermouth is Tribuno, which is his favorite brand because it is American and, according to Fielding, was developed with American know-how specifically for use in dry Martinis. Fielding grew up in the era of the four-stack liner and the steamer trunk, and—having a genius for travel—he has more or less forced the era of the jet aircraft to adapt to him. He publishes trim and sensible lists of things that his readers ought to pack for their own trips, but when he himself travels he ignores his own advice. He carries the basket because he noticed long ago that airlines almost never challenge a basket as excess weight. He does not mention this in his book, because he fears what would happen if five hundred thousand Americans were suddenly to turn up at airports carrying large straw baskets. His basket, with a full load of ice, weighs eleven pounds.

Fielding also carries a large calfskin briefcase that was designed by him (it is full of compartments) and was made by Loewe, a Spanish purveyor of stunningly fine leather goods. The forty-one items inside the briefcase are standard on all his travels. In hotels, the first thing Fielding does—after hitting the bellhop with a tip large enough to be called a scholarship—is to reach into his briefcase for his Épernay mustard, his shaker of Ac'cent, and his pepper grinder. He arranges them on his bedside table. They are the condiments of his breakfasts, when he generally has tomato juice, Melba toast, and cold ham. "I hate Continental breakfasts," he explains. "I'm so sick of croissants that I'd rather eat my shoes." Everything in the briefcase is arranged with such care that he can put the briefcase under a plane seat, reach into it without looking, and immediately find

his extra reading glasses, or his sterling-silver paper stapler (by Tiffany), his plastic fork, his plastic spoon, his stud box, his dwarf American cigars, his standard toothbrush, his collapsible toothbrush, his rubber bands, his paper clips, his eraser, his credit cards, his peanuts, his two-inch bottles of Johnnie Walker ("Say we're on a train and we're riding from Saint-Moritz to Zurich and there's no dining car"), his Fernet-Branca ("Nothing can settle the stomach like Fernet-Branca"), his working notebook (specially made by Loewe, with "no distinguishing marks"), his ink, his Scotch Tape, his ballpoint-pen refills, his undercover notebook for surreptitious notes (so small that it can be completely hidden in the palm of a hand), his alarm wristwatch, his Bueche-Girod alarm clock ("It's the world's smallest; it yodels"), his personal calling cards, his stirring rods (one from the Castellana Hilton, the other anonymous), his midget dictionary, his pen, his pencils, his brandies, his American Bible Society pocket edition of Ecclesiastes, his passport case, his *Fielding's Quick Currency Guide,* his matches, his extra lighter, his flints, his bottle opener-corkscrew, his gold notebook (for items that are too secret for his undercover notebook), his extra sunglasses, and his lucky piece—a small Mexican spinning top. He once carried a mink-covered beer-can opener, but he has discarded it. The alarm clock, which is one inch in diameter, and the alarm watch are evidence of Fielding's mistrust of concierges, who sometimes forget to wake him up. In all his years of travelling, Fielding has not once missed a plane or a train. He will probably preserve this record for the rest of his days, because he arrives consistently at terminals at least an hour ahead of his departure time. Only slightly less important to him than his passport and his notebooks are his peanuts. He could not get along without them. He buys Planters Salted Peanuts. Then he dumps them into a sink and runs water over them. Then he scrubs them. Then he dries them and sends

them out to be re-roasted. Then he seals them tightly in a double-walled plastic bag, which, when full, contains a ball of peanuts six inches thick—or two months' supply. He takes them one at a time, as if they were Seconals. Each day of every year, at home and on the road, Fielding reads the third chapter of Ecclesiastes ("To every thing there is a season, and a time to every purpose under the heaven . . ."). In his passport case, along with the usual documents, he will have, typically, six thousand lire, two thousand pesetas, sixty French francs, forty Swiss francs, a hundred and ten Danish kroner, ten pounds and ten shillings sterling, forty-five marks, and three hundred and seventy escudos. He always keeps a large inventory of miscellaneous currency like this—around a hundred and twenty dollars' worth—for what he calls "first use in a country," so that he will not risk embarrassment on the way to a hotel. This implies that he thinks a lot about money, which is not so. Money irritates him, and he won't talk about it. "It just dribbles away" is about all that he will say. Some of his friends worry about him because they feel that he has never saved any money to speak of and that he is too prodigal with what he has. In 1966, he spent eleven thousand dollars on gifts, and his wife, Nancy, told him to cut it out. He plans gifts sometimes for more than a year, purely for pleasure, and only a negligible number of them are the sort that might help the sale of his books. When he gave himself a fiftieth-birthday party in Copenhagen several years ago, he spent ten thousand dollars just to charter an SAS plane to fly in his American guests. "Our tastes are simple ones," he likes to say. "How many meals can a man eat? How many Purdeys can a man shoot?" Fielding's 12-gauge Purdey cost him four thousand dollars, and he says it is not a gun but a work of art.

Fielding uses two suitcases, and in them he packs thirty-five handkerchiefs (all of hand-rolled Swiss linen and all bearing his

signature, hand-embroidered), ten shirts, ten ties, ten pairs of undershorts, three pairs of silk pajamas, eight pairs of socks, evening clothes, three pairs of shoes, a lounging robe, a pair of sealskin slippers, and two toilet kits. Each category is in a separate plastic sack, and Scotch Tape covers every cap and lid. His shoes are built of light and flexible calfskin by Michael Edge, of Trinity Street, Dublin. Fielding has Neolite soles sent to Edge from the United States. "That Neolite is absolutely fabulous for cobblestones," Fielding says—perhaps nostalgically, for there are not all that many cobblestones left in Europe, and when Fielding passes over them he is usually in an automobile. His shirts, sewn from oxford cloth by a Mallorquin shirtmaker, have handmade buttonholes, two pockets, and extra-long French cuffs. On his right hand he wears a gold ring that is shaped like the head of a lion, and the lion has a diamond in its mouth. His suits are all dark-blue or black mohair and are made by one or another of his Roman tailors for a hundred and thirty thousand lire apiece. He wears one suit and carries two. All his suits have upholstered buttons, two watch pockets (one for his saccharin and one for his Zippo), and buttons on the sleeves with real buttonholes—a matter of very great importance to him. The small slit in the left lapel of his suits is cut horizontally, and not on the customary slant, so that his decorations will ride in perfect balance. His ties have regimental stripes and come from Rome. He never wears a hat. His topcoat, which cost thirteen hundred kroner at English House in Copenhagen, is dark blue and is made of vicuña and cashmere. "In other words, I don't look like the loud, brash American with the great big checks on the sports jacket," Fielding says. When he is not travelling, he will sometimes step out for the evening—say, to a restaurant—wearing a blue silk shirt covered with white stars, and silk shoes that match the shirt.

Fielding is quite conscious of the visual impact of the man

within his clothes, and he has done so many isometric exercises and lifted so many weights that his muscles are as hard as marble. A masseur comes to his home three times a week to polish it. There is quite often an implication of melancholy in his face, and this is said to be appealing to women. The expression of sadness, disconcerting within the bright-colored aura of his life, will disappear suddenly, giving way to a big grin or a warm and genuine smile, and then eventually will return. Fielding, handsome and heavyset, with wide shoulders and slow gestures, is a shy man, professionally unshy. Sometimes, when he talks about himself, he almost stutters. His eyes are far from 20/20, but he seldom wears his glasses. He is self-conscious to the point of preoccupation about a small and virtually unnoticeable scar on his nose. He makes frequent references to the size of his ears, which he thinks are extraordinarily large. They are not. For some years, when he was a boy, he hid his thumbs within his fists, because he thought they were so ugly.

Fielding is a man of clear choices. To him, for example, all other people are either good or evil, and he will hear no good of someone he considers evil and he will hear no evil of someone he considers good. He recognizes this as a weakness, and he is the first to insist that he himself is a complicated mixture of pluses and minuses, although he cannot discern such antithetical forces in others. At least two of his friends refer to him as Templex. Fielding often avoids the first person singular; he refers to himself as "T.F.," or uses what might be called a sliding "we." His book is written in the first person plural throughout, and this is apparently intended to refer to him and his wife. In conversation, he does the same, but when he says "we" or "us," more often than not he just means "I" or "me." He once wrote to a friend, "You know us better than anyone alive, except Nancy."

Some of Fielding's American friends believe that he has

become quite European during his long residence on the Continent, and his European friends, for the most part, seem to think that he has remained almost unalloyedly American. There is much double-cheek-kissing in his milieu, and any number of family customs have been borrowed from Continental neighbors. He flies the flags of Denmark and the United States from twin flagstaffs on his black-and-white Cadillac convertible. The first time I ever saw him, he drew up in this extraordinary car, flags fluttering, to an inn where I was staying, on a narrow and unpaved Spanish road. As he got out of the car—wearing slacks, rope-soled Mallorquin slippers, an ascot, and a shirt with red and white vertical stripes of a width that might be associated with football referees—he looked neither European nor American. In his slow, restrained voice, he told me that the flags and the Cadillac were neither ostentatious nor flamboyant. He explained that all Danes fly flags from automobiles, and he went on to say that he considered himself to be in a sense Danish because he had once lived in Denmark, a country beloved by him, like Spain, whose flag he unfortunately could not exhibit on an automobile because there is only one Spaniard who enjoys that privilege.

PROPAGANDA

Once a year, Fielding and a friend of his named Bernard H. Bridges meet in London, and customarily they start drinking to each other's health almost as soon as they shake hands. They keep it up for twenty-four hours. They like to crawl from night club to night club, searching for the floor shows that show the most. What little sleep they get is acquired for an extravagant sum at the Savoy. Fielding is always the host. Bridges, who is now an inspector of buses at the Victoria Coach Station in

London, was for the greater part of his career a bus driver in Dover, but during the Second World War he was a sergeant-major in the water-transport command of the supply corps of the British Army, and for a time, toward the end of the war, he acted as skipper of an Italian schooner that did liaison and rescue work in the Adriatic Sea. Fielding and Bridges met in a village in Dalmatia on November 23, 1944, when Bridges nearly gave up his life in order to save Fielding from capture and, almost certainly, execution. Fielding, who was then a major in the Army of the United States, is guarded when he speaks of this event now. Only in a general way will he indicate what he was doing in Yugoslavia. He was there several times during the war. He was a member of the First Independent American Military Mission to Marshal Tito. He also made several secret forays to Yugoslav towns and cities to disseminate propaganda. It was during one of these trips that he got into the difficulty from which Bridges rescued him. Fielding apologizes for being obscure, saying, "I'm sorry. I don't like to be this way. I can't stand cocktail commandos, and I don't want to sound like one. I was in the O.S.S. The C.I.A. has my file now. It's classified still. They'd be sore as hell if I blew on this." As a result of his work in Yugoslavia, he was eventually given a certificate of recognition and appreciation that said, in part, "Through his leadership and other perilous efforts, he was officially credited with more than thirty thousand voluntary enemy surrenders during the Allied military campaign in the Balkan Theater."

Fielding's military career had begun, curiously enough, with an assignment that had almost as much relevance to his future as the fact that he survived in Yugoslavia. In early 1941, when he was a newly activated second lieutenant, he was called into the office of Brigadier General Edwin P. (Speedy) Parker at Fort Bragg, North Carolina, and told to go right in, the General wanted to see him.

"Fielding?" asked Speedy Parker. "That's your name, isn't it?"

"Yes, sir."

"Fielding, this is the biggest Field Artillery Replacement Training Center in the country."

"Yes, sir."

"We've got five hundred and fifty new buildings right in this area, and there was nothing here but scrub pine and sand five months ago. No one knows how to get to the PX. Everyone asks a thousand questions. We need to write out the answers. What we need is a guidebook, but no one can write it. There have been four tries, all terrible. The chaplain tried, and *his* book was the worst. Would you like to take a crack at it?"

Several weeks later, Fielding's *Guide to the Field Artillery Replacement Training Center, Fort Bragg, North Carolina* was published. Both in tone and in format it was the prototype of *Fielding's Travel Guide to Europe*. Chapters in the Fort Bragg book had titles like "How Do I Get There?" And the Fort Bragg book, like the travel book, was full of helpful suggestions. ("Every week there'll be an inspection. Tip: Get ready the night before. You'll save yourself and your sergeant a mess of headaches. . . . Insurance? There's a special set-up for soldiers, offering them insurance at rates that are ridiculously low. Tip: Your family would appreciate the thought, if anything should happen to you.") Fielding, in April 1941, was describing a tour in the Army much as he now describes a tour of Europe. Speedy Parker liked that very much.

When Fielding was eventually assigned to the Office of Strategic Services, he was trained as a black propagandist. Propaganda was called white when the enemy knew the source. Propaganda material was white, for example, when it was dropped from planes or shot over lines by artillery. "Black

propaganda was a very, very different dish of porridge," Fielding says. "The enemy did not know the source. The material 'spontaneously' sprang up from groups in occupied countries. Once the enemy tied it to the true source, it was finished. The purpose was to undermine the enemy in any way. It was dirty stuff—rotten, nasty. Really dirty, dirty, dirty, dirty things. We used the filthiest Goddamned devices possible, to undermine morale, and we were very successful at it." Fielding's job was to think up ideas for black propaganda and to apply his ideas behind enemy lines. He reported to O.S.S. field headquarters at Bari, in southern Italy, and for a time he was attached to a two-hundred-man O.S.S. Commando unit that had set itself up on the Yugoslav island of Vis and from there made raids up and down the Dalmatian Coast. Fielding frequently slipped off alone to the mainland and, in his words, "did my business all over the damned place." He speaks with evident pain about this period in his life, clenching and unclenching his fists, and he will not say what he did. He goes on, "Then the big night came, the night before Thanksgiving, 1944. I was boxed, hopelessly boxed, and I knew I had had it. This went on all night, the whole bloody night, until five-thirty in the morning. It was a hopeless situation. I held out all that night just by anticipating every move, so I could countermove before it. I was *so* lucky."

While Fielding was being hunted down, someone in the town went for help. The nearest possible source of help was an Italian schooner, the Due Fratelli, which had been seen just off the coast and was known to be functioning in support of the resistance. A boat went out to the Due Fratelli to inform its skipper, Sergeant-Major Bridges, that an American was in serious trouble in the village. Bridges' crew consisted of twelve Italians. He told them to wait for three hours and if he had not

returned by then to sail away without him. Then he rowed ashore in a dinghy and walked in the darkness to the village. Fielding was in an upstairs room of a small house. Bridges apparently shot his way into it and out of it, bringing Fielding with him.

On the schooner, Bridges went into his gear and brought out a bottle of whiskey. Only about six ounces were left in it. Bridges drank three and gave Fielding the rest. Then Fielding told Bridges that it was impossible to say what he felt or to do anything adequate in return for Bridges' heroism but that after he got back to the United States he wanted to buy a gift for him. Fielding said, "All I want to know is: What in America would please you the most?"

Bridges said he wanted nothing. Actually, he was somewhat surprised. On a similar occasion, when he had saved the life of a British officer, the officer had said, "Thank you very much, Sergeant-Major," and that was that.

But Fielding kept pressing, and finally he could see that Bridges, standing there on the schooner's deck, was thinking seriously about the offer. Slowly, Bridges thought it through, and then he said, "There *is* one thing that I would like to have."

Cadillacs and Chris-Crafts flashed in and out of Fielding's mind, and he promised himself that even if he needed twenty years to pay for it Bridges would get what he asked for. "Anything," Fielding said. "What is it?"

"Well, if it wouldn't be too much trouble, a set of pinup pictures from *Esquire* magazine," Bridges said.

Fielding eventually sent him a hundred and fifty pictures. For more than twenty years, Fielding has been telling people how, that day on the Due Fratelli, he learned exactly how much his life was worth. Bridges, for his part, values Fielding more highly now. He worries about the hazards of Fielding's work,

and he repeatedly urges Fielding to be careful. As he put it in a letter to Fielding several years ago, "A lot of nasty things can happen sometimes in these foreign places."

When Fielding is in Dublin, he stays in one of four suites on the top of the Gresham Hotel, and they are his favorite hotel rooms in the world. He glows like an ember when he describes these rooms. Each suite has a kitchen, a sitting room, two baths, and a bedroom. Peat burns all day in the fireplaces. Each sitting room has a fully stocked bar, and a chambermaid takes notes on what is consumed. Floor-to-ceiling windows look out on a terrace, beyond which the city and the River Liffey are spread to view. One has one's private butler there. The mattresses are "good Irish ones." The flowers are fresh, and the cost, in Fielding's view, is virtually nothing—eighty-seven dollars a day. In the way that some tourists go from cathedral to cathedral, Fielding goes from hotel to hotel. His interest is obviously supra-professional. He says that he can remember the details of every hotel room he has ever stayed in. A hotel room is a work of such artistic consequence to him that he visibly shudders when he remembers some of the failures he has slept in, and he says, "Thank God we've reached the point where we don't have to stay in horrible, sickening, grimy dumps any longer." When he is in Venice, he stays in Room 110 at the Gritti Palace. "The door is here—there's a round table here," he says, re-creating the room in space. "The fabulous thing is the over-all Venetian taste—the deep golds, the rich colors. One really feels that one is in old Venice, fine Venice, Venice in its glory. Yet the Gritti is modern as hell in its comforts. It's damned expensive." The room at the Gritti is one of three

coequal favorites that he places just after the suites in Dublin, the others being the penthouse of the Bristol in Paris and 471–473 at the Palace Hotel in Madrid. The Bristol penthouse is a duplex with a private internal elevator that lifts the paying guest—he is paying NF 1,150 per day—to either of two Louis XV bedrooms or takes him down to the writing room, the panelled library, the sitting room, and the dining room, which seats twelve. All this agrees with Fielding, but is not as close to home as the flowing rooms and high ceilings of 471–473 at the Palace Hotel in Madrid. "Sheer comfort," Fielding says. "I just love that place." He has stayed in 471–473 for nearly a year in accumulated time. When distractions have slowed his work in Formentor, he has gone to the Palace to write, and has remained in 471–473 for more than a week without once coming out. Fielding thinks the Ritz in Lisbon is the finest modern hotel in the world. He is awed by the virtuosity of the Negresco in Nice, which has two hundred and fifty rooms, each different in décor from all the others. He has a special fondness for the Love Nest, a downy suite in the Dolder Grand in Zurich. And he greatly admires the "client attention" at the Savoy in London, where the staff outnumbers the clients by three to one, and where files are kept on clients' tastes and preferences. "Clients" is the Savoy's word. There are no "guests" there. In the early days of Fielding's clienthood, he once asked for guava jelly, and the Savoy kept giving it to him until he was thoroughly sick of it. Finally, after nine years, he developed enough courage to ask the Savoy not to give him guava any more.

Fielding last went to the Eiffel Tower sixteen years ago, and he wouldn't have gone then if it had not been for a business luncheon in the tower restaurant. Once every ten years, he will surprise himself and go to Westminster Abbey, but he is not a sightseer. He explains, "When we started, we worked through national tourist offices, and we were dragged by the earlobes

through every God-damned gallery, tomb, cathedral, castle, and stoa. We had such a tremendous overdose that now I just loathe sightseeing. When a city builds a new TV complex that is really spectacular, or when a new cathedral is built, like the one at Coventry, we go see it, but the tombs and the statues and so on—to hell with them." He prefers to absorb culture in optimum comfort, and he reads books in bed by the hundred each year. He does go with some frequency to the major art museums of Europe. His taste in museums has wide dimensions. On visits to London, he almost always has a fresh look at the waxen forms at Madame Tussaud's. "I enjoy them," he says. "Maybe it's ghoulish, but it's fun." Fielding publishes a *Selective Shopping Guide to Europe*, but his contribution to it is prose alone. "I hate shopping," he says simply. "When we're travelling, Nancy does ninety-nine point nine nine nine per cent of the shopping." Although his reports on night clubs are the result of tireless visits, he despises night clubs, too. Thus, for the most part, Fielding's Europe narrows down to hotels and restaurants, and when he is in a favored example of the one or the other, he is in the Europe he knows and likes best. Fielding's Switzerland, for example, consists not only of the Love Nest in the Dolder Grand but also of Bündnerfleisch and rösti potatoes. His Germany is primarily sausage. His Belgium is a coiled green eel. His France is, in his own words, "fresh crevettes with a Chevalier-Montrachet 1947, pheasant en papillote with wild rice, mashed turnips, romaine salad, a Romanée-Conti 1937, ice-cold melon, a Port du Salut, a Delmain Cognac —about 1928—and espresso without caffeine." Experts who have scanned this menu say that Fielding may not show much confidence in his choice of wines but that he more than redresses the balance by slipping turnips into a meal like that one—surely the mark of an experienced fork who has been through all the phases of gourmandise and now encounters him-

self coming the other way. As rarefied as his buds may be, however, Fielding's taste remains American, and more often than not he likes to secure his day with a dry Martini. When this has presented a problem, he has overcome it. Some years ago, Martinis of any quality were insignificantly available in Europe, but now there are good ones from Finnmark to Andalusia, and it is possible that Fielding will be remembered as Johnny Martiniseed, the man who ingratiated himself with several thousand European bartenders and then—almost always getting behind the bar himself—taught them how to make his favorite drink.

By and large, Fielding's Europe is peopled by American tourists, and if the fabric of his Europe were to be pulled away from Europe as a whole, a great deal would remain. "We have led people into certain byways," he will say, "but in general we try to follow tourist patterns." In the current *Guide*, Fielding has written fifteen hundred words on Marseilles and four thousand on Torremolinos, a coastal village in southern Spain that has had a fad as a resort in recent years. The *Guide* has a chapter on each of twenty-five countries and also has separate chapters on Mallorca, the Greek islands, and the French Riviera. Fielding is exhaustive on the places he covers and unconcerned with other places. "A place that's a hundred per cent French or ninety-nine per cent Italian may be great, but an American just wouldn't be happy there, so we leave it out of the book," he once said to me. "We won't go to Trieste this year. It's not too popular with Americans." It is no strain on him to scratch out ten thousand square miles of southern Italy ("There's nothing between Salerno and Reggio—just a waste") or a similar chunk of Germany ("The area between Düsseldorf and Hamburg is not important"). He has never been to Sardinia or Corsica. In his England, there is practically nothing between London and York. He describes Spain as "an

insipid picture in a million-dollar frame," and with the excep-
tions of Madrid and the tourist triangle in Andalusia—Gra-
nada, Cordoba, Seville—his Spain is predominantly coastal. He
dislikes some European tourists, and where they go he goes
lightly, if at all. The upper Adriatic coast of Italy is a badlands
for guidesters, he pointed out to me, because so many Germans
go there in summer that even the signs along the road are in
German. "Germans are O.K. in ones or twos," he said, "but
they are terrible in groups. You can spot a German group a mile
away, and hear them farther than that."

Fielding thinks that the most commendable traveller in
Europe is the Englishman, who as a rule is knowledgeable and
well-mannered. Fielding has been told by his hotelier friends
that English people will accept absolutely anything that is
served to them, and no matter how dismal things get they will
not complain. Apart from this unmatchable type, the American,
in Fielding's view, is the best tourist in Europe. The day of the
incandescent creature in the Hawaiian shirt may not have
ended, but the American rube, once the only travelling boor on
the Continent, now has peers from many nations. European
tourists are all over Europe each summer, and one has to hunt
for gauche Americans among the competition. Meanwhile, the
ungauche Americans—or most Americans who take vacations in
Europe—generally stand out in the other direction. "The
Americans come right after the English," Fielding told me.
"They're the most open. They're quiet. They don't complain.
They are mannerly. They're honest. They tip well. They're
generous of themselves. They dress well, or most of them do.
One idiosyncrasy that astonishes Europeans is that Americans
write letters of appreciation for extra kindnesses. In a hotel, if
they're not satisfied they just pay and move out. The image of
the American tourist has completely changed among hoteliers
over here. Of course, there are some Americans who are loath-

some. Some of them put their cowboy boots up on restaurant tables. Some of them try to haggle in Fortnum & Mason." Fielding's book is full of schoolmarmish warnings against sloppy dress and gross manners. He has done a great deal to improve the image he now applauds, and he wants to keep it that way. Once when I was with him in a Spanish city, he ran after a taxicab, stopped it, stuck his head into it, and bawled out three Americans whom he had seen being rude to an elderly Spanish woman a few moments before. Recently, he received a number of letters in which tourists complained about some of the fine old hotels of Europe. Comfort may be important to Fielding, but never at the expense of atmosphere. He inserted a thousand-word sermon in his book telling his readers that what they were complaining about was, among other things, precisely what Europe had to offer them. When Europeans deride Americans in Fielding's presence, they sometimes have a scene on their hands. "We won't tolerate anti-American talk," he said. "We used to be polite about it, but no longer. We flip on this, Nancy and I both."

Fielding said that the most frequent criticism of his book is that "we shoot for the snob reader," and he added, "Possibly there is a great deal of justice in it." But he doesn't follow the strawberries. In *The Rich Man's Guide to Europe*, Charles Graves uses that expression to describe the high-snob itinerary —being at Baden-Baden for Race Week, seeing the polo at Cannes—and what is hypertypically nibbled along the way. One knows when to be in Saint-Moritz or Deauville and when not to be. One tries to be in Gstaad in February for the Gala at the Palace Hotel—if one is one again after New Year's Eve in the Hôtel de Paris in Monaco. One tries, but Fielding does not. These are not the scenes he is trying to make, and he says of each of them, "Once, once is enough." Fielding does not make a strong impression at such events anyway. "The minute Tem-

ple puts on a dinner jacket, he is the most boring man on earth," a close friend of Fielding said to me one evening. "He is a very small little person inside, incredibly shy." There are hierarchies in snobland, and the criticism that is aimed at Fielding usually refers to nothing more than that he writes at length and with particular affection about expensive hotels and restaurants. Fielding has no single category of reader in mind when he writes, and last spring, for travellers on low budgets, he published a *Super-Economy Guide to Europe*, which sold a hundred thousand copies in paperback in its first month. Nonetheless, there is a personage farther up the money scale who makes frequent appearances in Fielding's consciousness as he writes. Fielding described him to me as "the banker in the small town who is a big shot, has security and respect in his community, and to whom Europe is a jungle." For this man—"who wants to get a smile, a good table, be well received"—Fielding has created Temple Fielding's Epicure Club of Europe. Members pay fifteen and a half dollars for a set of thirty cards, each of which serves as an introduction to a different European restaurant, all of them being first-rank and well-chosen places, such as Lasserre in Paris and Horcher's in Madrid. Fielding is selling prefabricated prestige, and it works. When a card carrier walks into one of the restaurants, he is treated even better than he would be in a restaurant within sight of his bank. He and his partner are seated in a prime location. So many waiters surround the table that it seems as if one of them is about to call a play. A round of "complimentary" cocktails is served. And the maître d' goes out of his mind. Maxim's, of Paris, which has held three stars in the *Guide Michelin* for a great many years, used to be a part of the Epicure Club, but Fielding dropped it for not meeting his standards.

When Fielding talks about a restaurant or a hotel, he frequently displays an intimate knowledge of the personalities and

personal histories of the chef, the headwaiters, the boss—the whole staff—and even their wives, naming them all by first names. A high percentage of his friends are hoteliers and restaurateurs. He goes on vacations with them. They visit him at his home. Among the people he refers to in casual conversation, none are more recurrent than his friends who run hotels and restaurants. "A good maître d' is always on patrol, snapping," Fielding will say. He should know. On more than one occasion, Americans entering the Bali in Amsterdam have been greeted by a friendly middle-aged maître d' who surprises them with his flawless English and answers their inevitable questions by saying, "I was in America once. Now I am here." He shows them to the best table he can give them. He makes discreet suggestions. He is always on patrol—snapping. Fielding does this, he says, because he wants to see how Americans look from a maître d's point of view. The owner and real maître d' at the Bali is a pal of his named Max Elfring. Fielding envies Max a little, for Max has all that restaurant to himself. Fielding wants to see, as well, how it feels to be Max.

His regard for hoteliers can amount to something like hero worship. "You can never fool a hotelier—no matter what—if he's good," Fielding told me. He described the steps of a hotelier's typical career as if he almost wished that he himself had followed it. "In their apprenticeship, they go through the patisserie, the cold kitchen, the hot kitchen, the spirits section, and on into room service," he said. "They're waiters. They go into engineering. They become assistant concierges. The dream, after they have moved around, is to get into reception. From there it's a straight line to *chef de réception*, assistant manager, and manager." Fielding won't say this in so many words, but he obviously thinks that the best hotelier in the world is Alfonso Font Yllan, managing director of both the Ritz and the Palace in Madrid. Fielding and Font have been friends

since 1946. Remembering Fielding when he first met him, Font once told me, "His line was not yet drawn. He was very plain, but he knew what he wanted. He liked wines. Good food. I thought that unusual in an American." Now, when Fielding sequesters himself in the Palace to work, Font appears most evenings at seven, pours a drink, and sits down to talk for an hour. Font's Palace is the largest hotel in Europe, and his Ritz is one of the most exclusive. He has said to Fielding many times, "You run a hotel like your own house, where you have friends." Fielding has taken this precept and reversed it. He runs his home as if it were a hotel, and, considered as a hotel, it is surely without parallel in Europe.

When a guest awakens at Fielding's home, he presses a button and a pretty chambermaid appears with a breakfast menu that is decorated with a sketch of a sunrise over the bay below the house. On the chambermaid's uniform, as on the uniforms of other members of the staff, are the words "Villa Fielding." The menu offers three kinds of fruit juice, eight kinds of cereal (including Rice Krispies, Corn Flakes, Shredded Wheat, and Grape Nuts), eggs in eleven styles, ham, bacon, sausages, dried beef, butifarra, creamed chicken on toast, liver and bacon, kidney and bacon, four kinds of fish, pancakes with Vermont maple syrup, eighteen kinds of baked goods, champagne, coffee, tea, hot chocolate, gaseosa, beer, assorted jams and jellies, Skippy peanut butter, three cheeses, and eight kinds of fruit. (At lunchtime, the resident chef, Rafael Pons, appears wearing a tall white hat and carrying a menu that is headlined "Rafael Recommends.") There is only one guest room at Villa Fielding, an outside double, with view—looking down a pine-covered hillside and across the mottling blues and greens of the Bay of Formentor to the cliffs of the Cabo del Pinar. Close to hand, for the guest's convenience, are Alka-Seltzer, Bufferin, Mercurochrome, Band-Aids, Noxzema, a bug bomb, sleeping

masks, and a fever thermometer. On the back of the bathroom door is a permanent notice:

> The small jar on the washbasin contains a special detergent to remove suntan oil from the body.
>
> Tap water saline, drink from carafe at bedside table.
>
> We always leave both windows wide open while showering in the sunken tub in order to enjoy the lovely view of the sea. No one would ever watch you, so please have no trepidations about this possibility.
>
> You will find a continental-style peignoir for your after-bath toweling.

Built of white stucco on a steep hillside, Villa Fielding is landscaped with a blaze of bougainvillaea, and plastic ivy climbs the columns of its sweeping terrace. Flags fly from a cantilevered flagstaff, selected from a large collection according to the nationalities of guests who may be there. Because of the declivity of the hill, the house has, in effect, two ground floors. Fielding's office, like the guest room, is on the lower level. The office is small and crowded. He works at a U-shaped table. The walls are covered with certificates—the first Equator Certificate ever issued by Ethiopian Airlines, a "Hangover Chart" from the late Shepheard's Hotel in Cairo—and the place is full of little doodads of the sort that public-relations men are forever giving to travel writers. Fielding seems to be touched by these gifts and to see them as gestures of personal affection. The calendar he uses is Pan American's, because his name is printed in large blue letters across the bottom of it. "Since it is personalized, I use this one," he told me.

At cocktail time, Fielding tends bar along with his assistant manager, Martín Cifre, who also acts as bellhop, butler, and chauffeur, and who has his own office in the building. The bar is in the living room, which is decorated with still-lifes and

nudes by the English painter Michael Huggins, and among dozens of souvenirs there is a handprint pressed by the Fieldings' son into solid gold. (Their son, Dodge, is their only child, and is now a junior at Hamilton College.) From a mass of bottles concentrated on the living-room floor, a visitor can choose any of some hundred and twenty different drinks from all over the world. Fielding has Irish moonshine, "non-poisonous Italian wood alcohol," 136-proof Spanish absinthe. Of the absinthe, he told me, "It is genuine absinthe, with the wormwood elixirs in it. It's not a beverage, it's a narcotic. We never drink it. It's for friends." For dinner, the Fieldings might serve turkey, cranberry sauce, and corn on the cob. Their meals are, like their flags and their liquors, intended to make their guests feel at home. They offer steamer clams for New Englanders, haggis for Scots, couscous for Moroccans, tortillas for Mexicans, bamboo sprouts and water chestnuts for Orientals, raclette for the Swiss, and, for Southern Americans, hominy grits, turnip greens, black-eyed peas, and White Rose yams. The cost of importing all this into Spanish Mallorca is very large, and Fielding hungrily pays thousands of dollars in duty to the postal authorities each year. He brings in kerupuk from Indonesia, truffles from the Périgord, and cornmeal from Louisa, Virginia. The Fieldings like Mallorquin food, too. Mrs. Fielding once said to me, "We try to live off the ground here as much as we can."

After dinner, over a frozen blue liqueur, the Fieldings sometimes flatter their guests with a Danish custom they have adopted that they call the Skål Ceremony. Going around the table, Fielding addresses each guest in turn, delivering a deep analysis of the guest's first name, giving its origin and etymology, and citing all the *other* great people who have shared the name. If a guest happens to be called Paul, for example, Fielding will solemnly mention that his name was Paulus in

Latin and Paulos in Greek, and he will liken the guest, if the comparisons seem at all appropriate, to Paul Gallico, Paul Tillich, Paul Scofield, Paul Gauguin, John Paul Jones, St. Paul, and Pope Paul, always with full explanations of the similarities involved. As Paul turns slowly into a pillar of crimson, Fielding finishes the address by lifting his glass and skåling him. Fielding will do absolutely anything to make a guest feel very special and very much at home. Once when Alfonso Font checked in at Villa Fielding, he found that Fielding had equipped the guest room with ashtrays, stationery, blotting paper, glassware, bedspreads, bath mats, towels, and soap from Font's Palace Hotel. Fielding's friend MacKinlay Kantor wrote a part of *Andersonville* at Villa Fielding, and when Kantor returned a year or so later he found that his bed had been fondly enclosed with barbed wire.

COMING BACK FROM KANSAS

"In 1928, I started off on a trip to Kansas with my sister, Loraine, in a Model A Ford," Fielding once said to me in conversation. "We had relatives in Kansas. I drove. It was hot, hot summer weather, and I was wearing gray flannel slacks, a flannel sports jacket, a shirt, and a tie. The humidity was almost unbearable. While we were still in Pennsylvania, I said I thought I would remove my jacket and tie, and Loraine said, 'If you do, I'm going to get out of the car and take a train home.' The next day was even hotter, but she said the same thing. Loraine was two and a half years older than I was. We bickered all the way to Kansas, and whenever I said I wanted to remove my jacket she said, 'We can't look like tourists,' so I gave in.

"Our home was in Stamford, Connecticut, then, but I had been born in a thirty-two-room house in the Bronx. My father

didn't care much for children, and I had a poor relationship with him when I was a boy, but this changed as I grew up, and we got along better and better the older I got. I called him George. He was an electrical engineer. He was a true genius. He held twenty patents at one time, including one of the first patents for an electric dishwasher. My grandparents, the Hornadays, lived with us. My grandfather, William Temple Hornaday, was the one who had the most pronounced influence on my life. He was really the greatest man I've ever known. He selected the site for the Bronx Zoo, he laid it out, and surveyed it himself. He was director there for thirty years. This ring I have—see the lion, with a diamond in its mouth?—belonged to my grandfather. He was a terrific fighter for things he believed in. He fought like hell for the first seal bill, and the egret bill. He was a conservationist, but he was also a sportsman. He shot, and mounted by himself, the buffalo that was used as the model for the buffalo nickel. From him and from my father I got whatever moral code I have—to try to be decent, be honest, be a gentleman.

"I was the middle child of three. My younger brother, Dodge, was the closest friend I ever had. He fought in the Solomons, the Russells, and Leyte. Just at the end of the war, on Luzon, he was doing reconnaissance in a jeep when he was killed. He had grenades all over the floor of the jeep. He came to a crossroads, and a Jap threw a grenade into the jeep and it detonated the others. I still dream about him. My sister was the golden girl—always No. 1. She was *so* beautiful, *so* ingratiating. She had straw-blond hair, and the boys flocked to her. She had everything—on the surface. She summered in the West and was a hell of a good rider. Her first book, *French Heels to Spurs*, was published when she was sixteen. She sold stories to *Collier's*, *Redbook*, the *Saturday Evening Post*. She wrote movies for Metro-Goldwyn-Mayer, and lived in Holly-

wood for three years. She came home with a mental breakdown. She never wrote again. She never married. She lived the rest of her life at home. She was—all her life—the most unhappy human being I've ever met. She was tied to my mother by a silver cord. As a young girl, she went to eight or ten private schools. She would complain, 'They make me finish my oatmeal,' and Mother would say, 'Oh, poor darling,' and pull her out of school. Loraine leaned on me. If she was unhappy at a dance, she called home, and I went and got her—by duty, not desire. She was the golden girl. On that trip we made to Kansas, I never took my jacket off once, all the way out there, and we kept on fighting about it on the way home. 'We can't look like tourists,' she kept saying. Finally, on a boiling day in Urbana, Illinois, I said, 'To hell with it, I'm going to take off my coat.' She threatened again to go home on the train. I said, 'Go.' We had a hundred and twenty dollars left. I kept thirty and gave her ninety. Then I raced for home, in the car, alone, trying to get there first, so that I could be the first to tell the story. I drove thirty-five hours, straight through. When I arrived, Loraine had been there for an hour and a half. Everyone—everyone but Dodge—was extremely cold to me, and, with no voices raised, they tore me apart in their dignified way. My mother. My father. Finally, my grandfather held up his hands for silence and he said, 'The boy is tired. Let him go to bed. We'll discuss it tomorrow.' "

METHOD

By the early nineteen-sixties, Fielding had expanded his coverage to such an extent that he and his wife could no longer manage to recheck each year all the places that had appeared in the *Guide* the year before. So they hired a young couple, Joseph

and Judy Raff, to assist them. The Raffs and the Fieldings now divide Western Europe between them, and they exchange areas of responsibility each year. (Curiously enough, these four, who are among the most widely travelled people in the world, all dread flying.) During the writing months in Formentor, Joe Raff, who was once managing editor of the *Daily American* in Rome, drafts nearly all changes or additions to the *Guide*, and Fielding has become, by his own description, more or less like a senior editor at *Time*, energetically pencilling Joe's draft until the material to be inserted is pure Fielding-ese.

Assessing his methods one day, Fielding said, "People think, 'Here is a guy who makes Jovian, Lippmannesque judgments.' But we don't want to be Jovian. We're not Zeus on Olympus. The book is not only Nancy and myself and Joe and Judy. It's as judicious a blending as we can get of hundreds of thousands of opinions." Fielding has set up a network of confidants in all the countries of Europe—people to whom he sends pages clipped from the *Guide* for criticism and suggested revisions and additions. The network is secret. It includes about seven people per country. It changes frequently, and it consists largely of businessmen who impart to Fielding all the gossip they hear about businesses other than, but related to, their own; a florist, for example, will know a remarkable amount about what goes on in hotels and restaurants. Fielding also has diplomats in the network, military personnel, a medical doctor, an antique dealer, and a maker of champagne. About half are Americans.

Fielding's readers are a network in themselves. They write letters to him by the hamperful, and he studies each one for clues and ideas. People sometimes return to the United States after a trip, sit down, and write forty or fifty thousand words to Fielding telling him all about it. Occasionally, the writers have their letters bound between hard covers before sending them. "No one at home wants to hear about anyone else's trip, so they

write to us," Fielding explained. Going through all the mail is a wearisome task, but in the aggregate the letters tell him when he is wrong about something, and inform him of new places that he ought to see for himself.

On the road, Fielding carries one guidebook other than his own. He uses the *Guide Michelin* in France. Otherwise, he no longer does more than riffle through his competitors' work. He riffles once a year, in Brentano's. He explains that he does not want to risk remembering anything in anyone else's book, for there is always the possibility that it will come rising out of his subconscious when he writes. He has little respect for many of his fellow travel writers, and he suggests that some of them are journalistic cuckoos who make their living on other people's research, usually his. Among "the clean guys," as he calls the good ones, his respect seems to go most strongly to Sydney Clark and Eugene Fodor. He describes Fodor as "a very nice, conscientious, hard-working guy who is perhaps our closest competitor." Fodor lives in Litchfield, Connecticut, and edits material written by resident stringers in the various countries. Fielding says that a Fodor guide is thus only as good as the local writer, and that, over all, the Fodor guides are uneven. Fielding does not think much of Arthur Frommer's *Europe on $5 a Day.* "We don't respect Frommer," he told me, in an even, sad voice. "That's why we wrote the *Super-Economy Guide*." Books like Samuel Chamberlain's *Bouquet de France*, David Dodge's *The Poor Man's Guide to Europe*, and Kenneth R. Morgan's *Bed, Breakfast, and Bottled Water* receive Fielding's unreserved praise. He regards them as non-competitive with his own and says, "Thank God none of those men ever undertook to do complete travel guides to Europe."

Wherever Fielding goes, he often pretends in taxicabs that he has no understanding of local currency. He holds out a palmful of change and asks the driver, by word or gesture, "What shall I

give?" Only once in twenty-one years has a London cabbie taken advantage of him. In Italy, the cabdrivers take everything he has in his hand. He has also been cheated in Spain, Germany, Belgium, Switzerland, Holland, Austria, and France. The Scandinavians are like the English, and the Finns will accept no tips at all. Arriving at a hotel, he continues his working day by going through all public rooms, sitting down in the lobby, making notes, and then identifying himself to the manager and asking to see at least seven rooms. On rare occasions, the manager says that he is much too busy for such nonsense (this happens in Germany more than anywhere else), and Fielding turns purple and begins to hammer the nearest surface with the side of one hand. He carries such skirmishes right on into the pages of his book, sometimes blasting a hotel manager while praising the hotel itself. When he is shown a hotel room, he pauses in the doorway and forms an impression. "It's amazing how quickly we can cover hotels, after twenty-one years," he said. "Décor, bedside lamps, furniture, curtains, radio, wardrobes, general illumination, grease spots—if something is missing or wrong, it clicks into our heads and we notice." He turns on the shower. He lies down on a bed. If the tub seems small, he gets into it. He looks under beds and runs his finger along the lintels over doors. Frequently, the rooms he is shown contain suitcases and other personal effects of travellers who are out sightseeing, or whatever. Often he sees copies of his book resting on beds or night tables, and when this happens he likes to take time to look through the book and see how much use it seems to be getting. If it is heavily annotated and well worn, he will take out his pen and inscribe it, saying, "Many thanks and happy travelling."

Fielding says that he "could name on one hand" the night clubs he likes, but on a research trip he will frequently go to fifteen in one night. He takes a car and a chauffeur, saves the

best club for last, and invites the driver into that one for a drink. He pays five or ten dollars to check out each night club on his list. "I go in and order a Scotch-and-soda, and I don't specify the brand," he said. "Up comes a so-called Scotch-and-soda that consists of raw alcohol, cheap cognac, caramel, and a little Scotch. I smell it, and sip it. It has a hot taste. In eighty-five per cent of the night clubs of Europe, the whiskey is false—sometimes at seven dollars a drink. The biggest cross we have as reporters is that we have to be suckers, knowing that we're going to be sheared."

Calling a restaurant to make a reservation, Fielding uses a false name. More often, he just walks in cold, as most Americans do. To examine an important restaurant, he will sometimes arrange to eat with a group of local friends, who camouflage him. He is not always as successfully incognito as he would like to be. A waiters' strike in Italy was postponed when leaders of the national waiters' union were informed that Fielding was in the country. He orders a restaurant's specialty, no matter what it is, and he frequently times the service with a stopwatch. He has test dishes—omelettes, vol-au-vent, Coquilles St. Jacques—which he, or those with him, will also order as standards of comparison with other restaurants. He may eat two lunches and two dinners, in four different restaurants, during one working day, and he has developed a method of piling up the food he leaves so that he appears to have consumed more than he has. "The trick is to leave as much empty space as possible," he explained. "Make piles. Leave a bean or two in an obvious place. Push all the rest around to one side of the rim of the plate and set the knife and fork on it. We are absolute masters at this." Fielding has another move that is ingenious in its conception and almost flawless in execution, even when tried by amateurs. If he wants to stare at what is going on at a neighboring table—to study the service, say, or the foods presented, or

perhaps just a beautiful girl who happens to be sitting there—
he slowly lifts one arm and points toward the ceiling, talking all
the while, as if he is commenting to his dinner partners about
the architecture or décor of the restaurant. Slowly, he turns. His
arm, still raised high, gradually gestures in a broad sweep across
the ceiling and down a distant wall—and by this time Fielding
has twisted almost completely around and is gazing steadily at
the object of his interest. No one at the neighboring table
seems to suspect what he is doing or even to notice him at all.
And yet if he had merely turned around, they would, by this
time, be shooting him with annoyed glances.

Fielding's Travel Guide to Europe discusses some twenty-
five hundred restaurants, but there is one restaurant that he con-
siders too good to mention. He doesn't want to spoil it. It is in
Inca, a town twenty miles from his home.

MONEY

One night in 1933 in New York, Fielding was dancing on the
roof of the Hotel Pierre with a débutante. Fielding was nine-
teen, and she was the girl not only of the hour but of his
dreams as well. She was undebatably beautiful, with dark hair
and dark eyes, but after all these years Fielding probably would
have forgotten her if during that evening in 1933 he had not
been humiliated beyond repair. It was a curiosity of that time
that a boy like Temple Fielding could frequent places like the
Pierre but could not afford to take his girl to a Childs Res-
taurant. Fielding's father had lost all of his money, and his job,
as a result of the stock-market crash of 1929. For nearly seven
years, the Fieldings would live almost wholly on the pension of
Temple's grandfather. Fielding remembers with pride how
uncompromisingly his family "kept up the front" during those

years, and his memory of his father in that era is of a man who "deliberately exuded an air of security, kept himself properly dressed, and showed no sign of trouble, but was dying inside." Fielding thinks that, in long-range perspective, the Depression was the best thing that ever happened to him. "In 1929, I was a dilettante," he said to me. "I was a little snob—the son of George Fielding and the grandson of the great, illustrious Dr. Hornaday. I had my own car, a little brown Oldsmobile. I must have been insufferable. I thought I was it. I had everything. I had all the spending money I needed, and I spent a lot. I had plenty of girls. I've always had the good fortune to get along very well with girls. I had a very speedy reputation, very rakish for a boy that age. I was a beautiful dresser. I've always loved clothes. The Depression made scars that will never be eradicated, but it was like combat—trial by fire." In 1933, his family could ill afford an automobile, but having one was a part of keeping up the front, and Fielding would use the car to go to débutante parties in New York, such as the one that night at the Pierre. As the dance approached its end, someone suggested that the whole crowd top off the evening at Childs on Fifty-ninth Street. In misery, Fielding had to retreat. He needed two dollars to be on the safe side of whatever his girl might order, and he had in his pocket exactly nothing. The last thing on earth he would have done was borrow the two dollars from a friend, thus exposing his embarrassment, so he made excuses and said that he had to go home. He went into the washroom before he left, and while he was staring suicidally at himself in a mirror the door to the washroom opened and in came a man who appeared to Fielding to be all but walking on affluence. He was wearing "a tailcoat that could only have been cut by Bell," and as he stood before a washbasin he casually unbuttoned his coat sleeves. What Fielding noticed above all else was that the

buttons on the sleeves actually worked. The man turned up the sleeves and washed his hands. An attendant whisked away at his back and shoulders. The man turned down the sleeves and slowly rebuttoned them. He then reached into a pocket, took out two dollars, and gave them to the attendant. Driving up the Post Road on the way home to Stamford, Fielding said to himself, "Someday you're going to have enough money so you can have real buttonholes on your coat, too." He drove on for a while. He stopped for a red light, and while waiting he said it again.

Among the things that disappeared from Fielding's life in the aftermath of 1929, travel was one. As a young boy, he had twice gone on vacation trips to Europe. In the first few years after the crash, he went almost nowhere but around Stamford, selling refrigerators. He had flunked out of prep school in 1930, and at the age of sixteen had gone to work as a full-time salesman. Despite the Depression, he did quite well, but in 1932 the sales company he was working for collapsed beneath him. He found jobs when he could. He ran a Connecticut beach club for a while, and worked for a firm of "management engineers" in Rochester. Soon people began to ask him where he had gone to college, and when he told them that he had not even finished secondary school they almost invariably had no other comment than "Oh." This gradually became unbearable, so at the age of twenty-one he entered Stamford High School as a senior. In one year, he took physics, history, English, three years of French, and three years of mathematics. More as a reward for his valiant effort than as a result of his college-board examinations, Princeton admitted him to its Class of 1939 and arranged for a part of his expenses to be paid through student loans. He would eventually be graduated with honors.

Fielding twirled two batons as he marched ahead of the band

at football games during his college years, and he also wrote for campus publications, but most of his free time had to be used in pursuit of money. He avoided the two jobs that were generally associated with students in his financial category: he never waited on table and he never washed dishes. Instead, he farmed his own considerable ingenuity. He ran a sheepskin-coat concession. He organized a lottery that yielded, each time it was run, a hundred dollars to the winner and a hundred dollars to Temple H. Fielding. While he was still counting the first of these hauls, he hurried to a travelling representative of the tailor Arthur Rosenberg, and was measured for a suit that would have functional buttons on its sleeves. Fielding still has Rosenberg's receipt, for seventy dollars. And that was only the down payment.

Money was never something to save. When Fielding has had it, he has spent it. For the past twenty-five years, during at least half of which his savings have been less than zero, his automobiles have always been Cadillacs. The early ones were used Cadillacs. All have been black convertibles with white tops. Fielding had a beat-up used Cadillac in the late nineteen-forties, when he was living in New York and working on the first *Travel Guide,* and for a time the car was about the only asset he had. First, his own money ran out. Then the reserves of his wife's literary agency became exhausted. So for three months the Fieldings had codfish cakes and beans every day. Not until 1955 did Fielding fully return to the easeful sense of money-to-spare that he had enjoyed when he was fifteen. In 1955, he cleared the last of his debts. He had, of course, been throwing money about with innate abandon during his travels. He did not become a big-time spender in 1955; he merely became a solvent big-time spender. He has always spent, one would judge, at least twice as much as might be necessary for

his field researches. His departures from hotels could be set to music. His aggregate tip always amounts to more than forty per cent. "I tip too much," he will admit. "I'm not trying to impress anyone—not consciously, anyway—but people are *so* kind, and I remember what tips meant to me once when I was an usher in the Paramount-Publix Theatre, in New Haven. Tips kept me going. Someone once gave me fifty cents."

Fielding hates the details of low finance, but Mrs. Fielding keeps a businesslike eye on things, and when she feels that he has been throwing away too much money she serves him codfish cakes and beans. He appreciates the symbol, and he restrains himself while the wells refill. He says that he no longer wears silver but "all gold now." He goes on, "I built one blazer around a set of gold buttons that someone gave me. Gold has a softer warmth. It's all a matter of taste." Of the foods of the earth, his favorite is caviar, and of caviars the kind he likes best is gold. "One in ten thousand pots of caviar is gold," he explains. "It's a beautiful berry—gorgeous burnished gold with gray overtones." Ordinarily, of course, he is content with simple black caviar, which, he points out, is worth more per ounce than sterling silver. Sometimes in the middle of the night when he cannot sleep, he goes to the refrigerator at Villa Fielding and fixes himself a snack of caviar. ("I dig perhaps fifty or seventy-five grams from the pot with an all mother-of-pearl caviar knife. As you know, caviar should never be touched by silver tableware.") Three years ago, after his five-day fiftieth-birthday party in Copenhagen, the Fieldings went to a sanatorium in Jutland to recover, and while they were there Fielding ate four and a half pounds of leftover caviar. Among the American guests who flew to Copenhagen in the SAS plane that Fielding had chartered were the débutante he had been unable to take to Childs that night in 1933 and her husband. In his office in Formentor,

Fielding has old newspaper clippings that tell of their engage-
ment and marriage. When Fielding rides in taxis, he habitually
unbuttons and rebuttons the sleeves of the suit he is wearing,
unbuttons and rebuttons them again, until he reaches his
destination.

FRANKNESS

In the first sixteen years of the *Travel Guide* (from 1948
through 1963), Fielding wrote about Zermatt as if he had been
born there. He called the village "the number one attraction in
Switzerland, *the* place no American should fail to see . . . a
handcart-and-sleigh paradise . . . the Matterhorn seemingly so
close that you can almost touch it . . . our favorite among
favorites . . . incomparable." During those years, dollars piled
up in twenty-foot drifts in Zermatt. The people of Zermatt
knew greatness when they saw it, and Temple Fielding took a
place in their hearts somewhere between William Tell and the
inventor of the cuckoo clock. Then, in 1964, Fielding savaged
Zermatt. He wrote of "the greed, the avarice, and the men-
dacity" of its residents. He used such words as "shocking,"
"revolting," and "indefensible." And he virtually commanded
his readers not to go there.

In 1963, typhoid had broken out in Zermatt, at a particularly
inconvenient time. The winter season was at its height, and in
the immediate future major skiing events were scheduled that
would bring crowds of tourists to the mountain village. The
village did not report the typhoid to the outside world. The
merchants of Zermatt let the tourists come. Hundreds became
seriously sick, and some died. Before reporting this story in his
book, Fielding spent twenty-five hundred dollars to send a team
of Dutch detectives to Zermatt to verify it. Then he clobbered

the village whose postwar prosperity he had largely created. After his diatribe had appeared in two editions of the *Guide*, the fathers of Zermatt wrote to him and said that he was ruining them, and would he please come home to Zermatt, as their guest, to learn the full story? He went, as no one's guest— there are only seven hotels in Europe where he will stay as a guest of the house—and met with the mayor and many others around a large table in a conference room. "Why didn't you close down the village?" he asked. The merchants said they had known nothing and that they had been as innocent as the tourists. When the last had spoken, Fielding said, "Is that all?" Everyone nodded. Then Fielding pulled out a thick folder and went over the history of the epidemic and the obvious effort that had been made to keep it quiet—from the first sick man, living on a certain mountainside, who had contaminated one of the village water sources, right on through to every detail of the town's hopeless water system. Fielding says that there was a silence for a moment and then the villagers crowded around him in an outpouring of confession and contrition. After that, Zermatt built what is probably the safest and most expensively engineered water system in any small town anywhere. Fielding still tells the whole story in the *Guide*, but he has restored his recommendation of Zermatt, and he finishes by calling it "one of the most breathtaking creations of Providence . . . Heaven on Skis . . . the Great Architect at His most majestic."

In the early years of the *Guide*, Fielding once flew with Air France from Copenhagen to Paris. While the plane was gassing up in Denmark, the pilot was standing beside it with a limp cigarette burning between his lips. Once in the air, the man flew at a thousand feet or less all the way, scaring Fielding stiff. On Air France flights generally, Fielding often watched a stewardess go through the door from the passengers' cabin into the pilots' cockpit carrying a tray on which were two glasses of

cognac. So he began to rap the airline in his book, calling attention to its safety record and to the "make-it-do" maintenance philosophy of the French mechanical mind. English-speaking people took to referring to the airline as Air Chance. Finally, in 1964, Air France banned the consumption of alcoholic drinks by its flight crews and ground personnel, and at the same time sent a graceful surrender message to Fielding in Mallorca: "Now the long struggle that you and we have made is over." In the 1967 *Guide*, Fielding gave the airline full marks on all important counts, and the only thing he complained about was that the caviar they had recently served him was Sevruga, and not "the larger, costlier Beluga."

Pan American World Airways once sent representatives to Formentor to try to persuade Fielding to stop criticizing the airline's cold treatment of passengers, but Fielding kept after Pan Am until, in his words, "they just picked up their socks." He has more recently been engaged in a similar war with Alitalia. Fielding goes after these people like a German shepherd, and among those he has badly chewed are American Express, the Italian State Tourist Office, nearly all Hilton hotels, the Steigenberger hotel chain in Germany, the French Line, the Portuguese government, the Norwegian government, the Trans-Atlantic Passenger Steamship Conference, and the International Air Transport Association—often forcing significant reforms through his persistence. He goes after individual friends when he has to, and he has lost many as a result of things he has written. Oskar Davidsen's, a restaurant in Copenhagen, was once described by Fielding as "one of the two best-known restaurants, internationally, in the north of Europe"—the other being the Five Flies in Amsterdam. Axel Svenssen, the manager of Oskar Davidsen's, was a close friend of Fielding. In Fielding's opinion, the quality of the restaurant declined seriously in

Svenssen's last years, and although Svenssen was sick and Fielding felt for the situation his friend was in, the *Guide* began to print warnings about Oskar Davidsen's, and eventually, as Fielding would say, disrecommended it. Svenssen died hating Fielding. Nicolaas Kroese, the owner of the Five Flies, was also a close friend of the Fieldings, and in 1952 he made frequent visits to a hospital in Amsterdam where Mrs. Fielding came close to dying of a tropical disease. Kroese read to her, and fed her by hand, and Fielding will be forever grateful to him. Unfortunately, Kroese's restaurant started to go precipitously downhill a few years later, and in 1960 Fielding disrecommended it. Kroese has not spoken to him since.

The Canterbury, a restaurant in Brussels, once mounted an effort to get information that would discredit Fielding. He had dealt severe blows to the restaurant, and now the people who ran it intended to finish him. They filed suit against him, and then they sent research teams all over Europe to ask other restaurateurs how much they paid Fielding for favorable comments in the *Guide*. After the researchers reported back, the suit was dropped. Fielding, for his part, conscientiously went on checking the quality of the food at the Canterbury, and he has found that in recent times it has improved. In the 1967 *Guide*, he recommended the place, and said, "Our Waterzooi' of lobster was out of this world—deeee-scrumptious!"

Fielding has been sued for libel nearly forty times, with claims of more than twenty million dollars made against him. He has lost only once. In 1950, he took twenty-seven rides in the taxicabs of a company in Brussels, and on each ride he was insulted or gouged or taken the long way round, and no matter what he tipped he was screamed at—even when he tried tipping one driver a hundred per cent of the fare. Fielding spoke to the United States Ambassador to Belgium, who told him that the

cab company was believed to be a Communist organization, under orders to discourage American tourism. In the 1951 *Guide,* Fielding described the company's drivers as "the meanest, surliest, greediest set of crooks in Europe." He was hit with a lawsuit, and he eventually settled out of court for thirty-five hundred dollars, plus legal fees. "All the libel suits have been horribly expensive for us, even when they haven't gone to court," Fielding told me. "We've spent at least twenty thousand dollars out of our own pockets just paying lawyers to talk to other lawyers. One of the things we sell is our frankness. These libel suits are the price for that frankness." It was MacKinlay Kantor who taught Fielding some of the craft of avoiding libel. Kantor was staying at Villa Fielding once, in the mid-nineteen-fifties, when Fielding—low on cash and discouraged about the taxi company's suit—was trying to describe a restaurant where he had ordered Bismarck herring and had been served a plate that contained a cigarette butt and a decaying fish of uncertain species with wrinkled flesh and a watery blue eye. Acting on advice from Kantor, Fielding began his paragraph on the restaurant, "May I indignantly deny a current rumor? It is not—repeat *not*—true that . . ." What Kantor had said to him was "Temple, you should know by now not to attack people like that. Do not attack them. *Defend* them."

In the first edition of his book, Fielding wrote about Denmark as if it were just east of Shangri-la and west of El Dorado. He still refers in the book to Denmark as his favorite country in Europe, and in that first edition he introduced to his readers a man named Mogens Lichtenberg, the Danish tourist chief, and told them, "If you want anything in Denmark—a hotel room, Hamlet's dagger, a pregnant elephant—see Mr. Lichtenberg." In the years that followed, so many tourists slyly asked Lichtenberg for pregnant elephants that Lichtenberg had a poll conducted and found that more than fifty per cent of the American

tourists who arrived in Denmark were carrying Fielding's *Guide*. Lichtenberg reported this to the Danish government, and in 1950 the government gave Fielding an award of honor that carried with it—in perpetuity—a house, a maid, and a monthly allowance. "The Danish award was the impetus that moved us permanently to Europe," Fielding told me. "It was one of the sweetest things that ever happened to us. We were met at the airport by the Prime Minister, and we were driven in a big car to Hornbæk, on the Danish Riviera, where the house was waiting for us. It was a Norwegian-style oversize log house, set in two wooded acres. There was a pine forest on one side. The house had an earthen roof with forget-me-nots growing in it. An American flag was flying from a flagpole. Mogens Lichtenberg had lived in the house himself for a full week before our arrival, to test its livability. The maid, in uniform, greeted us. There was a fire in the fireplace, chuckling away merrily. A pitcher of Martinis was all mixed and ready. There was a roast in the oven. The beds were turned down. We walked in—it was home. We stayed there four and a half months. Leif Hendil, of the Danish Information Foundation, used to pull out a thick stack of kroner, when he saw me, and hand it to me, and it used to embarrass me like hell. I finally felt so uncomfortable that we moved to Formentor."

INCENTIVE

In 1946, Fielding saw a Canadian Club whiskey ad in which a Portuguese fisherman was saving the life of some hapless American. The *mise en scène* was so obviously phony that Fielding went to Canadian Club's advertising agents and told them that he was going to Europe with assignments from the *Saturday Evening Post* and the *Reader's Digest,* and that he was sure he

could conceive and produce better ads than they were running
—and with real backgrounds. "You're right. They're phony,"
said the ad men, and hired him.

While he was planning that 1946 trip, he went to several
bookstores and to the New York Public Library, got all the
European travel guides available, and read them all. "None of
these books are worth a good God damn," he said to his wife.
"I'm learning nothing. Everything is either picturesque or
Romanesque, and I want to know where to go, how to get
there, what the hotels are—good and bad—and where the
restaurants are, how many cigarettes to take. I can't find a single
practical book."

"Do your own then," his wife said. She had been telling
Fielding what to do since the day they met, in 1941, when she
became his literary agent. They were married in 1942. Since
1950, Mrs. Fielding has worked steadily on the *Travel Guide* as
research assistant. In that year, Fielding took her to Europe for
the first time. He told her that European trains were hooked
together by magnets, and in Westminster Abbey he informed
her that she was in the House of Commons. But she caught on,
and her observations on shops and hotels, generally filtered
through Fielding's prose, are among the sharpest in the book.
Barring times of illness, the only long research trip that Mrs.
Fielding has not in some part shared with her husband was that
first one, in 1946, when he crossed Europe in trains whose
engines burned walnut shells, and rode in taxis that were
powered by wood fires. A Canadian Club ad consisted of pic-
tures called lead shots, panel shots, and drink shots, and
Fielding was brilliant in all departments. In Switzerland, he
encountered Arnold Gingrich, the publisher of *Esquire*, and got
him to cling desperately to the Riffelalp, above Zermatt, while
glue-toed natives saved him. In the celebrated quicksands at
Southport, in Lancashire, Fielding himself sank slowly in the

ooze, his regimental tie disappearing stripe by stripe, while a local fisherman prepared to cast a net to save him. Those quicksands have claimed innumerable victims over the centuries, but Fielding found that for some reason he couldn't sink far enough for the pictures to be properly harrowing, so he got a shovel and dug into the quicksand until he had himself in up to the chin. At home, when he had delivered his last drink shot to Canadian Club, he spent nine months writing his first *Travel Guide*. Much of the work was done in a Third Avenue bar. His wife sold the book to William Sloane Associates and took her ten per cent.

STYLE

From reading Fielding's *Travel Guide*, it is sometimes hard to tell which he enjoys more—the things he writes about or the writing itself. His considerable *joie de vivre* is nowhere more evident than in his writing. In his office, as he works, he roars with unself-conscious delight over his own puns and metaphors, but only in this one sense does he take his style lightly. He feels that he has established a special rapport with his readers, and he attributes this to the manner of his writing, which is designed to provide enough scintillation to keep their eyes from closing over what is essentially a catalogue. Some critics have written that they wish Fielding would turn off some of the verbiage and just give the facts, but Fielding says that he would sooner write nothing. He is a direct descendant of Henry Fielding. Words pour from him. But he is at times a seeker of the *mot juste*, and he will spend two hours on a single sentence. "It's not literature," he told me, "but it's damned good writing. I enjoy doing it enormously. The techniques are engineered. We're shaping the style to the taste of the reader, and we're trying for a style

that will be universally popular. It looks effortless, but it is carefully worked out. In the copy, there is a certain metre, with which we try to hypnotize the reader—dah, dah; dah, dah, dah; duh, duh, duh. We keep the reader going fast, so he can absorb more. With semicolons we break the pace for emphasis. Frankly, we have modelled our work very closely on the style of *Time* magazine. Open the book anywhere. You'll see what I mean." Of the Hotel Piccadilly in London—about three hundred pages in—Fielding writes:

> This house gives its guests a ringside seat at the Circus that puts shoppers right in the limey-light. Its $420,000 revamping added baths where none existed previously; it also reupholstered the furniture à la 16-ounce Boxing Glove. Large, comfortable rooms, as British as plum duff; bid for the rear side, which is quieter. Rates? Its $19 price for doubles strikes us as being almost as overstuffed as one of its sofas. Late reader reports about this one fairly froth with rage about the reception, hall porter's desk, and general staff attitudes. Still far from the dilly-of-the-pick.

He notes that the dampness of England is "enough to give chronic rhinitis to a cigar-store Indian." He praises one Madrid hotel for being "cleaner than a surgeon's fingernails." He reports that he has done a great deal of "Costa del Sol-searching." He speaks of "de Gaulle's galling headaches with his Gauls," of Norway's "Lapp of Luxury," and of a London restaurant called the Elizabethan Room that cooks with a "Bess-emer converter." He tells ocean travellers, "Arrange for your table with the head dining room steward. A smile, a tear, and a little fast chatter will keep you from breaking bread with the Jukeses."

Time's style is often called Time-ese, and Fielding calls his

style Fielding-ese. He even has his own style book, delineating the essentials of Fielding-ese. "We must always try to enlist the zip of our reader's empathy," he writes in the style book. "A chair is not tipped over; it is kicked over. We don't fly to the Swiss ski glaciers. We rocket, we soar, we jetstream. Write *up* to the intelligence of readers. The buyers are much smarter than any of us superficially would take them to be. What we *must* have throughout is a regional stamp with looseness, relaxation, and the type of our own very human fun in writing, to which most readers respond as to a tuning fork. Re clichés: use them often, but always with our own special Fielding-ese twist. A miss is not as good as a mile; a miss is as good as the sixteenth hack of the same Albanian razor blade. Originality in always interjecting a new zing into the classic bromides is mandatory. We love semicolons for tightness, terseness, and fast pace, but they must be blended harmoniously into our reading rhythm. Learn by heart the following words: accuracy, pace, crackle, wit, rhythm. Lard sly, not too obtrusive, generally sophisticated wisecracks and plays-on-words as thickly as possible into the copy. Sparkling word-plays are our literary potatoes." Fielding never underbakes them. Of the Puerta de Moros, a restaurant in Madrid, he writes, "If its Moorish Chieftain would reward his palace with a bit Moor spick and polish, we would admire it a heckofalot Moor. But for now, only Moor-or-less recommendable."

Fielding likes to tell people that aboard Air Force One President Kennedy kept a library of four books—a dictionary, a Bible, the Congressional Directory, and *Fielding's Travel Guide to Europe.* Adlai Stevenson carried the *Travel Guide,* and so does the present Foreign Minister of Spain. Countless Europeans use it, too—businessmen, especially—and there are American expatriates of the Jet Set who have lived in Europe for twenty years who say they would not be without it. Prince

Albert and Princess Paola are guidesters, and so was Perle Mesta, when she was Envoy Extraordinary and Minister Plenipotentiary to Luxembourg. Ernest Hemingway was a guidester, too. Once, soon after his African plane crashes, Hemingway was staying at the Gritti in Venice, and he learned that Fielding was there as well. Hemingway asked Fielding, whom he didn't know, to lunch, and whenever Fielding's glass was empty he said to the waiter, "Pour the kid another glass of wine."